The Verbum Book
of Digital Painting

Also by Linnea Dayton and Michael Gosney
The Verbum Book of Electronic Page Design
M&T Books/Prentice Hall, 1990

The Verbum Book of PostScript Illustration
(with Janet Ashford)
M&T Books/Prentice Hall, 1990

**This book
is dedicated to painters across the ages.**

The Verbum Book
of Digital Painting

Michael Gosney ▮ Linnea Dayton ▮ Paul Goethel

M&T BOOKS

M&T Books
A Division of M&T Publishing, Inc.
501 Galveston Drive
Redwood City, CA 94063

Printed in the United States of America
First Edition published 1990

Library of Congress Cataloging-in-Publication Data
Gosney, Michael, 1954–
 The verbum book of digital painting / by Michael Gosney, Linnea Dayton, Paul Goethel
 p. cm.
Includes index.
ISBN 1-55851-090-7: $29.95
 1. Computer art — Technique
 I. Dayton, Linnea, 1944– II. Goethel, Paul, 1952–
 · II. Title.
 N7433.8.G68 1990
 760- -dc20 90-13428
 CIP

93 92 91 90 4 3 2 1

Produced by The Gosney Company, Inc. and *Verbum* magazine
670 Seventh Avenue, Second Floor
San Diego, CA 92101
(619) 233-9977

Book and cover design: John Odam
Cover illustration: Michael Cronan, adapted by Jack Davis
Production Manager: Martha Siebert
Production Assistants: Jonathan Parker, Mike Swartzbeck
Administrative Manager: Jeanne Lear
Technical Graphics Consultant: Jack Davis
Proofreading, research: Valerie Bayla, Jackie Estrada

Contents

Hello, and welcome to the *Verbum Book of Digital Painting*. Like the other books in the Verbum Electronic Art and Design Series, this is an art instruction book rather than a technical computer book. This book stands out in the series because the subjects it covers are as closely related to fine art as they are commercial art. Although the idea of fine art created with the aid of personal computers is still very new, this book should be of particular interest to artists who are working in both the commercial illustration and fine art spheres, and it should prove beneficial to those working with desktop publishing systems who wish to know more about digital painting techniques.

The first two chapters of the book give you an overview of digital painting technology and the personal computer products that make it possible. The succeeding chapters take you through the step-by-step development of actual illustration projects by talented artists. Each chapter introduces the artist and project and re-creates both the technical steps and the artist's creative thought processes as the project was developed. At the end of each chapter is a portfolio of other illustration examples by the artist, with brief descriptions of each.

You'll find sidebars and tips throughout the project chapters. The sidebars provide supportive information on significant subjects. ▌ *Tips are introduced by this vertical symbol, and they appear in italics.*

An extensive Gallery of exemplary digital paintings follows the project chapters. These paintings are from artists who have had extensive experience working with personal computer systems. We've chosen works that represent not only excellent illustration but effective and innovative use of the electronic tools. You'll find a variety of examples of pc-assisted fine art in this section. At the end of the book, the Glossary provides terms and definitions, while the Appendix lists useful products and services. Production Notes provide details on the development of the book itself. And of course the Index will help you find specific information.

Jack Davis

Origins of digital painting

Where did the electronic art and design world of the '90s come from? Raster imaging, or bitmapped illustration on the screen of a computer, is a technology that goes back to the early mainframe systems. Then the first personal computers popularized this imaging capability, crude as it was by today's standards. In the early 1980s we saw bitmapped painting on Apple II systems, IBM PCs and even $100 Commodore 64 systems.

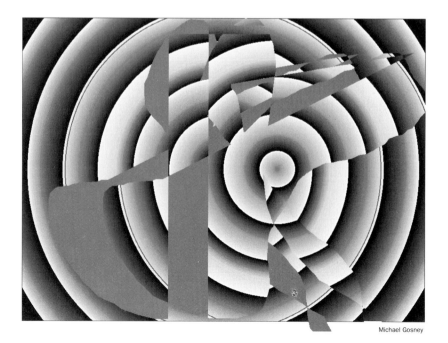

Michael Gosney

However, it was the Macintosh, introduced in 1984, that set the standard for digital painting. With its high-resolution screen, mouse-driven interface and revolutionary MacPaint program, everyone — artists and accountants alike — got an exciting taste of a new kind of art medium.

Today, as this book illustrates, bitmapped illustration tools have found their own niche in the wide-ranging world of digital art and design. Fast, high-resolution pc systems combined with extremely powerful and easy-to-use software applications have brought digital painting to a technical plateau that awaits full exploitation by creative individuals. The technical capabilities of these new pc systems are indeed substantial — to many artists they are downright intimidating. But the painting programs are really quite natural, or "intuitive," to use. We call the process "digital painting" because the experience is the closest, of all the digital art tools available, to the spontaneous, tactile experience of painting on canvas. Only this is a canvas of silicon — and the paint is light itself.

On an established plateau

After several years of rapid evolution, the field of digital painting is finally established. A plateau has been reached with hardware and software standards for electronic art and design, services and support networks. Most of the tools, even if on different hardware platforms, work in similar fashion. During the next few years, we don't anticipate quantum leaps that will make the existing standards obsolete; rather, we expect steady refinements of existing tools, added speed and power in available hardware platforms and progressive innovations in high-end processes such as color separation. That is why most of the material in this book will be useful to you regardless of your specific system configuration, and for several years to come.

What can I do with electronic paint?

When the Macintosh II came out — about the same time that artists were souping up IBM PCs with Targa boards and other hardware enhancements, and even the Amiga was gaining impressive capabilities — we started seeing amazing high-resolution digital paintings on the screen. The sharp 13-inch or 19-inch screens and 256 colors were a far cry from the constrained black-and-white, or low-resolution 16-color worlds we'd been working in. These $10,000 Mac systems were more like $75,000 high-end graphics workstations. But they were better: more intuitive, innovative and flexible, with a market of tens of thousands, versus a few thousand, users.

Shortly after these stunning images began appearing on pc screens, people started asking, "But how do you get it out of the computer?" Very few options were available at first for producing paintings that could be hung on the wall. Although some film recorders (systems to convert digital information directly to film) were around, they were very expensive, they were difficult to find in service bureaus and only a few could handle pc output. Instead, artists often

Jack Davis

photographed the 19-inch high-resolution monitors with 2¼-inch film and made large Cibachrome prints. Eventually, less expensive film recorders became available for pc's. And other options emerged, as fast as manufacturers could develop products for this voracious market: desktop inkjet printers and then thermal transfer printers.

With these new printers, artists had instant 8½ x 11-inch four-color prints of their works, and they could even "tile" the letter-sized sheets into huge versions. More recently, large-format inkjet printers are able to interface with pc's, and artists are printing digital paintings on archival rag cotton paper to produce what can be considered museum-quality output.

Many artists combine traditional and electronic media in interesting ways, at both input and output stages. Scanning a sketch or a finished color painting — converting the image to digital information — is a fascinating process. The delicate detail or textural richness achieved with pencil, chalk and other traditional tools can be converted into electronic form for enhancement, manipulation or combination with other imagery. Printed output — tiled ink-jet prints on cotton paper, for example — can be colored with india ink or acrylic paint. Constructions, with computer output as one of several materials used, are another form artists are experimenting with. Silkscreens and lithographs printed from digital color separations are increasingly common. And the stunning crispness of a large Cibachrome print, the medium of choice in the world of fine art photography, is still one of the best ways to reproduce the "light painting" an artist creates when working on a brilliant 19-inch color monitor. Giving computer-assisted works a "fine art" form — something tangible that can be sold in a gallery — is a challenge many artists have accepted in recent years.

In commercial illustration, which is what most artists are using digital painting for, there are many options for output. Here we enter the domain of 1990s-style "desktop publishing:" a highly evolved world of full-color page design and color separation. Designers can easily "import" a digital painting into a computer-produced brochure or ad layout and automatically color separate the work, along with the rest of the layout, for offset printing. Making a digital transparency is relatively inexpensive and easy, as film recorders are now common in electronic output service bureaus and in design studios. With the emergence of 24-bit color systems — giving users 16.7 million colors to choose from — we're seeing the emergence of a new plateau for digital painting. The "jaggies" will no longer bother us, scanned images and painted images will be hard to tell apart, and the use of 3D imagery and animation will become more and more common.

Beyond fine art prints and commercial illustration, digital painting has an important relationship to "multimedia," an emerging presentation technology. The ability to combine and spontaneously access text, graphics, sounds and animations on a personal computer is known as "interactive multimedia." In this exciting new technology the screen — not the printer — is where the

Jack Davis

action is. Both black-and-white and color "pixel paintings" are ideal for multimedia, and the many kinds of applications indicated by this umbrella term represent opportunities for digital illustrators.

What is *Verbum?*

Verbum, the Journal of Personal Computer Aesthetics, is a magazine dedicated to exploring the aesthetic and human aspects of using microcomputers. Founded in 1986 by a group of artists and writers who had the good fortune to be involved with the early electronic design tools, the journal has tracked the evolution of electronic design and illustration, contributing the artist's perspective (and conscience) to an industry that has at times been unbalanced in its commercial and technical emphasis.

Each issue of *Verbum* has served as an example of the latest desktop publishing tools, beginning with the early issues' laser-printed camera-ready art evolving to today's digital four-color separations. Through the development of the magazine, we've helped galvanize the community of advanced artists, programmers and industry visionaries who have pushed the new frontier forward. As an ongoing experiment, *Verbum* has covered electronic design, illustration, fine art, typography, digitized imaging, 3D graphics, animation, music and even the new realm of interactive multimedia. The Verbum Electronic Art and Design Series of books was conceived as a way to bring *Verbum's* accumulated resources into a practical, instructional context.

Beyond the magazine, Verbum has been involved in popularizing pc-assisted art as a fine art form. The Verbum team has produced the "Imagine" exhibit of personal computer art since the spring of 1988. Sponsored by Apple Computer, Inc., Letraset USA, SuperMac Technology and other firms, "Imagine" is an evolving exhibit featuring the work of over 60 artists from around the world. Major shows have been held in Boston, San Diego and Tokyo, with abbreviated exhibits at conferences in Toronto, Washington, D.C., San Francisco and Los Angeles. In the summer of 1990, the Verbum Gallery of Digital Art opened in San Diego, showcasing some of the top digital painters from the United States and other countries.

A few acknowledgments

Producing *The Verbum Book of Digital Painting* and the entire Verbum book series has involved the helpful efforts of many people, too many to mention here. But we would like to give special thanks to the contributing artists who committed that most precious resource to the project: time. Also, we would like to thank our literary agent William Gladstone; our patient editor at M&T Books, Brenda McLaughlin; our service bureau here in San Diego, Central Graphics; and the many software and hardware companies that helped keep us up-to-date on products. Finally, we'd like to thank our *Verbum* readers, who keep inspiring us to push the envelope — just a little further!

C H A P T E R 1

An Overview

Computer "painting" (also known as *bitmapped* or *raster graphics*) is a new art medium that's highly valued for the spontaneity it encourages, the powerful special features it offers and its "painterly" approach to creating art on a computer (Figure 1). In the realm of computer graphics, bitmapped illustration is the most widely embraced medium for creating what is traditionally considered fine art — although the commercial applications for bitmapped graphics are also many and varied. Paint programs are interactive and responsive, letting the artist see the painting develop as the strokes are made. The *user interface* (what you see on-screen and how you interact with the program's functions) is generally intuitive and modeled after the pencil, brush and other tools traditionally used by artists. Both adults and children, with or without art training, can quickly learn to produce at least a rudimentary image with a paint program. But

Figure 1. Creating "fine art." "Violin" by San Francisco illustrator Michael Cronan was painted on a Macintosh II computer with the Studio/8 program.

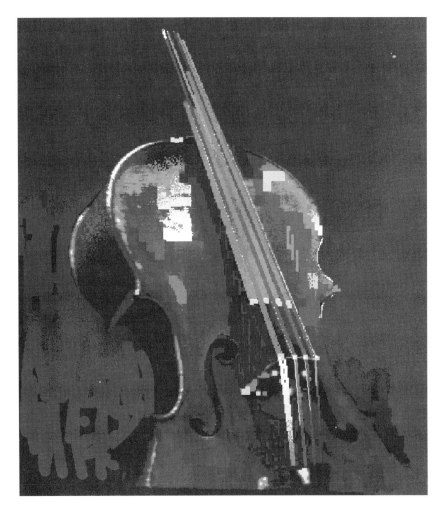

sophisticated art and illustration can also be produced, and it involves being thoroughly familiar with the many graphic effects and tools available in the more highly evolved paint programs.

The bitmap medium

Creating art in the bitmap medium can be likened to working with dots on a piece of paper. One dot on the page equals one pixel (or dot of light) on the screen, although pixels are rectangular rather than round. Any given computer system has a standard number of pixels that define its screen resolution. The Macintosh's standard resolution, for example, is 72 dots per linear inch (dpi). The pixel structure of a composition can be thought of as a superimposed grid. Each pixel requires at least 1 bit of computer memory corresponding to its position on this grid — to indicate whether the pixel is "on" (black) or "off" (white). Any design created on the screen will be read by the computer not as a combination of shapes, but as a pattern of these minute grid units. When you paint in a bitmap program you're actually creating an on-screen "map" of these tiny "bits" of information (Figure 2).

Bitmapped graphics are sometimes referred to as "dumb art." Each pixel is either on or off and is not logically connected to its neighbors. A circle drawn on screen looks like a circle to the eye, but the computer knows only that some of its pixels are on. With object-oriented graphics (also known as *vector* or *draw* graphics), by contrast, a circle drawn on-screen becomes not only a bitmap pattern (for purposes of screen display) but a logical object. It can be moved

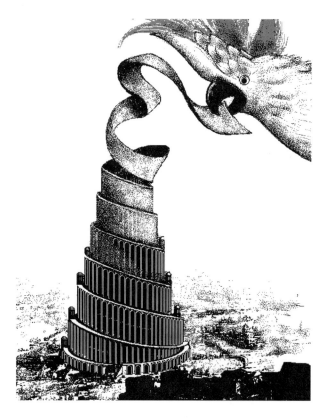

Figure 2. Making pictures with pixels. "Tower of Babel" by Swiss artist Dominique de Bardonneche-Berglund was created with Super-Paint on a Macintosh Plus. An enlarged area of the bird's head shows its pixel structure, while a further enlargement of the eye reveals the underlying "grid" on which the black and white squares are placed.

and distorted as a whole, and all the pixel locations associated with it will be recalculated automatically. A vector object remains separate from other objects and can be selected and moved independently without affecting other areas of the image.

It *is* possible to paint a bitmapped object and then ask the computer to enlarge, rotate or move it. The computer looks at the pattern of square dots and estimates mathematically where and when to add and delete pixels to achieve the changes called for. But when a bitmapped object is moved or changed in shape, it typically leaves behind a "hole" and then overlaps and obliterates the previously painted area where it's placed (Figure 3).

Figure 3. Painting versus drawing. A bitmap or paint image (top) is literally a map of all the *bits* or pixels that make up the picture. When part of a bitmap image is selected and moved, a "hole" is left behind. By contrast, an *object-oriented* program treats each graphic element as an independent, logical entity (below). Objects can be moved without disturbing the background, for example, and can be smoothly resized and distorted.

When you print a bitmapped image, each dot on the screen is read and printed on a one-to-one basis. Each rectangular pixel on the screen results in a printed rectangle on the printed page. In computer terminology this means that working with paint programs can be characterized as WYSIWYG, or "what you see is what you get." The printed pixels are small but still individually distinguishable, and bitmap prints can appear quite jagged or stair-stepped, especially along diagonal or curved edges. Object-oriented images are also rendered on-screen with pixels, but because they're based on mathematical equations rather than pixel maps, they can be printed at higher than screen resolution (for instance at the 300 dpi resolution of a laser printer) and therefore the prints appear less jagged.

Painting the digital way

Of all the computer graphics media, bitmap painting *feels* the most like traditional brush-and-canvas painting. With metaphoric tools such as the pencil, brush and paint bucket, the artist spreads "paint" over an electronic canvas, using the tools to deposit color, pixel-by-pixel, along the strokes defined by the movement of the mouse or stylus. Seen in a magnified view, the painting looks like a grid of black-and-white or multicolored squares; but seen at normal view, from the user's usual distance from the screen, the pixels blend to give the composite effect of an image.

Although bitmap programs are relatively easy for artists to use, they limit the artist in two important ways. First, once an image is created, it can't be easily changed or manipulated, though most paint programs can "undo" the last paint stroke, and the newer programs include elaborate tools and functions for masking, selecting and altering groups of pixels without affecting their neighbors. The second problem is the stair-stepping of the pixels (see "Smoother transitions: antialiasing and dithering" on page 10).

The right tool for the job

Standard paint programs include a variety of *tools* for painting strokes of color (or gray tones), for filling large areas with tone or pattern, and for selecting portions of previously painted areas of an image (Figure 4). These tools include:

- a pencil for free-form drawing of lines 1-pixel-wide (Figure 5)
- a paintbrush for making strokes that can vary in shape, thickness, pattern and color (Figure 6)
- a spray can for applying scattered pixels as though from an airbrush (Figure 7)
- a line tool for drawing horizontal, vertical and diagonal straight lines (Figure 8)
- polygon, rectangle and oval tools for drawing geometric shapes that are outlines or solids (Figure 9)

Figure 4. Tools of the trade. Icons, many of them representing traditional artists' tools, appear in the on-screen toolbox typical of bitmapped illustration programs. This is the toolbox for SuperPaint.

- a paint bucket for filling large or small enclosed areas with color (Figure 10)
- an eraser for removing paint (Figure 11)
- marquee and lasso tools for selecting areas of an image that are to be re-positioned, copied, deleted or otherwise altered (Figure 12).

The electronic paint applied by the tools can be black or white in a black-and-white program, one of 256 shades of gray in a grayscale program, or one of over 16 million colors in a 24-bit color system. Colors or tones are selected

Figure 5. Using paint tools. The basic tools and icons developed for Mac-Paint are still used in most Macintosh-based paint pro-grams. The pencil tool is used to draw free-form lines of one pixel width, like this line drawing of a face.

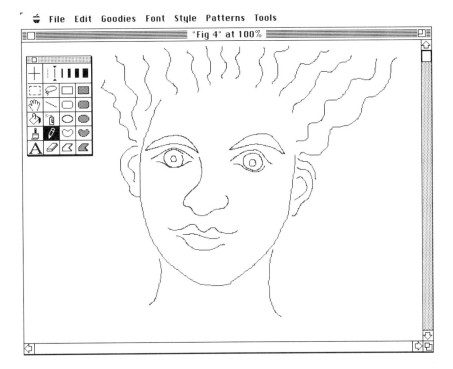

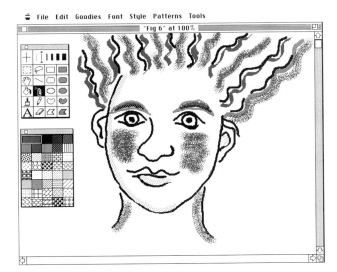

Figure 6. Adding thick and thin. The brush tool can be modified to provide strokes of varying size and shape, includ-ing a round dot "footprint," a square dot or a line edge like a calligraphy pen.

Figure 7. Spraying pixels. The spray can provides a soft stroke by spraying pixels out from the center of its "footprint."

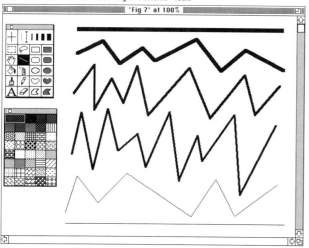

Figure 8

Figure 8. Drawing lines. The straight line tool creates lines of variable thicknesses. Line segments can be horizontal, vertical or diagonal, connected or separated, and can be of any length.

Figure 9. Drawing shapes. The standard shape-drawing tools make it easy to create rectangles, ellipses, rounded-corner rectangles, polygons and curved shapes either as outlines or solids. Holding down the Shift key while painting constrains a rectangle to a perfect square and an ellipse to a circle.

Figure 10. Spilling paint. The paint bucket tool is designed for filling large areas with color. It was used here to quickly add solid black to the background and patterned fills to some of the shapes created by the overlap of graphic elements. The paint dumped by the bucket spreads until it encounters an unbroken outline.

Figure 11. Eliminating paint. The eraser tool, with its large square footprint, is used to wipe the paint off fairly large areas. For more detailed

work the pencil or brush tools can be used as erasers by assigning them to use white paint. Double-clicking on the eraser tool wipes the entire image area clean.

Figure 12. Selecting and moving. The marquee and lasso tools are used to select and then move or copy portions of an image. The marquee selects only a rectangular area while the lasso is used to select free-form shapes.

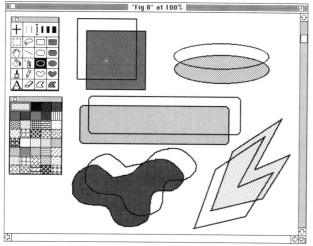

Figure 9

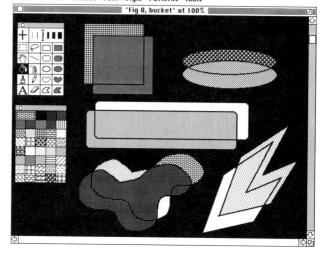

Figure 10

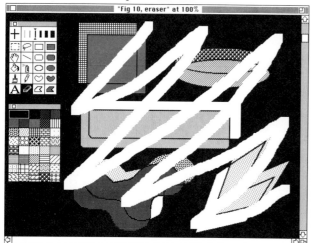

Figure 11

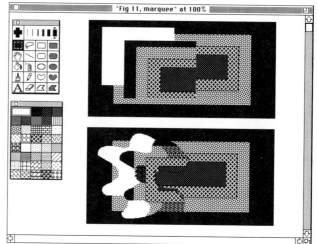

Figure 12

from a palette, and the currently active color usually appears on-screen near the toolbox in a "foreground color" box. Whatever color is currently displayed there will be used by the painting tools until a new color is chosen.

In addition to colors, paint can be applied in patterns, almost like painting with liquid wallpaper. Common patterns range from the simple black-and-white basket-weave, brick, dot and line patterns available in MacPaint (Figure 13) to complex custom color patterns created in advanced programs by sampling or selecting a part of an image and designating it as a pattern.

The artist's strokes are communicated to the computer either by using the hand to move the computer's mouse or by using an electronic stylus. The mouse works by translating the movement of a floating ball that slides along

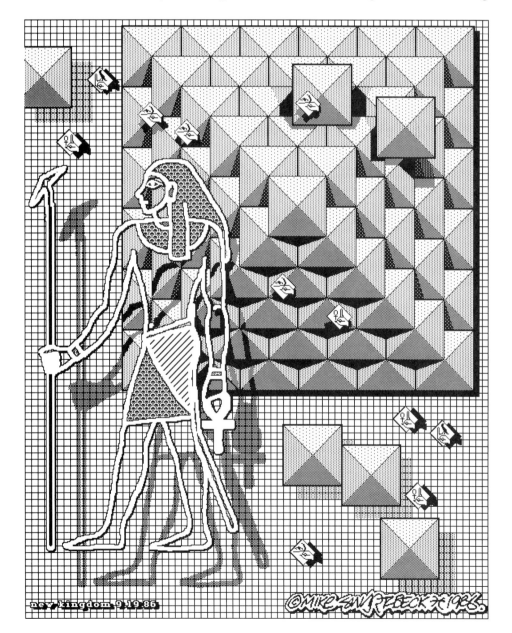

Figure 13. Painting with patterns. Most paint programs include a palette of patterned fills that vary from simple line and dot grids to tiers of bricks, tiles, shingles, basket-weave and plaid. "New Kingdom" by Mike Swartzbeck illustrates effective use of fills.

the table surface or pad on which the mouse is moved. The electronic stylus communicates by dragging across the surface of a desktop "tablet" that uses an underlying wire mesh and a magnet to translate the movements of the artist's hand into digital information that can be seen on the screen. Drawing with the mouse may at first seem somewhat like drawing with a bar of soap, though with experience the user can achieve smooth, fine control of lines and strokes with this device. The stylus is preferred by many computer artists because it more closely simulates a hand-held brush, pen or pencil. Digital artists must adjust their working habits so their eyes follow the developing image as it appears on the computer monitor, rather than on the pad or tablet beneath the stylus or mouse.

Bitmapped images can also be created by scanning photographs, artwork or three-dimensional objects with a flatbed or video scanner. These images can be used as is or modified in a paint program or a grayscale or color image-editing program (Figure 14).

Black-and-white

Paintings created in black-and-white programs are called 1-bit images because 1 bit of computer memory is assigned to each pixel. Working in the single-bit mode means that each pixel can be either on or off, black or white. The impression of shades of gray is created by placing pixels of black and white next to each other in checkerboardlike patterns of varying density. These patterns appear gray when viewed from a distance. In the Macintosh, 1-bit images are typically saved in one of several standard file formats like MacPaint, PICT (for *picture*) (Figure 15) or TIFF (*tagged image file format*).

An illustrator may choose to work in black-and-white when creating line art for a newspaper ad, for example, or when sketching rough ideas that may later be executed in color. Or an artist may prefer black-and-white solely for

Watch out for lost pixels

There's a down side to the wondrous effects and flexibility possible with paint editing functions; after all, the screen image is (to the computer) nothing more than a pattern of adjoining dots. So when a section of a painted graphic is stretched to, say, four times its area, its component pixels are also stretched; one pixel becomes four pixels. A thin line becomes a thick line; diagonal lines become grossly jagged.

Conversely, if a detailed graphic is reduced, and then later enlarged, it won't return to its original appearance. During reduction, some pixels are literally squeezed out of existence, and they're not re-created when the image is returned to its original dimensions.

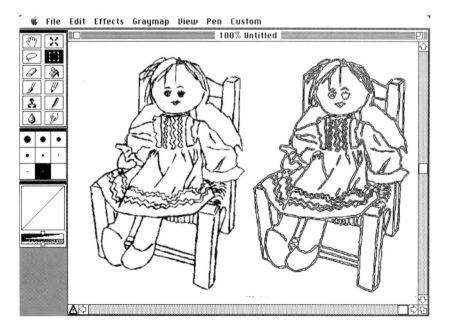

Figure 14. Using a scan. Drawings, photographs and live models can be scanned as high-contrast black-and-white images and imported into most paint programs. The scan appears as a bitmap and can be colored, copied and manipulated in the same way as an image painted with the paint tools. This scan of a line drawing of a doll was opened in ImageStudio and copied. The copy was modified using the Trace Edges filter, which draws a thin line along both sides of the lines in the original image.

Figure 15. Creating grays with 1 bit. In 1-bit art each pixel can be only black or white. When a continuous-tone photograph is scanned as a 1-bit image, for example, the shades of gray are translated into areas with varying densities of black pixels (15a). A close-up of the right eye of this scan of a girl shows how the image is constructed (15b).

Figure 16. Creating grays with 8 bits. In 8-bit art each pixel can be any one of 256 shades of gray or color. This greatly extends the subtlety of gray or intermediate color tones in a bitmap. The same photograph used in Figure 15 was scanned here as an 8-bit TIFF (16a). A close-up of the right eye shows how many different shades of gray have been assigned to the pixels (16b).

the simplicity and beauty of this medium, as pen and ink drawing is sometimes preferred to paint. An advantage of working in black-and-white is that it's faster than working in color, especially when the screen is redrawn after changing the view of an image. Also the images are dramatically smaller in terms of the storage space and working memory they require.

Grayscale

A bitmapped grayscale image assigns 8 bits of memory to each pixel, which means that any one pixel location can display one of 256 different shades of gray, ranging from solid white to solid black (Figure 16). A grayscale image is typically saved as a TIFF file, which stores a "gray map" that specifies the

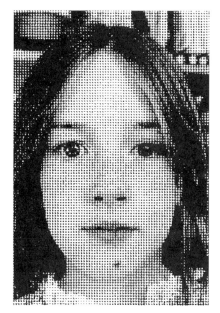

15a

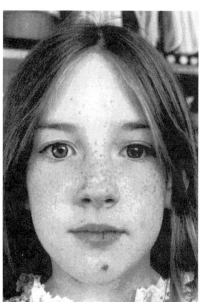

16a

15b

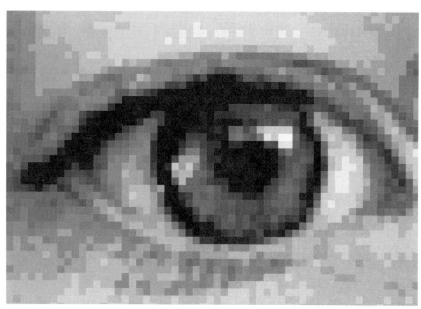

16b

level of gray that's associated with each pixel. ▮ *The number of available "information slots," or color options, for each pixel is determined by the number 2 raised to the power of the number of bits assigned to each pixel. So an 8-bit program can display one of 256 (2^8) different shades of gray or colors in each pixel.*

Color

Painting in color, like grayscale, means making the jump from 1 bit to multiple bits of information per pixel; 5 bits (2^5 or 32 available colors) is the normal graphics mode for Amiga computers. State-of-the-art, 24-bit graphics boards for IBM PC–compatible Targa systems and Macintosh II systems offer the bitmap artist a mind-boggling 16.7 million (2^{24}) color choices. Today it's entirely feasible to use bitmap programs for creating everything from simply drawn cartoons using only a few colors to intricate fine-art paintings with subtle shadings and color blends. With the increasing sophistication of paint programs and concurrent hardware advances, digital painters have the tools to greatly expand the realm of computer art.

Output

Images created in a paint program can be printed in black-and-white on a dot matrix printer or a laser printer, or can be output on paper or film by an imagesetter such as a Linotronic 300. Color images can be printed on a

▮ **Smoother transitions:
antialiasing and dithering**

There's a way of dealing with the "jaggies" that plague bitmap art. Known as *antialiasing,* the technique involves blending the diagonal or curved edges of lines or shapes into the background. The result is an illusion of reduced jaggedness and smoother color transitions. In some programs, the artist is required to accomplish antialiasing by hand, a tedious and time-consuming process that entails pixel-by-pixel work while zooming in and out of the painting. Some paint programs provide automatic antialiasing, while others have functions that can be applied to accomplish this effect, known variously as "blurring," "blending," "filtering" or "solid averaging."

Another way to soften the "pixel look" of bitmapped art is a paint technique known as *dithering.* A dither is a way of alternating pixels so that optically an intermediary "color" is created in the area of overlap where the first color is fading out and the second is fading in. Many paint programs and digital scanners include an automatic dithering function.

antialiasing

dithering

thermal wax or inkjet color printer or can be output as color separations on film for use in making match prints, color keys or printing plates. When an image is destined for mass production — for example, as part of an ad in a four-color magazine — the color separation capabilities of the advanced painting programs make possible a high-quality printed image. But for the individual artist who intends to produce a single art piece or a limited edition of prints, getting good-quality output can be difficult and expensive, especially when archival materials are required.

Digital artists are learning to produce museum-quality output in a variety of ways. For large images, some artists print sections on separate pieces of pH-neutral rag paper that are then tiled together (Figure 17). Black-and-white images can be printed in this way and then hand-colored using paint, watercolors, pastels or colored pencil. Printed images can be used to create photo stencils for silkscreening (Figure 18). Film recorders can transform the computer image into a 35mm color slide, which can then be used to generate

Figure 17. Tiling large-format output. "Memento Mori/ Manchild," by Marius Johnston, was created in SuperPaint on a Macintosh Plus. The finished piece, measuring 38 x 30 inches, was output on an ImageWriter II with a four-color ribbon onto cotton paper in sections. These "tiles" were then assembled and mounted on canvas.

a large Cibachrome photo print. Color slides can also be used with a computer-driven system that creates billboard-size (6 x 8 feet and larger) prints on paper or canvas using an inkjet printer. Inkjet printers can also print on archival materials in smaller sizes (about 24 x 30 inches). Color-separated film or color slides can be used to produce the plates for limited-edition lithographs employing traditional four-color process printing (Figure 19).

Future trends

A number of future trends in bitmapped illustration will depend on new technologies as well as on changes in the way artists think about the capabilities of the bitmap medium. New pressure-sensitive stylus/tablet systems make it possible to control the rate of flow from an airbrush tool, for example, by applying stylus to tablet with more or less pressure. This is one way in which bitmap painting is moving closer to the feel of traditional media.

Figure 18. Creating silkscreen stencils. This *Verbum* t-shirt design created in SuperPaint by Mike Swartzbeck was output as a negative on film (above) from which a silkscreen stencil was made.

In addition, the ability to handle very large document files will make it possible to use paint and image-editing programs more extensively for desktop pre-press functions. On high-end systems, like the Scitex for example, a single color photograph can consume as much as 100 megabytes, whereas the practical limit for use on a Macintosh II is about 5–10 megabytes. Personal computers continue to improve to meet the demand for handling larger files by increasing processing speed and *RAM* (random access memory, or "working space") and by using *virtual memory*, a system software scheme whereby the computer employs disk memory as additional RAM.

In the area of style, the bitmap medium is encouraging a trend toward blending graphic elements derived from many sources. For example, a bitmap program can be used to combine images drawn from a still video system with three-dimensional graphics, scanned photographs and textures, as well as painted graphics.

Figure 19. Producing limited-edition litho-graphs. "Westbound Train" by Brentano Haleen was created in PixelPaint on a Macintosh II. A digital transparency was made with a high-resolution film recorder. The image was then color separated and printed, using traditional four-color lithography, as a limited-edition print.

C H A P T E R 2

Applications

Figure 1. Designing basic tools. The toolbox in the first version of MacPaint featured tools for creating free-form lines and geometric shapes as well as a lasso and selection rectangle for isolating parts of a painting. A text tool provided the lettering, but the bit-mapped type couldn't be edited as text.

Figure 2. Selecting and pasting. The bitmap medium makes possible many art techniques that would be difficult to achieve with traditional media. For example, in this illustration a free-form shape was created with the brush tool and then filled with solid black. The marquee tool was used to select a rectangular section near the center of the image and move it slightly up and to the left. The selection was copied and pasted in two places.

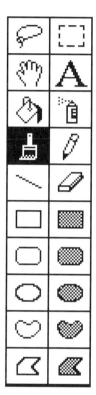

acPaint was one of the first paint programs created for the home computer and was shipped with the first Macintosh computers. Though earlier systems like the Apple II and Commodore 64 featured color paint systems, MacPaint was the first to offer good-quality resolution and a WYSIWYG format, along with an icon-based interface. MacPaint's basic painting tools and the icons developed to represent them are still used (Figure 1). MacPaint provided painting in black-and-white only, tied to the black-and-white Macintosh screen. With a single keystroke, art produced in MacPaint could be printed via the Apple ImageWriter, which provided a one-to-one relationship between pixels on-screen and dots on paper. Art could also be saved in MacPaint format and placed in other applications, for instance with a page layout program.

Artists using MacPaint and other early paint programs were able to sketch and paint on-screen as they would on paper, using the movements of the mouse or a stylus to direct each electronic tool. But beyond basic drawing, the bitmap medium made possible some surprising and unique effects. For example, one might create a textured image and then select a portion and move it, a technique that couldn't be done conventionally without cutting into an image on paper. Going further, the selected portion might be copied and pasted back into the image in several places, a relatively difficult operation using conventional means (Figure 2). Bitmap painting soon gave rise to a new graphic style, based on the special capabilities of the medium.

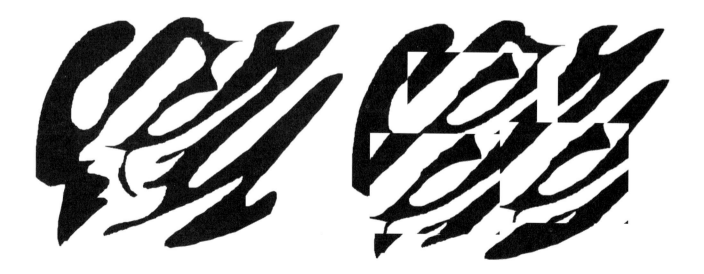

As artists and designers discovered the new medium, demand for more sophisticated features grew rapidly. FullPaint, building on the success of MacPaint, added many features, including multiple, scrollable windows, movable tool palettes, variable type size (from 1 to 127 points), rulers and grids for alignment and the ability to rotate and distort selected areas of an image. But both MacPaint and FullPaint were limited to black-and-white.

With the advent of color on the Macintosh II, many programs have appeared that provide high-resolution bitmap graphics in color and continue the evolution and enhancement of tools and functions. The ability to import and edit scanned images in the PICT and TIFF formats has added greatly to the creative possibilities of bitmap art. Color paint programs can now be used to add color to art created in other media, to scans or to art originally created in a black-and-white paint program.

Some programs, like PixelPaint and Studio/8, are designed primarily for creating original color bitmap paintings, which might include both scanned and hand-drawn elements. Other programs, like SuperPaint and Canvas, integrate an object-oriented draw function into the color bitmap medium. A new group of products designed primarily for retouching and enhancing scanned photographs can also be used for original painting. These include ImageStudio and Digital Darkroom for black-and-white photos, and Color-Studio, PhotoMac and Photoshop for color.

Most paint programs share common features, including the standard set of painting and selection tools. Most make it possible to change the size and shape of the brush tool's "footprint." Some also provide a brush symmetry function that automatically mirrors painted brush strokes across the horizontal or vertical axis. Most paint programs also allow modification of the spray can tool, adjusting spray area, rate of flow and dot size to duplicate the functions of an airbrush. All are able to reorient objects or selected portions of an image through commands like rotate, flip and scale, and many can stretch, shrink and tilt selections according to a specified three-dimensional perspective grid. In many paint programs a variety of *filters* (program functions that apply special effects) can be used to change the quality of an image or selection. These include filters to darken, lighten, sharpen, blur, posterize or trace the edges of an image. All paint programs allow magnification of an image so that editing can be done pixel by pixel. Most also provide a masking function so that areas of an image can be protected from filters or other changes applied to the rest of the image.

All color paint programs provide a way to create and modify color palettes. These are often based on the RGB (red, green, blue), HSV (hue, saturation, value) or CMYK (cyan, magenta, yellow, black) color models. A color selection tool available in many programs can be used to choose a color from any previously colored area of an image and designate it as the current color for painting. Most color paint programs include utilities for producing color separations for printing. Most read PICT and TIFF formats and some also read and write MacPaint and EPS (encapsulated PostScript) files.

Bitmap paint programs for the Macintosh

MacPaint MacPaint 2.0 is the upgraded version of the original MacPaint. Though it works in black-and-white only, its basic tools and new functions still make it a useful program. The paint and tool menus can be torn away from the menu bar by dragging them with the mouse and can be placed wherever the artist finds convenient. An image can be saved not only as a PICT file but also as a Startup Screen so that it will appear when the Mac is turned on, or as a Stationery Pad — a template that saves all working preferences (such as brush styles and line weights) for use in a new image. Text blocks can be specified to appear as black on a white background, as black on a clear background, or as a black that reverses to white where it overlays black areas. A Take Snapshot function saves the current screen without altering the name or saved version of the file. The artist can revert to the Snapshot at any time, using it as a form of "undo." MacPaint is a classic, easy-to-use digital painting program (Figure 3).

Figure 3. Painting the digital way. "A Door Somewhere" by Bert Monroy was painted with MacPaint's various brushes and patterns.

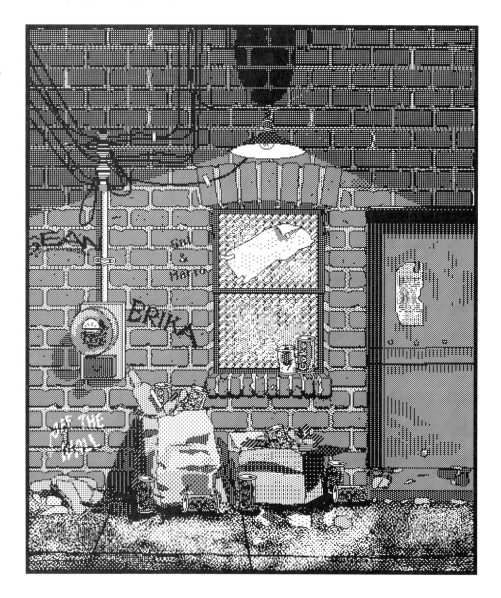

Among MacPaint's other useful features are these:

- Up to nine documents can be open at one time.
- Overlapping images can be set as opaque or transparent.
- Different line thicknesses can be specified for vertical and horizontal lines.
- Shape-drawing tools can be specified to draw from the center, or from a corner (for rectangles) or a point on the circumference (for an ellipse).

SuperPaint 2.0 SuperPaint was the first program to combine a paint layer with a draw layer, which can be superimposed on the screen and in printouts. When one layer is active, its tools can't affect objects created in the other layer. But objects can be transferred from one layer to another. This combination of functions offers the best of both worlds. The draw layer contains shape-making tools, including a freehand tool that lets the artist draw lines and curves roughly, and then precisely edit them by moving points associated with the line. The precision of the draw tools can be used to create objects in the draw layer that can then be transferred to the paint layer for coloring and detailing. Or textured, painted images can be created and transferred to the draw layer, where they become objects, for precise positioning (Figure 4). In addition, bitmap graphics can be created or imported into the paint layer and autotraced to create line art in the draw layer (Figure 5).

Figure 4. Positioning for precision. "George Observed Contemplating the Truth" by Lawrence Kaplan was created with SuperPaint using various images scanned with a video camera and the MacVision digitizing system. He copied the bitmap images, such as the cherries, to the draw layer so that he could easily arrange them for the final composition.

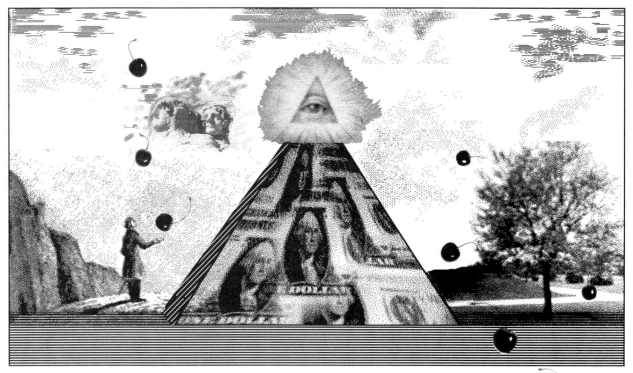

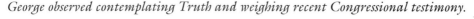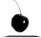

George observed contemplating Truth and weighing recent Congressional testimony.

Custom tools add to the power of the standard toolbox. A quill tool simulates the thick and thin lines of a calligraphy pen. A 3D tool draws three-dimensional box shapes. A toothpaste tool draws a line with rounded ends. A dry brush tool simulates the feathered look of paint applied with a dry brush. In addition, SuperPaint expands the capabilities of the marquee and the lasso by letting the artist select areas of an image with oval, polygon or freehand selection tools.

SuperPaint was the first paint program to incorporate color, but its capabilities are limited. Only eight colors are available and only one at a time can be applied to the paint layer. In the draw layer, each object can be assigned its own color.

SuperPaint has these other special features:

- An expandable tool palette includes standard MacPaint tools plus custom plug-in tools, including custom plug-in "paint," which includes blended linear or radial fills and patterns blended from light to dark.
- SuperBits allows pixel-by-pixel editing at a user-specified resolution.
- Document size can be user specified.
- Type fonts, styles and sizes can be mixed within a single text block.
- Arrows and dashed lines are available.

Figure 5. Autotracing a bitmap. Some programs, like SuperPaint, allow autotracing of bitmap images. In this illustration a bitmapped scan (upper left) was autotraced (upper right) and the traced shapes were filled with black (lower left). The new art lacks some of the detail of the original, but since it's now a vector graphic, or object, it can be easily modified in any number of ways. For example, it can be converted to a gray screen and superimposed over a patterned background (lower right), and then altered again any number of times.

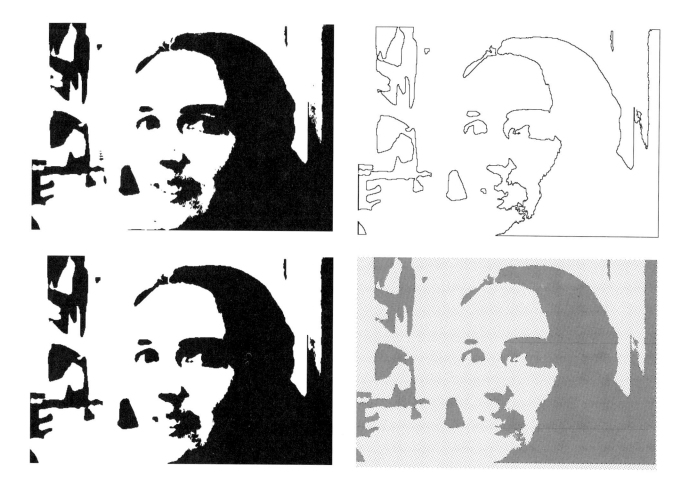

PixelPaint and PixelPaint Professional PixelPaint was the first full-featured 256-color paint program on the Mac. It provides a variety of sophisticated and subtle functions for creating and modifying color images (Figure 6). A group of 18 standard and custom palettes can be modified via Pantone, RGB, HSV, CMYK, color theory, Apple and QuickEdit models. Five palettes are designed to simulate watercolor palettes, with colors that vary in saturation and brightness from white to black for each hue.

The standard set of painting and selection tools, plus some new ones, work in both Normal and Special Effects modes. For example, the spray can tool, used conventionally in Normal mode, can be modified under Special Effects to function as an airbrush or a graffiti tool or to cycle through a range of colors. The line tool can be modified to draw fractal lines, radial lines sweeping around a fixed point, a "neon" line with colored edges, or a line that looks like a three-dimensional tube. The arc tool can be used to fit a curve to a series of straight line segments or to have a curve pass through each point where a line changes direction (spline). Other special effects include functions that simulate charcoal, that paint in two colors, that smear and diffuse and that add a drop shadow.

Beyond the tools and their special effects, PixelPaint includes a variety of functions that can be applied to areas of an image that have been selected with the lasso or selection rectangle. The standard effects include the ability to invert colors, trace edges, and flip, mirror or rotate images. A Visual Effects

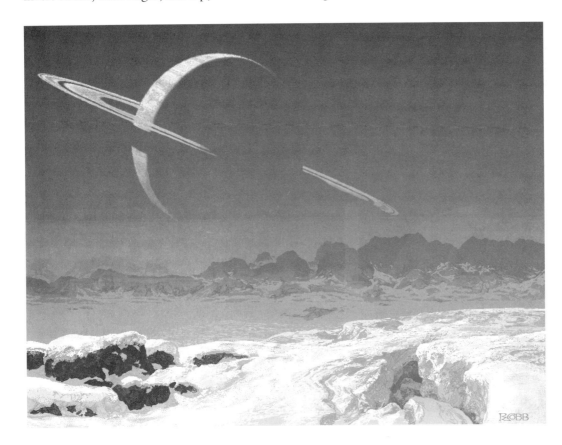

Figure 6. Creating and modifying color images. "Afternoon on Titan" by Los Angeles film industry illustrator Ron Cobb was created in Pixel-Paint using careful brushwork and color blends. (The painting is shown in color on page 169.)

menu provides functions that smooth, blur, sharpen, lighten, darken, and wash selected areas or turn them into mosaics. Other choices include contour, diffuse, dither, etch, relief, thicken, thin and warp. Dynamic effects can be used to change the orientation of a selected area, through commands such as crop, distort, free rotate, perspective, slant, arch and balloon (Figure 7).

PixelPaint reads and writes documents in almost all Macintosh graphics formats. In addition, it can save files as a Startup Screen or as a Stationery Pad, which retains the palettes and custom brush styles and other features of a document but without saving the image itself.

PixelPaint has these additional features:

- A Pantone color formula guide is shipped with each program.
- Color separations can be created electronically.
- Screen angle and percentage of under-color removal can be specified for offset printing.
- A "tween" function automatically fills gaps left when the artist is drawing quickly.
- A palette of 121 patterns is included.
- Color fills can be extensively customized by method of fill, style, speed of color change and orientation.
- Drop shadows and blended shadows can be created automatically.
- A masking capability is included.
- A Select Last function selects the last area painted.

Figure 7. Applying a filter. Pixel-Paint includes many filters that apply special effects to a painted image. This painting of an apple was created primarily with the brush tool. A copy was selected and modified with the Diffuse filter. Other filters apply effects like Soften, Sharpen, Mosaic, Emboss and so on. Filters can be applied to an image in turn, and then reversed with the Undo function if the result is not satisfactory.

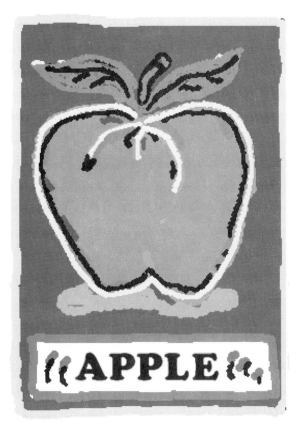
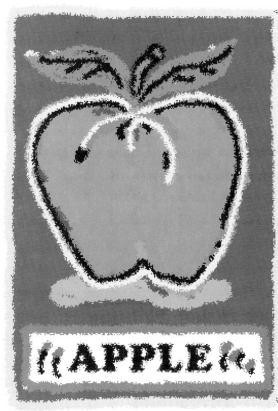

- A PixelScan utility is included for use with Howtek Scanmaster or Sharp JX-450 scanners.

 Special features of PixelPaint Professional include:
- operation in either 8-bit or 24-bit color
- improved dithered blends
- expanded masking tools
- additional visual effects, including transparency
- reading and writing of color TIFFs
- a Quickcolor Editor to globally search for and replace user-specified colors.

Studio/8 Studio/8 allows use of either a 16- or a 256-color palette. In the larger palette, 96 color cells are left blank, to be filled with user-specified custom colors. A selection menu offers many ways to change a selected object or portion of an image. Colors can be changed and blended; shapes can be flipped, rotated, sheared, bent, resized and distorted. Perspective functions make it possible to align selections along a three-dimensional plane. The selection tools can be modified to make it easier to pick up parts of an image.

The shape tools can be filled with opaque or semi-transparent paint selected from three preset levels of transparency. Areas can be filled with both linear and radial fills, and the center point of a radial fill can be selected by clicking (Figure 8).

Figure 8. Using radial fills. Studio/8 allows the user to define radial fills by determining an object's "light source." Shown at top are two circles with different light sources, each filled with Gradient Fill to Shape; at bottom the two circles are filled using Uniform Gradient Fill.

Custom brush shapes and fills can be created by designating a portion of an image as a brush. The brush tool can also be modified to paint with a single color, a pattern, or a neonlike tube, and with tinting, blending, watercolor and color mixing effects (Figure 9). A masking function makes it possible to protect areas of an image from paint being applied in neighboring areas. Text can be edited and repositioned as long as the text box is selected. However, as with all paint programs, once the type is deselected, it's frozen into the image. A slide show program with built-in fades and wipes can be used to create portfolios and on-screen presentations of images.

Studio/8 has these additional features:

- Polygon, freehand and rectangle selection tools are available.
- Tools for drawing freehand shapes, curves and Bezier (spline) curves are included.
- Line weight can vary from 1 to 10 pixels.
- Images can be enlarged to 800 percent and edited in this view.
- A palette of 32 patterns is included.
- A Smart Keyboard offers quick selection of tools.
- Color cycling can be used to achieve an animation effect.
- A library of backgrounds and textures is included.

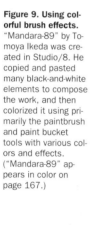

Figure 9. Using colorful brush effects. "Mandara-89" by Tomoya Ikeda was created in Studio/8. He copied and pasted many black-and-white elements to compose the work, and then colorized it using primarily the paintbrush and paint bucket tools with various colors and effects. ("Mandara-89" appears in color on page 167.)

UltraPaint UltraPaint is unique in offering four major graphics capabilities in one package: black-and-white painting, color painting, grayscale image editing, and object-oriented drawing, including Bezier curves. UltraPaint is designed for advanced users as well as by entry-level artists. It can be used in black-and-white with a Mac Plus or SE, or in color on a Mac II. An Open Architecture program design makes it possible to add updates and new features simply by dragging them into a special folder.

UltraPaint offers these features:

- The color paint mode has a multicolor airbrush.
- An editable lasso is included in the black-and-white paint mode.
- New tools, effects and file-format filters can be easily added.
- Images in the draw and paint layers can be created at 600 dpi resolution.
- The draw layer provides autotracing of bitmaps.

Image editing programs for the Macintosh

Digital Darkroom Digital Darkroom is image-processing software designed for enhancing, retouching and composing scanned images and other bit-mapped graphics in black-and-white. Like the equipment in a traditional darkroom, the software can be used to change the contrast and brightness of an image, for example; but the brush and airbrush tools can also be used for touch-ups or original painting (Figure 10).

Figure 10. Painting with grays. "Touching the Light" by Los Angeles artist Nira shows careful use of Digital Darkroom's use of grayscale painting and special effects tools.

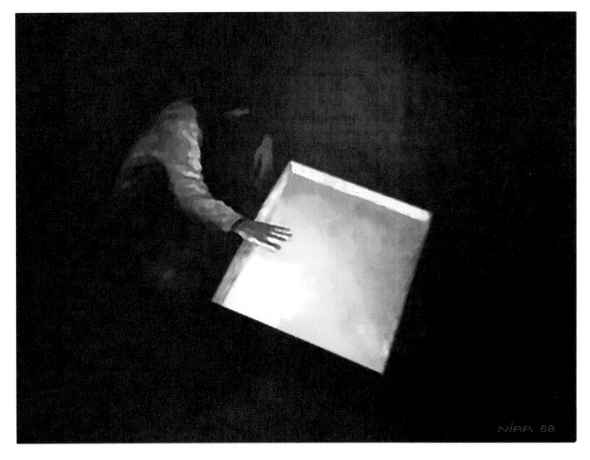

Digital Darkroom has these useful features:

- Five different selection tools help to define image areas for separate treatment.
- A magic wand tool automatically selects all areas of an image that have the same gray value.
- A Paste If function allows a choice of which gray values of a copied selection to paste and which values in the base image to paste into. Selections can be pasted at any level of transparency, allowing the image underneath to show through.
- An autotrace function allows automatic tracing of black-and-white and grayscale bitmap images into draw-type objects. The drawings can be exported as Bezier curves for use in a drawing program like SuperPaint, Illustrator or FreeHand.
- Specialized graphics functions can be added via plug-in modules developed by the user or third-party developers.

ImageStudio ImageStudio can also be used as a stand-alone paint program, though it's designed primarily for grayscale image editing (Figure 11). Its sophisticated water drop, charcoal and blending finger tools make it possible to achieve subtle blending and smoothness in both scanned and painted images. A rubber-stamp tool can be used to pick up part of an image and apply it to other areas.

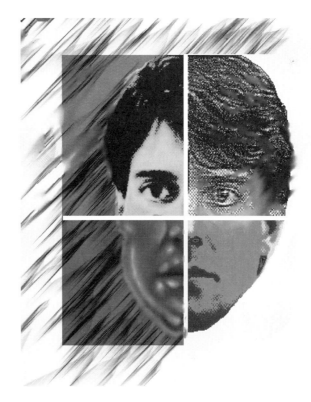

Figure 11. Painting and retouching. "Quad-Portrait" by San Diego designer Mike Uriss illustrates various painting and retouching effects possible with Image-Studio.

ImageStudio is characterized by these features:

- The entire on-screen page can be rotated 90 degrees to the left or right to reorient images that were scanned sideways.
- The attributes of tools can be specified so that diameter, rate of paint flow, light-to-dark transitions and so on are precisely controlled.
- The brush tool is modified to apply a soft edge to its strokes.
- Custom tools can be created by combining existing tools and attributes. The new tools become available as named items in a menu.

ColorStudio ColorStudio is designed for painting, retouching and assembling scanned color images. Its features build on those included in Image-Studio, with powerful added capabilities for handling color. The color palette allows on-screen mixing of new colors as though with a brush on a real palette. Because the document size of color images can be very large, ColorStudio makes it possible to use the computer's virtual memory when working on documents that exceed the available RAM.

Custom fills can be created either by using the painting tools or by selecting an area of a scanned image. Image process filters can be used to modify all or part of a scanned or painted image. Functions include Blur, Soften, Sharpen, Diffuse, Star Lens and Trace Edges.

ColorStudio has these features:

- Both 8- and 32-bit color systems are supported. (A 32-bit system allows all the colors of a 24-bit system plus 8 bits for grayscale masking.)
- A Color Correction function can be applied globally or to a selection to adjust color balance.
- Tools can apply paint at any percentage of transparency.
- Scanner modules are supplied for commonly used scanners.
- Paint tools have an automatic antialiasing function.
- Pen styles and tools can be customized.
- A Shapes module can open EPS files, using the PostScript code to produce the best possible screen resolution, for imported PostScript type, for example.

PhotoMac PhotoMac is designed for editing and merging scanned color images, for retouching and for producing color files that can be placed in a page layout program or color-separated for printing. The program can be used to convert color images to black-and-white with 256 shades of gray or to add color tints to monochrome images. PhotoMac tools are similar to those on a standard paint tool palette, but the icons have been redesigned and are displayed on-screen in 16 colors.

PhotoMac offers these features:

- TrueVision files (from Targa and Vista systems) can be imported, along with PICT and TIFF files.

- A virtual memory system allows display of images that exceed the capacity of 2 megabytes of RAM.
- An autoselect tool selects image areas that contain a single color.

Photoshop Photo retouching, image editing and color painting can all be performed with Photoshop. The program can read and write 14 different file formats, including Photoshop, Raw, EPS, TIFF, PICT file, PICT Resource, Amiga Iff/ILBM, CompuServe GIF, MacPaint, PIXAR, PixelPaint, Scitex Ct, TGA (Targa) and ThunderScan. A plug-in module allows the import and export of even more file types. A rubber-stamp tool makes it possible to pick up a portion of an image and place an exact or modified copy somewhere else. A cropping tool makes it easy to discard the unwanted edges of an image. Three special paint tools, the smudge, blur and sharpen tools, act like filters to change the color qualities of individual pixels, but under the direction of the mouse or stylus.

Photoshop has these features:

- It supports 8- or 32-bit color.
- A variety of filters include the standard functions along with Add Noise, Custom, Despeckle, Facet, Fragment, Gaussian Blur, High Pass, Motion Blur and Spherize (Figure 12).

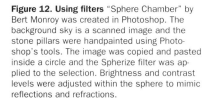

Figure 12. Using filters "Sphere Chamber" by Bert Monroy was created in Photoshop. The background sky is a scanned image and the stone pillars were handpainted using Photoshop's tools. The image was copied and pasted inside a circle and the Spherize filter was applied to the selection. Brightness and contrast levels were adjusted within the sphere to mimic reflections and refractions.

- A magic wand tool allows automatic selection of objects based on the color similarities of adjacent pixels.
- A Revert option of the eraser tool can be used to undo a series of operations by returning to the last saved version of a specific part of the image.
- A Lasso Options function makes it possible to feather the edge of a selection so that a pasted copy will blend more softly with the background.
- Copied selections can be pasted at any level of transparency and as floating (on top of the base image) or underlying images.
- A system of dividing images into "channels" analogous to traditional overlays makes it possible to isolate and work on different parts of an image.

Paint programs for other systems

TGA TIPS (IBM PC/Targa) A fully equipped paint program with some impressive special effects, TIPS is also valued for its video drawing capabilities. The program can input or output an NTSC signal, letting the artist pick up an RGB image from videotape, for example, manipulate it with TIPS's standard complement of paint, pattern and color features, and then drop the image back into the tape. A Video command under the Special Effects menu lets the artist overlay graphics and text on a live image from a video source; the program also features a Mosaic function that enables video editors to do tricks like "pixeling out" a suspected criminal's face on news broadcasts. More special effects include a Blend tool that lets the artist set the level of dithering from –2 to +10, a Duplicate function that creates offset images within a composition between designated "source" and "destination" points, and Tint, which is like a transparent color wash that retains background textures and images while changing them to the same hue as the Current Color.

A special feature, Window (under the Storage menu), lets the artist save a section of a canvas, and then scale, rotate, reposition and otherwise manipulate that section for use with other pieces (Figure 13). TIPS features movable on-screen windows, and produces high-quality slides through a film recorder at the 32-bit level.

TIPS has these other features:

- A palette of 32,768 standard colors can be expanded to more than 2 million by writing a painting as a 32-bit file with TrueVision's RIO program.
- A 16-pattern palette allows for editing patterns or designing new ones.
- A Mask effect has seven features for creating and manipulating custom masks, including Invert, which masks all areas that were unmasked and vice versa.
- A gradation feature called Spread lets the artist fill any shape, or the entire screen, with a defined range of gradated color.

Figure 13. Combining scanned photographs. "Leda and the Swan" by Orange County, California artist Michael Johnson is composed of the artist's scanned photographs, which have been modified and arranged using TIPS software on an IBM PC with a Targa graphics board.

DeluxePaint III (Amiga) An upgraded version of DeluxePaint II, DeluxePaint III offers the full assortment of draw and paint tools. It provides 64 colors and has proven to be a valuable animation program for Amiga artists because of features such as Animate Brushes. This function lets the artist select any portion of the screen with a standard rectangle tool or a Rubber Band tool and use it as a brush to paint with; by painting over a selected area or the projected path of an animated element, it's possible to animate just the selected screen element over an unchanging but repeating background (Figure 14).

A Transparency feature lets the artist change the color of an entire background or foreground (to any of the Amiga's 64 colors or a combination thereof) at any time by covering it with a transparent layer of color. DeluxePaint III provides each animation frame with a "scratch frame" that the artist can copy to, draw on separately, and then integrate with the original frame as either a foreground or a background element; single-stroke key commands allow for switching between the two frames. A Stencil feature functions like a mask to lock selected areas from painting or color changes or from animation functions. Images can be altered around an X, Y or Z axis for a "two-and-a-half dimensional" perspective in a Perspective mode that has antialiasing; this feature can be applied to animation by presetting the

perspective before animating an object. Brushes can also be made to rotate around X, Y or Z axes.

DeluxePaint III also includes these features:

- Access is available to all Amiga bitmap fonts.
- Compatibility with all picture resolution modes lets the artist work in 320 x 200, 320 x 400, 640 x 200 or 640 x 400 pixels.
- The airbrush can make different shapes, such as a circle.
- Sixteen levels of magnification are available.
- Screen dumps can be printed with any printer the Amiga supports, including color printers.
- Color Cycling simulates animation by repeatedly moving an object's colored pixels through a preselected range of five colors; for example, Color Cycling can make a river appear to "flow."

Clip art

A variety of bitmap clip art is available from many vendors (Figure 15). Images include scans of photographs in black-and-white and color as well as painted images or textures. Clip art collections are often built around a theme of commonly used subjects, such as art for business or medical publications, for community newsletters and so on. Clip art may be used as is, for placement in a page layout program for example, or may be opened and further modified in a paint program.

Figure 14. Animating over a static background. "Roman Hound" by Adam Kish was produced as an animation by Pat Knoff and Charlie Unkeless for the stage show of the rock group Oingo Doingo. The painting was animated using the Animate Brushes function to animate the figure over a static background.

Figure 15. Clip art options. There are many companies who have created bit-mapped clip art that is ready to use or can be further manipulated. Shown here are examples from (a) *Mac the Knife, Volume 5* by Miles Computing and (b) the *ClickArt* collection by T/Maker; (c) is a grayscale image from Gold Mine Publishing.

a

b

c

CHAPTER 3

Artist

Junko Hoshizawa began her graphics career in Tokyo, producing advertising packaging, posters, brochures and other material for corporations. She quickly progressed into computer animation and soon formed her own graphic design and illustration company, fielding major clients such as Toshiba, Nissan, Tokyo Newspaper, Teichiku Recording and Seibu Group. Hoshizawa staged two exhibits of her computer graphics and computer animation work in Japan before moving to the United States in 1985. Since arriving, she has continued her design and illustration career on a freelance basis for advertising and graphic design firms, as well as clients like *Verbum* magazine, Q-106 radio and Marvel Comics, publisher of the *Street Poet Ray* comic book series. For the *Street Poet Ray* books, Hoshizawa teams up with San Diego poet Michael Redmond to portray a different theme in each issue, among them ecology, the meeting of Eastern and Western cultures and the plight of homeless people.

Project

This assignment came from *Verbum* publisher Michael Gosney specifically for the *Verbum Book of Digital Painting*. It may eventually become a *Street Poet Ray* cover, but the point of the project was to show off the capabilities of SuperPaint in the context of the *Street Poet Ray* style of illustration.

Equipment included a Macintosh II with 5 MB of RAM and a 100 MB internal CMS hard drive, an Apple 13-inch color monitor and an Apple extended video card. The entire cover was created in SuperPaint 2.0.

MultiMedia Man

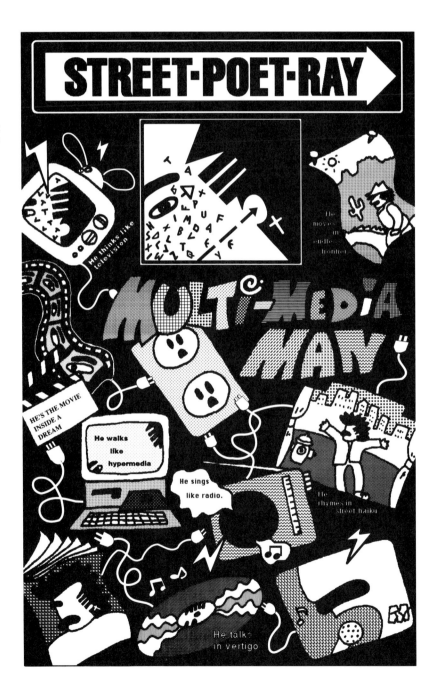

PROJECT OVERVIEW

Design goal

The idea with this cover was to express the MultiMedia Man concept as simply as possible. Michael Redmond, who *is* Street Poet Ray, is also MultiMedia Man; he writes, makes music videos, creates stories for theater and does radio spots; he's the face on the cover of *Verbum* issue 4.1 and he's appeared on television.

To illustrate this, I chose to portray the different media: computer, records, radio, TV, magazine, poster and so forth. All the different media appliances on the cover plug into the electrical outlet in the center, and Michael is like the electricity that feeds the power outlet. MultiMedia Man can be anything; his energy is universal. Michael wrote the phrases that accompany each picture; MultiMedia Man is first and foremost a writer, and words are his main tools. The cover design ties together all the different facets of MultiMedia Man.

This image is part of the standing Street Poet Ray logo. It was scanned into the painting and resized. The visual symbolizes how Street Poet Ray's eyes and ears perceive his environment, providing the stimuli from which his poetry is created.

A sheet with various sizes of the Street Poet Ray logotype, produced by PostScript illustration, was printed for scanning. Notice that some of the logos have no fills. The outline type can be filled with any pattern or color I wish to use on a particular cover.

Street Poet Ray began as a hand-drawn series, so it was appropriate in this electronic edition to work from a scanned-in pencil-drawn sketch to preserve that flavor. Here is the original sketch, before all the patterns, fills and embellishment were later added in Super-Paint — it's basically just line art. The first step once the sketch had been scanned into the Mac II was to draw over all the lines with brushes of various thicknesses to solidify the sketchy lines of the scan and to create solid boundaries that could contain fills. The logotype and the visual immediately below it in the box are sketched in here for position only, as they were later scanned in separately from standing art.

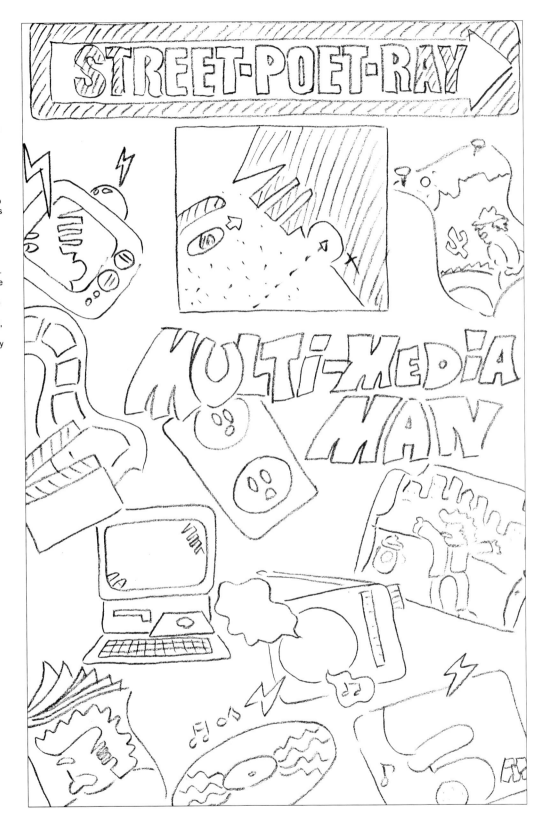

The completed sketch of the MultiMedia Man cover was scanned (see page 35) so it could be used as a basic reference to work from in SuperPaint. Besides the sketch itself, the two logos needed to be scanned into the system: the Street Poet Ray logotype and the visual directly below it. I positioned these scans on the page and left cleaning them up for later. The scanned pencil sketch itself appeared much too light and unclear to use for final electronic line art. Working in SuperPaint's Paint layer, I used the paintbrush tool to draw over the lines of each picture element, selecting different size brushes from the brush shape dialog box to make a thicker line for the outline of each element, and thinner lines for the details within the outlines (Figure 1). This was important not only to give each picture a clear definition, but also to create a continuous, unbroken boundary around each one so that the fills I would add later wouldn't "leak" out into other parts of the painting. To make sure there were no breaks in any of the pictures' boundaries, I used Zoom In for a magnified view that showed every pixel.

Figure 1. Drawing outlines. Different brushes were used to make the thicker and thinner lines that define the details of each picture element on the cover. It was important to make continuous, unbroken lines so that the solid and pattern fills that were added later wouldn't leak into neighboring sections of the drawing. Working in magnified view made it possible to find and patch up some potential leaks.

Filling the background

With the individual pictures in the painting — the TV set, the magazine, the record, the electrical outlet and so forth — all "sealed," I was ready to fill in the black background. For this I used the paint bucket, with black selected from the pattern palette. I poured black paint into the enclosed areas defined by the outlines I'd drawn so carefully, only to find that there was still some "leakage" here and there, so it was necessary to Undo, zoom back in to the leaky areas and clean up the lines further. Then I tried the paint bucket again and eventually managed to achieve a complete black backdrop for the elements of the MultiMedia Man cover (Figure 2). ∎ *To save time painstakingly searching for leaks in zoom modes, you can try using the paint bucket first. If you find leaks, use Undo immediately. Then you can zoom in on the leaks by lassoing outlined objects one by one. If the outline is continuous, the lasso will shrink around it and only the outline itself will shimmer. If the outline is broken, however, the lasso will penetrate it and the contents inside will shimmer also. Then you'll know it's worth the effort to zoom in on the outline and look for the leak pixel by pixel.*

Creating pattern fills

If you look closely, you'll see a number of different patterns used throughout the MultiMedia Man cover. Some of these are standard patterns from SuperPaint's patterns palette; others are customized patterns created by modifying some of the existing patterns that I didn't intend to use. SuperPaint lets you edit its patterns with the Edit Document Pattern window (available by choosing Patterns under the Options menu) by displaying a magnified

Figure 2. Filling the black background. The paint bucket with black paint was used to fill in the enclosed areas created by outlining the individual images. The first time the picture was filled many of the images leaked, so the fill was undone and the leaky lines repaired before the fill was attempted again.

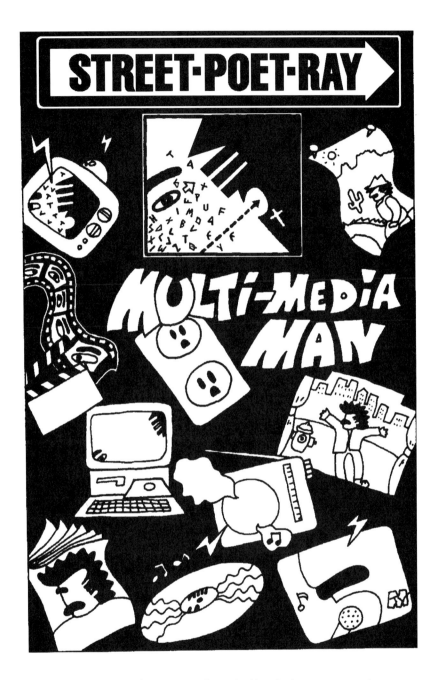

section of the pattern that you can alter, pixel by pixel, to create a unique new design. ▮ *A shortcut for opening the Edit Document Patterns window is to double-click the pattern you want to edit in the patterns palette.*

Once I'd created new patterns, I used the paint bucket to select them from the patterns palette and pour them into the various enclosed areas. The three letters in the word "MAN" are filled with three different custom patterns (Figure 3).

Drawing the electrical plugs

To create the electrical plugs and cords, I switched to SuperPaint's Draw layer. While everything you create in the Paint layer is bitmapped, and thus jaggy, the Draw layer allows you to add smooth-edged elements to your painting. I used both the freehand Bezier and arc tools to make the smooth, sharply defined coils of cord, drawing them freehand on the screen because they were not part of the original sketch. ∎ *When you use the freehand Bezier tool to draw lines, be sure to click None in the fill box at the left end of the pattern palette. Otherwise, the curve will close itself by drawing a straight line from the ending point to starting point.*

The plug ends were drawn with the polygon tool, and it was possible in some places to use the Draw layer's rectangle tool to make the electrical prongs (Figure 4). Notice that the plug ends all lead to the electrical outlet in the center of the image, symbolically tying the various facets of MultiMedia Man to the source. The electrical outlet, as it's used here, is a metaphor for Street Poet Ray himself — the intelligence behind the message.

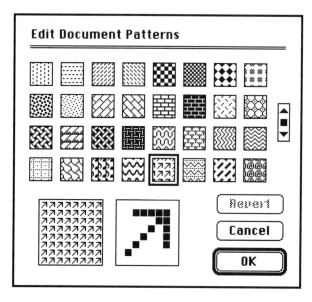

Figure 3. Filling with patterns. Many customized patterns were created from the standard ones that SuperPaint supplies by using the Edit Document Patterns window. It's easy and rather fun to play around with the pixels of the standard patterns and then step back out of magnified view to see the results of your work multiplied endlessly to make up an entire pattern.

Figure 4. Drawing electrical cords and plugs. These weren't on the pencil sketch, but were drawn freehand on the screen using the Draw layer's Bezier drawing tools and selecting white as the line color and None as the fill color. The polygon tool (also with white line) was used to draw the plug ends.

Figure 5. Adding text. The black lettering, created by typing in the Draw layer, is crisper than the white lettering, which was typed as outlined type in the Paint layer and filled with white paint.

Spelling it out

Still in the Draw layer, I was ready to create the text letters that accompany the various pictures. Choosing either Times or Helvetica from the Font window, I was able to create nice crisp letters by simply typing them into the picture. Where appropriate, I selected the text blocks and tilted them at 45 degrees using Free Rotate from the Transform menu. Unfortunately, I had to resort to the Paint layer to create the white letters because the outline type in the Draw layer is transparent — whatever patterns, lines or fills are behind the type will show through. So in a couple of places I created outline letters in the Paint layer and filled them with white paint. You can see the difference in sharpness — the type created in the Draw layer is much more clearly defined (Figure 5).

Clean-up time

At this point the image was ready for fine tuning. SuperPaint has a feature called SuperBits, which lets the artist edit an image, section by section, to a very high resolution — it's like antialiasing in that it smooths away all the jagged edges so angled lines are straighter and curves are much cleaner (see "Increasing Resolution" on page 41). SuperBits allows the artist to convert a low-resolution bitmapped image to a high-resolution bitmapped object in

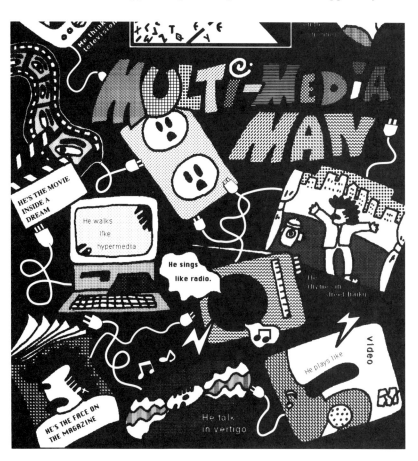

the Draw layer without losing access to the Paint tools. To get into SuperBits, you select the area you want to work on while still in the Paint layer, then choose New SuperBits from the Paint menu. A dialog box appears to let you choose the resolution you want. Sometimes it's hard to tell the difference on the screen once New SuperBits has done its job, but the higher resolution is very apparent on a printed image, for example.

Even after using New SuperBits I wasn't entirely happy with some parts of the painting so, still working in the Draw layer, I selected areas I wanted to clean up some more and got ready to work on them with Edit SuperBits, which is available under the Draw menu. This function magnifies the selected section and lets the artist go in with the Paint layer's tools to edit the lines and shapes by hand, pixel by pixel if necessary. I deleted the original Paint layer of the section I had selected to work on. I switched from the Paint to the Draw

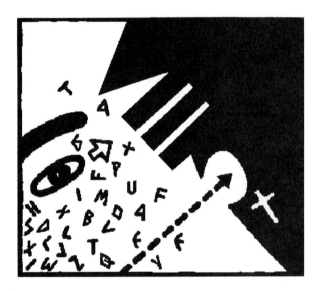

Figure 6. Fine tuning. Some of the lines needed further smoothing, and this is where a function called Edit SuperBits came in handy. Edit SuperBits is available in the Draw layer after a bitmapped image has been converted to a Draw layer SuperBits, and lets the artist clean up an image by hand, section by magnified section using the paint tools. These two views show how some of the rough spots in the logo art (top) were cleaned up (bottom) using Edit SuperBits.

layer with the pointer, then chose Edit SuperBits from the Draw menu. I used the Edit SuperBits function to smooth out or redo some of the elements in the Street Poet Ray logo art, for example. With the pencil, the line tool and the Bezier tools, I cleaned up the eyebrow and hairline and used the paint bucket with black to fill any areas that needed it. The arrows were redone in the Draw layer using the Arrow tools, which let the artist custom design arrows and the lines attached to them (Figure 6), until I finally got the high-resolution black-and-white picture I wanted (see page 33).

In retrospect

The best way to learn a program is to just "play" with it for a while. This lets you discover for yourself its capabilities, subtleties and nuances; you become comfortable with the software and can find your way around better. At the beginning of creating MultiMedia Man I didn't know SuperPaint's SuperBits feature very well, but I quickly picked it up as I progressed. It's always that way — the better you know a program, the more you can do with it, and faster.

The next time I use SuperPaint I'd like to integrate the Paint and Draw layers more to make even better use of the program's ability to combine PostScript sharpness with painterly images. This capability had many possible uses, especially in the areas of graphic design and commercial art.

Increasing resolution

These three examples show how SuperPaint lets the artist increase the resolution of bitmapped graphics created in the program's Paint layer: In the top example, the original 72 dpi bitmapped graphic was Autotraced as a polygon in the Paint layer, which automatically created a copy in SuperPaint's Draw layer. This copy was then converted to a Bezier Autotraced image, tweaked further using the Bezier settings dialog box and finally filled with black. In the second example, the original 72 dpi graphic was selected in the Paint layer, and then New SuperBits (under the Paint menu) was chosen; this automatically created a copy of the image in the Draw layer and smoothed its resolution to 300 dpi. The graphic's resolution was further enhanced in the bottom example by choosing (in the SuperBits dialog window) to scale the original 72 dpi graphic to meet the desired resolution. In each case, the artist was able to use the flexible and intuitive Paint tools to create the original graphic and then improve its resolution by making use of the features in SuperPaint's Draw layer.

Before After

Before After

Before

After

Junko Hoshizawa

"For me, the most useful aspects of working on the computer are the time and money I can save — this is very important for a commercial designer or illustrator because there are always pressing deadlines and impatient clients.

"As an artist, I can experiment freely with colors and shapes, save versions and then change them without losing the original. In the past it was very difficult and time-consuming to experiment with a project.

"An artist's talent can mature on the computer because ideas become flexible with the computer's abilities; because it's not necessary to start over from scratch, I'm much more likely to experiment with an image and discover new directions I can take it."

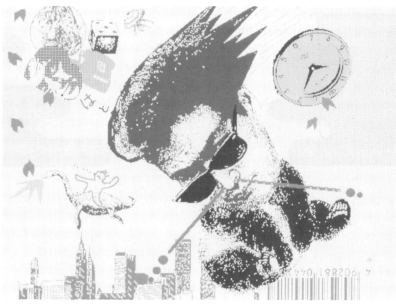

You Can Get Anything You Want was the cover illustration for a Japanese publication on satellite and cable TV information. The face depicted is that of a well-known actor in Japan. The idea for the cover was to play with the face and drop other elements into the image to create a collage illustrating the variety in programming available on cable TV.

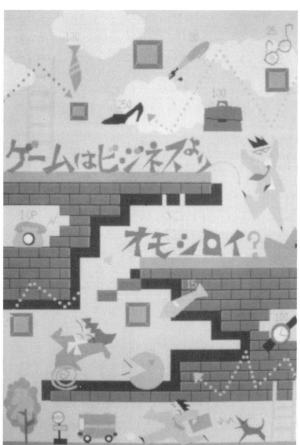

Is the Computer Game More Fun than Business?, painted on an NEC system with Art Processor software, was an assignment from an ad agency in Tokyo for use on a brochure.

Fingernail was done for the cover of the Tokyo magazine, *New Media.* It was part of a series of various body parts, including knee, belly button, armpit, breast, bottom, nose, eyes and neck, all of which made up a year's worth of covers for the magazine. It was produced on an NEC system using Art Processor software from Linkage Systems.

The piece at left was created to illustrate an article for the magazine *NATPE Programmer,* a story on how to get a better job in broadcasting. Drawn on a Mac II in SuperPaint, it's somewhat similar to the MultiMedia Man cover — that is, line art with pattern fills. It was printed in two colors.

Fat Woman (above) is an image designed for the outside of a case containing a video about how to diet. It was also done on an NEC system, and depicts a woman going shopping — probably for food. I enjoy drawing fat people more than thin people because I find the fuller contours and rounded shapes more interesting.

C H A P T E R 4

Picture Cards for Molly

Artist

Janet Ashford studied music at the University of Southern California and received a B.A. in psychology from UCLA in 1974. She worked as a graphic artist and print maker until the birth of the first of her three children, and then spent 10 years writing and lecturing on home birth and midwifery. Janet now works as a writer, illustrator and graphic designer specializing in computer graphics and design. She is a frequent contributor to *Step by Step Electronic Design* newsletter and is a co-author of *The Verbum Book of PostScript Illustration*.

Project

The project was to illustrate a set of picture cards for the artist's young daughter. Each card features a brightly colored drawing of a familiar object along with its name. The art was created on a Macintosh IIcx with PixelPaint 2.0, using MacPaint-format scans created with AppleScan. Proofs were printed on a LaserWriter IINT and final output was through a QMS thermal transfer color printer. The color output was mounted on heavy card stock and laminated.

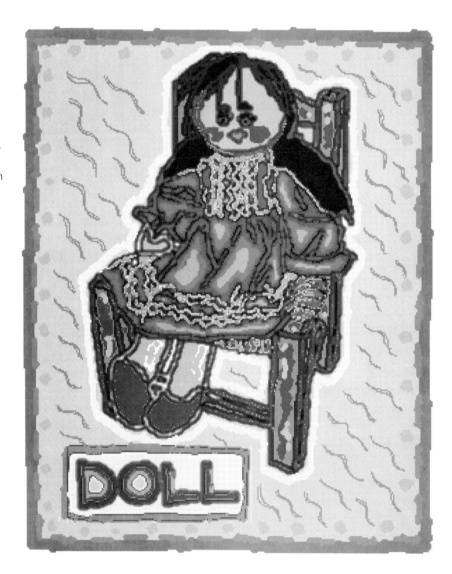

PROJECT OVERVIEW

Design process

When my daughter Molly was about one-and-a-half years old her interest in speaking accelerated. She greatly enjoyed pointing out and saying the names of objects she recognized, both in books and around the house. She also enjoyed holding, shuffling and stacking decks of cards, both conventional playing cards and children's cards with pictures. I got the idea of creating a special deck of oversize cards just for Molly, based on illustrations of things from her own environment. I photographed many of her favorite toys and other items, made line drawings based on the photos, scanned the line drawings, and opened the scans in PixelPaint, where I added color, decorative borders and lettering. Molly enjoyed viewing the illustrations on-screen and as laser proofs while I worked on them. She was delighted to receive the finished set of cards. But in the few weeks it took to complete the project Molly learned scores of new words!

A baby bottle and oranges were among several familiar objects photographed for a series of picture cards for one-and-a-half-year-old Molly.

A line drawing was made from each photo, using pencil and pen on matte acetate. Each drawing was scanned as a 75 dpi MacPaint-format scan and opened in PixelPaint.

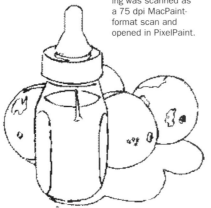

Many of the images were modified with PixelPaint's Trace Edges function. This drew a thin line along both sides of the original lines in the scan, creating more areas to be filled with color.

The scanned drawings were painted with bright colors chosen from PixelPaint's Vivid palette. Some colors were edited to achieve hues not available in the palette.

Many shades of color were applied to some areas — for example, Molly's hair and face — to achieve a rich, modeled effect. Once the drawings were completely colored, the boundaries between color areas were softened by applying PixelPaint's Smooth function.

Each drawing was surrounded by a 4 x 5-inch background rectangle that was painted with complementary colors and decorated with squiggles, lines and dots. Hand-drawn lettering was added to identify each card. The cards were output as QMS color prints, mounted on artist's board and laminated.

Molly's vocabulary at one-and-a-half included the basic *Mama*, *Daddy*, *Baby* and her special words *dolly, chair, shirt, shoes* and *socks*. Using her speech as my guide, I used an Olympus OM-1 camera and 1000 ASA Kodak color print film to photograph objects around the house, as well as Molly herself. I shot close-ups of each object and tried to arrange a pleasant composition within the camera frame. Most photos were set up to provide a neutral background, but some subjects were captured with their messy environment intact; I knew this could be eliminated in later stages. The film was developed and printed as 4 x 6-inch color glossy prints (Figure 1).

Tracing and scanning

Using matte acetate and a pencil, I traced over 13 of the photographs, reducing the continuous-tone information by eye to simple line drawings. Once each pencil drawing was right, I drew over it with black ink, to make sure that the finished drawings would have enough contrast to produce good scans (Figure 2).

Using an Apple Scanner and AppleScan software, I scanned each drawing at 75 dpi and saved it as a MacPaint document (Figure 3). I did not attempt

Figure 1. Photographing objects. A soft cloth doll sitting on a pink Mexican chair was one of many objects photographed for Molly's card series. The objects were photographed with a 35mm camera and developed as 4 x 6-inch color prints.

Figure 2. Creating the line drawing. A line drawing of the still life was made by drawing over the photo with pencil on matte acetate. The drawing was later darkened with black ink, to ensure a good scan.

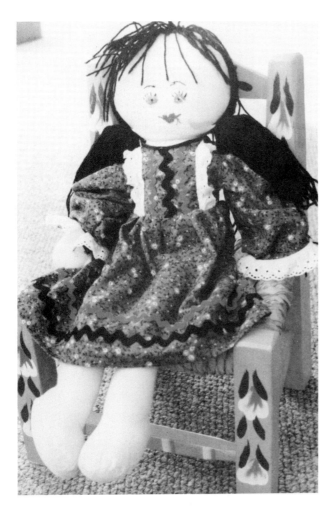

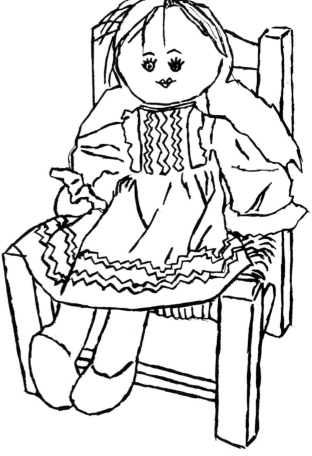

Figure 3. Scanning the drawing. The acetate drawing was placed on the platen of a flatbed Apple Scanner and scanned as a 75 dpi MacPaint image.

to scale the drawings at this point, because AppleScan's ability to save images at different percentages is somewhat limited. Also, I was not yet sure what the finished size of the cards would be.

Experimenting with sizes

After the scans were done, I printed each one through PageMaker in order to check its size against that of the original drawing. I found that the scans, though processed at 100 percent, were all slightly larger than the originals. I used a ruler to measure each printed drawing, and then used a proportion wheel to determine the percentage of reduction I needed to make each one fit in the card size I planned to use. Some of the drawings fit without reduction. I opened the others in ImageStudio, a grayscale image-editing program that allows bitmaps to be saved at a percentage reduction. The percentage is specified by entering the appropriate number in a box in the Print dialog window.

Bringing the scans into PixelPaint

After rescaling the scans in ImageStudio, I began the process of opening each in PixelPaint. But there were a few problems at first. The 4½ x 6-inch card size I'd decided to use looked awkward and was too large to permit placing two cards in each PixelPaint document (which would help save money on color printing costs later). I reduced the card size to 4 x 5 inches, which rendered useless all the careful measuring and reduction I'd done in ImageStudio. But I remembered a PixelPaint trick that allowed me to rescale each scan to fit the new card size. ∎ *To rescale an image in PixelPaint, first select it with the marquee, move the cursor to a corner and wait until it changes from a crosshair to a pointer. Then hold down the Command key, hold down the mouse button and drag the corner in or out to make the image smaller or larger.*

Fitting the drawing to the card

To create each card I opened PixelPaint, selected Open from the File menu, and specified MacPaint from the Type menu that appears on the Open dialog box. This brought up a menu of all the scans I'd done. I double-clicked on a scan name — for example, Doll — which opened the bitmap scan in the PixelPaint window. My first step was to select Show Rulers from the Options menu and use this reference to measure the scanned image. I then used the Command key/mouse drag method to make the drawing small enough to fit the card size. Next I drew a 4 x 5-inch rectangle around the Doll drawing and positioned the two elements relative to each other. I used the marquee tool to select both rectangle and drawing and moved them into the upper left portion of the image area to make room for another card to fit alongside. Because I was working on a 13-inch color monitor, I couldn't see the entire painting window on the screen at one time. It took several passes with the marquee tool to select and move the graphic. Then I had to scroll the screen in order to position the card.

Ganging two cards to a file

Getting the second card in place in the document was a bit tricky. For example, in order to place the scan of Molly's shoes next to that of the juice, I had to close the PixelPaint document that contained the Juice card and then open the Shoes scan. I selected the shoes with the marquee tool and chose Copy from the Edit menu to place a copy of the image on the clipboard. I then closed the Shoes document, reopened the Juice document, and scrolled the image area so that the Juice card was temporarily off the screen. I chose Paste from the Edit menu to bring the shoes into the file. I then used the same method of selecting, moving and scrolling to position the Shoes next to the Juice card and drew a 4 x 5-inch rectangle around them.

Editing the drawing

Once the images were in place, the coloring fun started. I had paired the cards so they could appropriately share the same palette. I spent some time playing with different color palettes and trying different ways of painting. After experimenting with several styles of rendering, I developed a method of coloring the drawings that could be applied consistently from card to card with some flexibility, still resulting in a uniform look. For example, with the Doll card I selected the scan of my drawing and chose Trace Edges from the Standard Effects submenu under the Edit menu. This told the program to draw a thin line around the inside and outside edges of my drawing and to

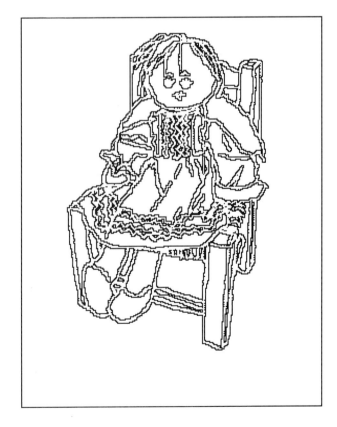

Figure 4. Tracing the scan. The scan was opened in PixelPaint 2.0, positioned within a 4 x 6-inch rectangle and modified with the Trace Edges function.

drop out the original lines (Figure 4). Then I was able to add color to the empty space within the shapes that resulted.

Filling basic shapes with color

I used the paint bucket tool to fill the large shapes within the drawing with solid color (Figure 5). In some cases a "leak" in the bitmap caused the paint to spill out into the background. When this happened I chose Undo from the Edit menu and then used the pencil tool and black paint to plug the leak by adding black pixels until any dangling lines were joined. ▌ *PixelPaint has only one level of Undo, so it's important to reverse your mistakes immediately.*

I also filled the narrow shapes drawn by the Trace Edges function with color (Figure 6). To accurately position the paint bucket cursor in these small shapes, I enlarged the image to 400 percent with the Zoom In function.

Modifying the palette

I decided to use the Vivid palette, as I wanted strong, deeply saturated colors. But it was necessary to edit the palette to get some special colors I needed, especially for skin tones and for modeling the shapes. I edited some of the browns and pinks in the Vivid palette to create tones for the doll's face and dress. ▌ *To edit a color palette, double-click on the color selection box to bring up the Color dialog box. Use the mouse to select a color to be edited, then click on the choices available (Lighter, Darker, Warmer, Cooler and so forth).*

Figure 5. Coloring the image. The modified scan was painted with bright, flat colors chosen from the Vivid palette. Some colors were edited to achieve desired hues.

Figure 6. Enhancing the colors. Large areas were filled with main colors, and the thin shapes created by the Trace Edges function were also filled with complementary or contrasting colors.

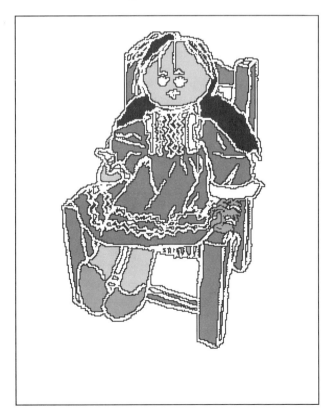

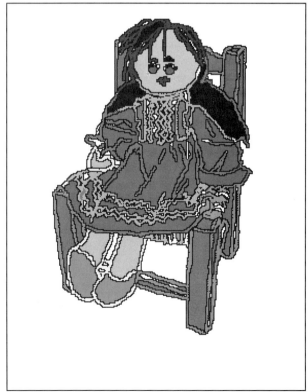

I sometimes referred to my original color photos when painting in PixelPaint, but for the most part I simply responded to the colors I saw on the screen. For example, with the Doll card I chose not to try to duplicate the green flowered cloth of the real doll's dress and instead painted a blue dress that fit better with the pink of the chair.

Adding painterly details

Once the entire drawing was filled with basic, solid colors, I used the brush tool, in various sizes, to add layers of color in different tones to create a painterly, modeled look. On the Doll card I used two shades of pink on the face and three shades of blue on the dress. The modeled areas took on a soft, blended look. But the traced edges of the original drawing, still in black, looked too harsh. In addition, there were some stray white pixels that gave the whole drawing a messy look. To eliminate these distractions and give the drawing a softer look, I selected the drawing with the lasso tool, then chose Smooth from the Special Effects submenu under the Edit menu. This caused the program to average contiguous color areas and add a third color between them. The effect was a beautifully smooth and soft rendering of the doll (Figure 8).

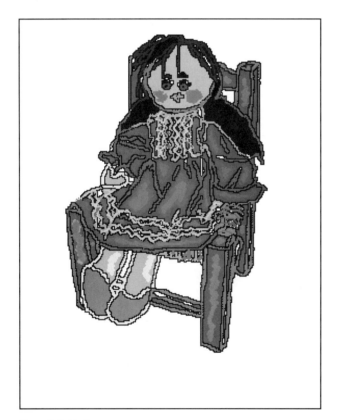

Figure 7. Achieving a "painterly" effect. Painterly modeling was added by painting layers of color in different saturations.

Figure 8. Softening the edges. Once all areas were filled with color, the Smooth function was applied over the whole drawing to soften and blur the edges between color areas.

Decorating the background

The next step was to color and decorate each card's background to complement the style and colors of the drawings. I filled the surrounding rectangle with a solid color and softened its hard edges by drawing a fat line with the brush tool in a complementary color. Then, using colors already in the drawings and some new complementary colors, I used the brush tool to paint squiggly decorations around the edges of the rectangles (Figure 9). Then I created and decorated a box to frame the title and I used the pencil tool to add patterns of thin lines and squiggles to the solid background.

Creating lettering

The first few cards I made incorporated the name of the card set in 30-point bold American Typewriter type in black. The type was surrounded by a horizontal rectangle that was filled and decorated in a manner similar to the outside border of the card. The fat black type looked attractive on screen, especially when the cards were still in a rudimentary form. But as I added more and more detail to the illustrations and borders, the type began to look stiff and out of place. I decided to draw in the letters by hand and color them to fit their surroundings. First, I deleted the old type by drawing over it with a

Figure 9. Creating the background. The background rectangle was filled with solid color, and a border was painted with the brush tool.

brush in the same color as the background. Then I scrolled to a blank space below the card and used the brush tool to draw the letters I wanted. To give the letters interest, I selected them and ran them through various permutations, such as Trace Edges, Thicken and so forth (Figure 10). When the basic outline of the letters was right, I used the lasso tool to select them and move them back into the horizontal bar. Creating the words in a blank space as separate elements and then moving the word into the bar made it easier to center the word. Once they were in place, I painted the letters with colors already used in that card (Figure 11). ∎ *To quickly select colors, use the eye dropper tool to touch a color you want to use, which selects it in the color selection box.*

Figure 10. Making letters. The American Typewriter type used in designing the first few cards was later replaced with hand-drawn lettering modified with PixelPaint's special effects, such as Trace Edges and Thicken.

Getting color proofs

While working on the cards, I printed black-and-white proofs on my LaserWriter IINT. This gave me an idea of how the cards would look. But I needed color proofs to check how the final printed colors would look and for creating the cards themselves. Experience has taught me that blues look much darker when printed on a color printer than they look on-screen. So once the cards were colored on-screen to my satisfaction, I created a duplicate of each file, named it "Molly/Tummy Card, light," and so forth, and lightened all the blues by changing their specifications in the color palette. The resulting screen image was lighter than I wanted, but I hoped that the printed colors would be just right. I also added an overall background color behind the cards, so that I would have an edge of color when I cut the cards for mounting. When all the files had been prepared, I sent the PixelPaint documents to a local service bureau to be run on a QMS color printer.

Mounting the cards

I carefully cut each card from the QMS prints using a paper cutter. I used spray mount to fix each card to a piece of precut white artist's board. Then I took the cards to a local photocopy shop where they were laminated to protect them from peeling and moisture. I made two complete sets of cards, one for Molly to play with and one to keep for myself.

Coloring book

At the beginning of the card project, as I was printing the scans of my drawings through PageMaker, I realized I had simultaneously created a second project — a coloring book. I used PageMaker to design a page layout to incorporate the original scans, added type for the name of each object and created a cover design. I printed the pages on plain white paper and stapled the edges. Molly enjoyed being able to color the same images she saw on her cards, and the coloring book could be reprinted each time she needed a new one.

In retrospect

In all, I was very happy with the way the cards turned out. It was a pleasure to create them, since I was dealing with a very familiar and beloved subject, and because I had complete artistic freedom. I think the process of working from photos to line drawings, to scans, to painted illustrations worked well, and I'd like to apply it to more illustration work. It would work especially well for children's books. The project was also a good demonstration of how using a computer for graphics expands the options and opportunities I have for making art. I could have created cards for Molly using marker pens or water colors, but the process would have taken much longer and I would have been reluctant to entrust the finished original artwork to Molly, given her propensity to chew on the edges of things. And having four-color lithographs made of original art would be much too expensive for a project of this kind. The computer enabled me to easily create more than one copy of my art, and I have only to return to my computer to generate new, improved copies.

Figure 10. Adding lettering. Hand-drawn letters were grouped into words in the blank spaces below the cards. Then they were moved onto the cards and colored to match.

PORTFOLIO

Janet Ashford

"I've recently heard of a concept in psychology called "flow," which occurs when a person is totally, vitally engaged in the work at hand. Flow occurs when an activity matches or just slightly exceeds a person's own level of skill and intelligence — when the work is complex and interesting enough to present a challenge, but without creating anxiety. Athletes experience flow. So do musicians. Working with a computer to create color graphics puts me into a state of flow more reliably than just about anything else I do. I admit that I've become addicted to it."

Self-Portrait Grid was made by holding a mirror in my left hand, holding the mouse in my right hand, and drawing directly into PixelPaint with the brush tool. Four separate self-portraits were drawn, colored and then combined into one document by cutting and pasting via the clipboard. The portraits were assembled into a grid, and additional painting was done to join color areas where the portraits butt together.

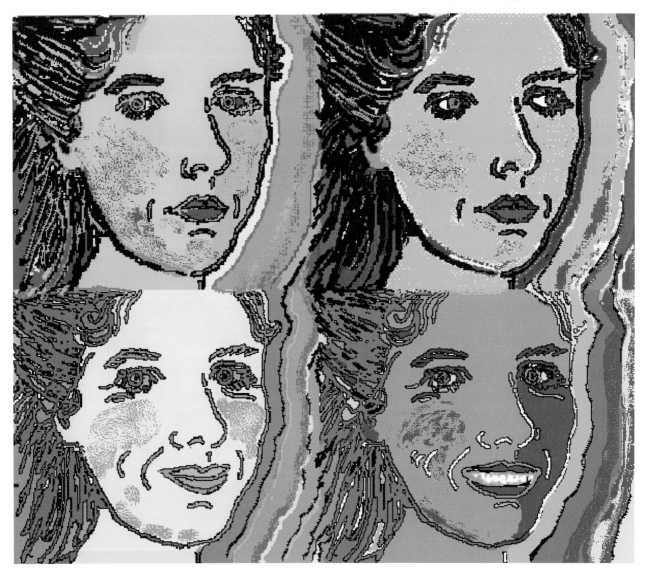

Apples and Hearts was drawn quickly and spontaneously on-screen in Pixel-Paint as a demonstration of the colors available in the Rainbow palette. The brush tool was used throughout.

Serena Fauve (below) was created in Pixel-Paint by adding solid and screened color to a scanned portrait made via a live video scan through Mac-Vision. The scan was saved in Zebra format, which added heavy black-and-white lines to the image.

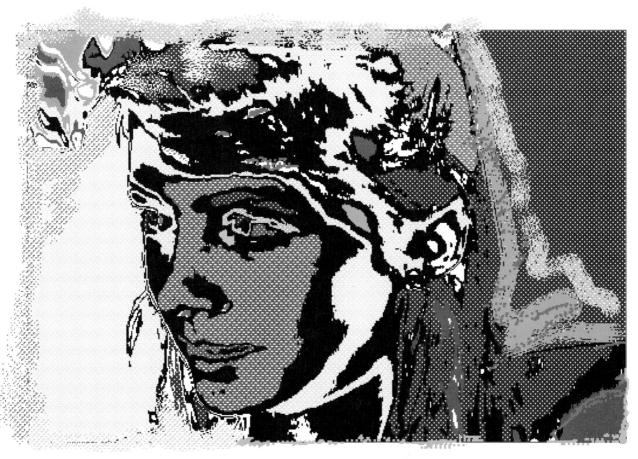

CHAPTER 5

A Glass Logo

Artist

Claire Barry majored in graphic design at the Academy of Art College/San Francisco primarily because of its pioneering computer graphics program. She has worked in computer graphics since 1984 and taught computer painting since 1988. She works for SuperMac Technology in Sunnyvale, California, where she made the switch from user to developer, helping to design PixelPaint Professional.

Project

A monochrome version of the Ideas Inc. logo was created in Aldus FreeHand, imported into PixelPaint Professional in 24-bit mode and transformed into a three-dimensional, full-color "glass" logo. This colorful version of the logo will be used in environments that are not limited in color, such as television, slide presentations, video and color CRTs in multimedia presentations.

The logo was created with a Macintosh II with 8 MB of RAM, SuperMac's Spectrum/24 graphics board and a DataFrame XP150 hard drive. For color output, slides were created using a Montage FR1 film recorder.

■ **PROJECT
OVERVIEW**

Design process

My challenge in creating the three-dimensional glass logo was to emulate software that runs on expensive minicomputers. Because of the color subtlety required to create the effect of glass, I chose PixelPaint Professional along with a 24-bit graphics board, allowing the use of realistic airbrushing and adjustable transparency.

My first step was to study the transparency effect. I studied the apparent opacity of all sides of many glass objects and examined the way light bounced off them and produced highlights. Studying the subject is the first step in illustrating any effect, whether it's glass, neon or chrome. I've been known to run around the parking lot examining the chrome bumpers on cars!

For desktop publishing applications, the Ideas Inc. logo is used in one color.

I had to be very careful, with all of Pixel-Paint Professional's transparency at my disposal, to avoid creating a confusing logo. I clearly defined the top, bottom and sides by using the airbrush to highlight the edges where the separate planes came together.

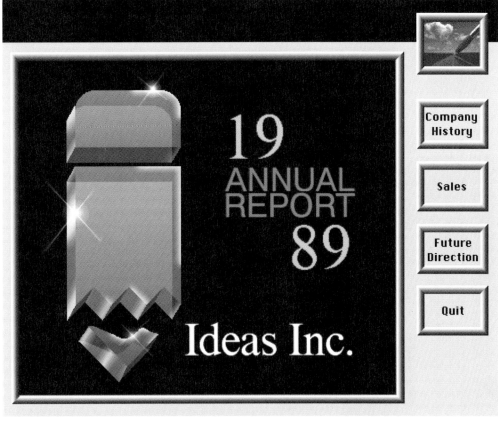

The glass logo can now be used in color desktop media presentations. An interactive digital annual report was created with the glass logo on the "cover."

designed the original logo for Ideas Inc. using Aldus FreeHand. The logo was saved in EPS (encapsulated PostScript) format, which I opened in PixelPaint Professional (Figure 1). Since I was altering only the pencil section of the logo, I used the eraser tool to remove the text (see page 60). I wanted the logo to appear over a black background, so I used the Invert effect to reverse the black and white. ∎ *It's important to decide your background color(s) before creating any transparent elements, because an object's transparency relates directly to what's behind it.*

Mixing color

The colors of the pencil had already been established as Pantone colors when it was previously used in spot-color printing. For the glass effect, however, a tint range for each of the hues was created to produce highlights. First I selected the appropriate colors from the Pantone picker supplied with the program. Then, using the color mixer, I was able to blend the colors together with the finger tool, establishing the palette I needed (Figure 2). Using paints from this palette, I filled in the sections of the logo.

Figure 2. Selecting Pantone colors. The logo was originally designed with specific Pantone colors. I was able to maintain consistent color by using the Pantone Color Selector in PixelPaint Professional.

Figure 1. Importing the EPS file. The original logo was created using Aldus FreeHand. When the logo was imported into PixelPaint Professional, the type was removed (see page 60).

Making the logo 3D

The traditional process for simulating a three-dimensional object is to copy the outline, offset the copy and then join together the edges. The same principle applies to creating glass, except that instead of using an outline of the logo I used layers of transparency (Figure 3). I wanted the base of the logo to be almost invisible. To achieve this I set the transparency control to 60 percent, selected the logo by lassoing it, and then copied it to the clipboard with Copy Using > Transparency. When I pasted the clipboard's contents onto the screen, a barely visible image of the logo resulted. ▮ *Assigning a transparency value of 60 percent to an object allows it to become 60 percent transparent, retaining 40 percent of the intensity of its own image. When the object is placed in front of a background, the background makes up 60 percent of the intensity of the resultant composite image, so the background appears to show through the transparent object.*

For the top layer, I repeated the above procedure using transparency (about 35 percent), and when I pasted it back to the screen I overlapped it upon the first faint image of the logo. The resultant image was about 65

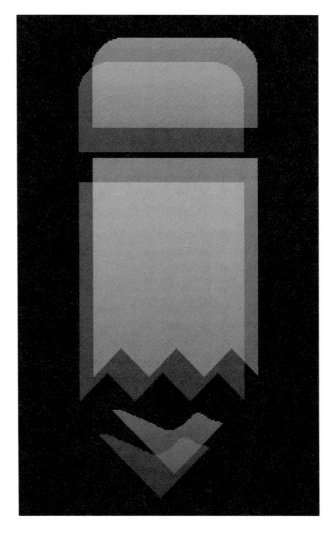

Figure 3. Simulating 3D. The basic process of creating the illusion of 3D is to offset a copy of the outline of the shape and then connect the edges of the outlines. To create the glass effect, transparent copies of the logo were offset in the same way.

percent top-layer logo and 35 percent combined bottom-layer logo and background. I usually offset the top of a logo to the upper right side, but this is a decision that should be based upon the shape of the element in question.

Creating the mask

The logo now appeared as two separate overlapping planes. I used the masking tools to isolate the sides that join the top and bottom pieces together, giving the illusion of depth. Making a digital mask is very similar to cutting a Rubylith or creating a frisket, except a digital mask can be created with lines, shapes, fills and so on. In Mask mode I used the lines to "seal" the edges and the bucket to fill each sealed area (Figure 4). I selected Reverse Mask to invert the entire mask, protecting the whole image except for the sides.

Defining the sides

Next I needed to define the sides of the logo. I went to the palette of colors I had mixed at the beginning of the project and chose a light shade of pink to define the side of the eraser. I set the transparency control to about 60 percent and drew a very faint pink rectangle that included the eraser. The program created the entire rectangular shape and then swept away the area that was masked, so that only the sides were affected by the transparent rectangle. I repeated these steps on the wooden area of the pencil and the lead.

Mask Line used to close up the edges.

Mask Bucket used to fill the entire side with the mask.

Figure 4. Masking the edges. In Mask mode, the ends of the surfaces were closed up with lines and filled with the bucket, completely masking the sides. Then Reverse Mask was used to invert the mask to protect everything except the edges.

Airbrushing the edges

Using the airbrush, I made the edges really glimmer. ▌ *The trick for effective highlighting is to place the highlights where the light hits the edges and turns of the shape.*

To create the highlights, I selected an even lighter shade of the color of the object, almost a white. I wanted the highlight to run along a line so I selected the airbrush in polygon mode. ▌ *The brushes in PixelPaint Professional can be used in three states: freehand, polygon and spline.*

I ran the highlights parallel to the offset of the logo. This emphasized the direction of the light (Figure 5).

Accenting the front of the logo

To accent the front plane, I isolated the logo by clearing the background and then filling it with the mask. Now only the logo could be affected by the tools. Again using the airbrush in polygon mode, I ran it over the top and right side of the logo (Figure 6). Now the logo really looked like a solid piece of glass!

Highlights

To make the logo really sparkle I added bright highlights. This is a technique I use whenever I want a surface to look highly reflective. Setting the transparency at 30 percent, I created a faint, antialiased line, which is also parallel to the offset of the logo (Figure 7). (Recall that *aliasing* is the technical term for the jagged effect you get from working with pixels; it's especially visible in diagonal lines. *Antialiasing* is the process of making the edges appear less jagged.) A second perpendicular line was placed over the first to create the gleam of the highlight. To finish the highlight, I used the airbrush in freehand mode to place one "dab of paint" where the two lines intersected.

Output

I think that output — getting the screen image onto paper or film — still is the single biggest question mark in the minds of designers admiring a true-color image on a monitor. And it should be. But there has been an explosion in advances in output technology. When I first began using computer graphics, photographing the screen with a standard camera was the only option. Now you can output to digital film recorders and to paper via inkjet printers, thermal transfer and dye sublimation transfer technology for continuous-tone prints. There are now devices for creating billboard-sized output. And with the compatibility of Macintosh file formats, digital paintings can be imported into page layout programs, animation programs and even high-end color separation devices for perfect four-color separations. So the beauty in creating a digital logo is that it can be produced quite easily in a variety of formats. The pencil logo was imported into Persuasion, Aldus's presentation program, and output to the Montage FR1 film recorder for

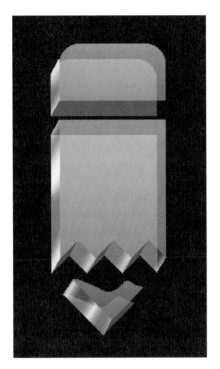

Figure 5. Highlighting the sides. With the airbrush in polygon mode and with the mask on to protect the background from change, highlights were created parallel to the offset of the logo.

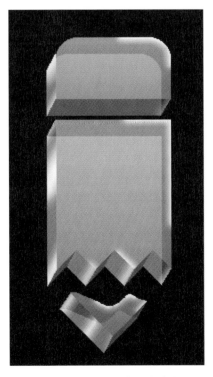

Figure 6. Defining the front plane. With the mask protecting everything except the logo, the airbrush was used again to highlight the upper and right edges.

Figure 7. Creating sparkles. A partly transparent, anti-aliased line was used to create perpendicular crosshairs with an airbrushed highlight in the center.

slides. It can also be included in PageMaker or Director files for color desktop publishing or desktop media presentations.

In retrospect

Because I've been working with computer graphics for over six years, I've had the opportunity to watch how dramatically the systems have changed. As I created the glass logo, I thought about how I would have created it on some of the earlier graphics stations I used. Because they were 8-bit, I could have come close to emulating transparency, but it would have been impossible to achieve the subtleties in the highlighting.

The first true color paint programs I used were on the IBM PC, where I first learned to create the glass effect. Although these programs were powerful, I remember how complex it was to emulate transparency. I taught a 10-week course in computer painting for several years, and this technique was far too involved to teach — even in person.

The Macintosh interface is clearly as powerful as its tools. For instance, I found the masking to be completely intuitive; instead of learning a whole new set of masking tools, the user clicks a button to get into mask mode and then continues to use all the already familiar painting tools. To be able to explain the methodology of a complex function in just a few pages is testimony to the Macintosh's ease of use.

24-bit technology

rue, or 24-bit, color provides over 16 million possibilities for painting pixels on the screen. Twenty-four-bit technology changes the way color is addressed by the computer and drastically modifies the tool set the artist has available. Graphics boards that define colors using a total of 8 bits or less are indexed color systems. In an 8-bit system the image can contain 256 colors out of a larger palette of 16,777,216 (256 x 256 x 256). The color content of a pixel is assigned a number (often referred to as an "address") between 0 and 255 in a color map (see "8-bit color systems" on page 124).

A graphics board with more than 16 bits per pixel is referred to as a *true color* system. This system discards the color map and stores all the color information in direct association with the pixel on the graphics board. Therefore, a 24-bit graphics board is able to display all 16.7+ million colors at one time (or more realistically, every pixel on a monitor can be different). The obvious difference in 24-bit display systems is the number of colors the computer can display simultaneously, but having direct access to the pixel information also makes the tool set function better.

Color mixing

In previous graphics systems, creating color has been a very mathematical, nonintuitive process. Typically, the user was expected to define color by percentages of red, green and blue. Now with over 16.7 million colors available, colors can be mixed together as with real paint (Figure a).

Overall, true color technology has made graphics tools on the computer much more like the traditional tools artists are fluent with. Hence, they're easier to learn and use.

Transparency

Transparent color is the result of a percentage of color combined with another color that seems to show through from underneath. True transparency can be obtained only if the program has full access to all potential colors. A transparent object may be very simple — a red transparent object over a yellow object, resulting in orange in the overlapping area, for example (Figure b). Or it may be very complex, such as illustrating a green bottle on a window sill with a landscape showing through it. To accomplish this kind of effect, the user must be able to define the precise percentage of transparency and have the brushes, pens, shapes, lines and text all operate in transparent mode.

Antialiasing

Aliasing (also called *staircasing* or *jaggies*) is unavoidable when pixels are used. The pixels become very apparent along a diagonal line. They can't be made smaller, but a technique called antialiasing can make them less noticeable. Antialiasing "smooths" the edges and gives the viewer a perceived greater resolution. It works by placing an in-between color (gray, for example, if white meets black) along the edge of a jagged line. This fools the eye into believing the edge is less jagged (Figure c). Typically, tools in 24-bit paint programs have the option to antialias as they create polygons, text, lines and so on. Also, there are tools to smooth an image after it's created. In PixelPaint Professional these tools are the water drop and the finger tool.

Scanned images

Because of the enormous color range available, an image can be scanned into the computer with total color accuracy. With sophisticated dithering, 256 colors were sometimes adequate, but you could quickly run out of color if you were producing a layout that contained several photographs per page (Figure d). True color allows the artist freedom from "color rationing."

Figure d

Figure a

Figure b

Figure c

PORTFOLIO

Claire Barry

"The introduction of true color (as many colors as the eye can see) to the personal computer is a significant event in computing and art. The computer is just a tool that allows information to be translated from thought to the screen and perhaps to film or print — it's a very powerful pencil.

"When graphics were first generated on a computer, the artist had to conceive where to place a pixel on a grid of x and y coordinates. This method was very production oriented and didn't lend itself to creative experimentation. As technology developed, the computer became a more interactive medium, and because of its digital state it encouraged the artist to take chances and work in a freer, less linear way.

"With true color, the computer can now effectively emulate traditional tools; the airbrush now functions like its traditional counterpart, transparency is automated and color mixing is done intuitively, as it is with real paint. This is exciting because an artist can translate the skill gained in the traditional world to the computer, fully maximizing creative talents.

"I look toward pushing the inherent qualities of the digital medium for its own sake. Watercolor looks the way it does because that's how water and pigment and paper react. How does a computer react? What is it best at? These are the things I'm interested in seeing the art community explore."

The **Vuarnet** image was created in January 1989, using a very early version of PixelPaint Professional.

Egyptian Neon was created by first scanning a photograph of hieroglyphics and then painting the neon onto it with PixelPaint Professional. The neon effect was simulated by using an airbrush attached to a polygon.

These **shapes** are an example of an interface design exploration for PixelPaint Professional. Although my artwork is the most visible aspect of my work, my main responsibility is program definition and interface design. Many, many designs are considered before any coding takes place, and after the coding begins, they undergo constant changes as we "feel" and test the program.

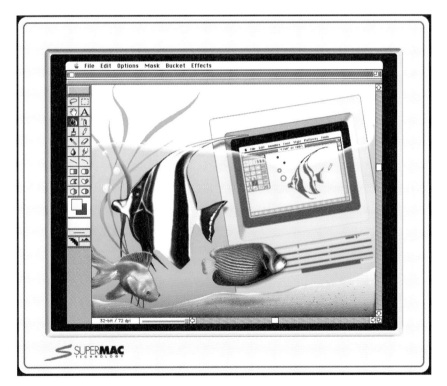

Macquarium was created to highlight 24-bit technology. The low-resolution 1-bit fish is humorously set within the true color realistic environment, which, of course, isn't real at all. I hand-painted all of the elements in this image, although the fish were originally scanned from photos to save steps.

These **icons** are examples of interface design exploration for PixelPaint Professional.

CHAPTER 6

Mt. Hood

Artist

Bob Woods is an artist and freelance illustrator with a background in photography and photographic set and costume design. After college, he began doing illustration with pen and ink and serigraphy in northern New York. He moved to Portland, Oregon in 1978 and has done digital illustration for several years, mostly for regional publications. His commercial work led to invitations from artists and gallery owners to exhibit artwork. He has his own studio, Woodsymmetry, and has worked on several different machines, most recently the Amiga and the Macintosh II. Woods is currently the System Manager at Fred Meyer Advertising in charge of their Prepress System.

Project

This piece is a little unusual in that it was done on two different computers. I started it on the Amiga and finished it on a Macintosh IIcx.

I was recruited to join "Animators Anonymous" — a group of artists, programmers, designers and animators — to do the opening screen for an animation sequence. This was to run at the beginning of the local cable-access show NAG-TV, produced by members of the Northwest Amiga Group desktop video SIG (special interest group).

After the picture is displayed for a few seconds, "flying logo" titles spin onto it, and the entire assembly rotates into the distance to become a "floppy disk." This is then grabbed by an animated Amiga computer character, who inserts it into the disk drive and starts dancing. The animation is about 30 seconds long.

The second phase of this project was self-assigned. I ported the artwork to the Mac II, because I wanted to see how close I could bring it to a photorealistic image. The intended end use of the image also changed here, from an element in an animation to be displayed on television to a still image to be printed and framed.

I began on an Amiga 1000 with 2.75 MB of RAM, an Amiga RGB monitor and two floppy drives. DeluxePaint II from Electronics Arts was the software used to create the still picture. The animated part of this project was done with Animation: Apprentice (Hash Enterprises), along with the rest of the Animation line of integrated products: editor, soundtrack controller, rotoscope, animation stand and compositing software.

Later I moved to a Macintosh IIcx with 4 MB of RAM and one floppy drive, an Apple RGB monitor and an 80 MB hard disk. Studio/8 (also from Electronic Arts) was the graphics program. The graphics file translation programs I used were IFFGIF (Amiga), and GIFfer (Mac), both shareware utilities.

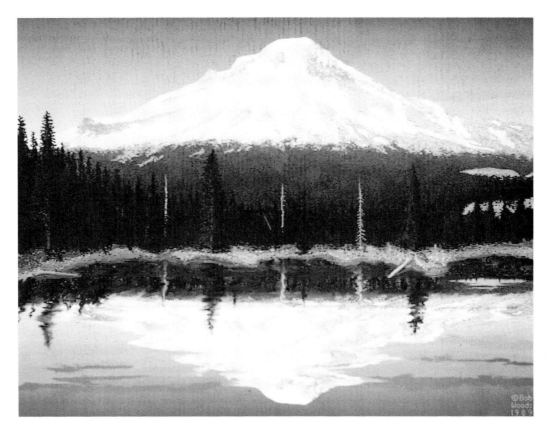

The Mt. Hood illustration is shown in color on the back cover of this book.

PROJECT OVERVIEW

Design goal

Part of the motivation behind continuing the development of this piece on the Mac was my interest in digital retouching of photography. This work has previously been done on high-end graphics work-stations but is quickly coming down to desktop machines, with programs like PhotoMac from Avalon, Letraset's ColorStudio, Adobe's Photoshop and others to come. In the end, though, all the fancy hardware and software will still be secondary to the skill and artistry of the operator. A thorough understanding of lighting, perspective, color and optical theory is necessary to convincingly combine elements of two or more different photographs into one seamless image.

In image assembly, understanding the interactions of the various elements is critical. Does this part shade that part or throw a color cast onto it? Do the elements look as if they were photographed under the same light source, from the same angle, with the same color temperature? Are any of the objects reflective? If so, what do they reflect?

I felt the best way to explore questions like these was to create an image completely by hand, not using scanned-in images at all. If I could do this by hand, I could do it with scans. So when the animation project was completed, I realized I had a good subject to start with.

A close-up of the trees from the Mac II version of this project. Studio/8's color and tool palettes are visible in this slide shot from the screen. (For suggestions for photographing on-screen art, see "Shooting a color monitor" on page 147.)

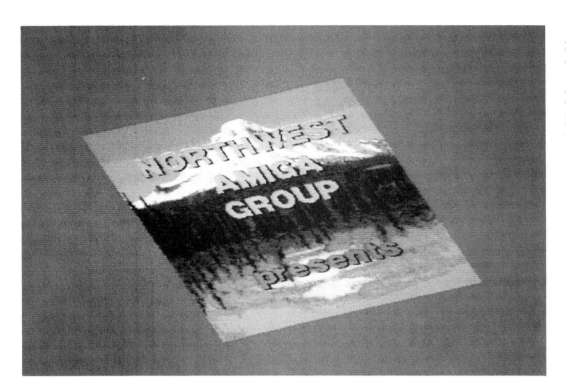

In a frame from the Amiga animation, the titles have been composited onto the picture, and the assemblage has started to rotate into the distance. This is a good example of an "animation stand" type of effect — a still image is put into motion.

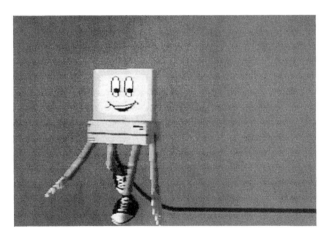

In these frames from late in the animation, the Mt. Hood title illustration has been transformed into a floppy disk and inserted into the disk drive to animate the NAG man.

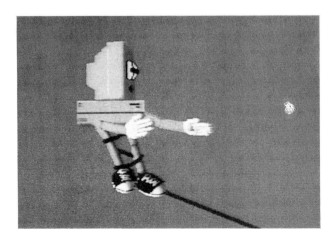

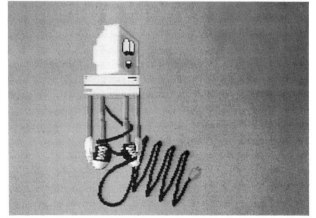

After much storyboarding, character design and discussion, the choice was made to do a Northwest landmark, Mt. Hood, in a watercolor style on the Amiga for the opening scene of the NAG-TV animation. Some decisions were made in advance as to the number of colors to be used (32) and the resolution (352 x 480, the highest resolution available with 32 colors). Ten of the 32 colors in the palette were reserved for titling, drop shadows and so forth.

At first, I worked from a 35mm slide projected onto a screen next to me while I drew with the mouse, using DeluxePaint II. I picked the palette, with a gray scale for the mountain above timberline, a range of forest green to blue-gray for below timberline, and a range of tints of cyan for sky and water. Then I sketched in the outlines of the mountain, using the filled polygon tool to draw the various colored rock, snow, tree and water areas (Figure 1). Next, I concentrated on rendering the mountain to look as much like the slide as I could (Figure 2). Mt. Hood is a distinctive peak, and the reference photograph was taken near one of the more popular viewpoints. Most of this stage was done in the Zoom mode. I find a magnification of about 4x a good compromise between being able to work in fine detail and being able to see the overall effects of each change. After putting the detail on the mountain, I turned off the projector and drew the rest of the scene pretty much from memory, trying to capture the essence of the setting, rather than attempting to "hand-digitize" a photograph. Next, I made a gradation for the sky using

Figure 1. Sketching the forms. Each area was sketched first and painted over later with much finer detail. This first version is like a "for position only" picture — the elements of this version are placeholders for later detail.

the fill tool. At this point I added the trees (Figure 3). The slope above the trees was done with the airbrush tool. I worked from side to side and changed colors gradually as I approached the snow and rock areas above. The sky, rock and snow colors were "masked" from being painted over by use of the Stencil feature.

The water area was kept "soft" without too much detail, as light-colored titles would be composited over this area and we wanted to keep them legible (Figure 4). At this point the image was ready for use in the animation.

Figure 2. Working in mountain detail. Much of the construction of the familiar Mt. Hood was done in the Magnify mode with a close eye on the reference slide's detail. After the mountain was complete, other details of the scene were added from memory.

Figure 3. Adding trees. Trees were added along the lakeshore with the pencil tool. The airbrush tool was used above the foreground trees but below the upper mountain.

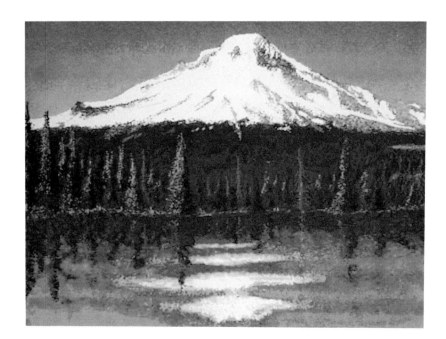

Figure 4. Getting ready for animation. This is the final Amiga version of the Mt. Hood painting. Note the soft reflection in the water to allow titles to be composited over this area. At this point the image was used as an animation background. Later it was ported to the Mac II for continued development.

The Amiga version of this picture is not really indicative of the full range of capabilities of the machine — particularly of the unique "HAM" graphics mode (capable of displaying up to all 4096 colors on the screen at once). However, we wanted to use the HAM mode for combining elements of the animation, which meant we couldn't use it effectively for individual illustrations.

Transporting the image: GIF files

After purchasing a Mac IIcx for the studio, I decided to port some of my artwork from the Amiga to take advantage of the 16.7 million–color palette available on the Mac. On the CompuServe network, I found a set of software routines for conversion of graphics files to and from several different platforms — Mac II, Amiga, IBM and others. These encode and decode a special type of file called Graphics Interchange Format — GIF files. These files are essentially a computer-independent graphics standard, capable of accepting pictures of up to 32,000 pixels in each dimension and up to 256 colors. The picture displayed on the destination computer is automatically adjusted to the best capability of the display hardware. Obviously, the results are better when a picture is displayed on a system that has resolution and color capabilities equal to or better than the originating computer. Hence, an Amiga graphic looks better on an 8-bit Mac II display than on an IBM CGA monitor (320 x 200, with four colors from a palette of 16).

I encoded my files on the Amiga and used a utility program to write the file to a 720K IBM-format disk that the Mac IIcx can read. I then decoded the file on the Mac with the GIFfer conversion routine, scaling it to full (640 x 480) screen size, and saved it as a PICT file. ▮ *All the latest Macs — the SE/30 and the IIfx, for example — have a high-density floppy drive called the FDHD*

Converting graphics files

GIFfer is by no means the only way of transporting graphics files to different computer platforms. It's also possible to transfer a file via modem, and several commercial utilities do much the same thing as GIFfer. Hijaak for MS-DOS machines will read and write most of the numerous PC graphics file formats as well as GIF and most Amiga and Mac formats. A new utility called PICTure This, available for Mac, Amiga, IBM and Sun will read and write most of the aforementioned formats plus Sun Raster and X11 (Unix) bitmaps. In some ways PICTure This is even more flexible than GIF: the files can be converted directly from their native formats — they don't have to be preprocessed. Also, it allows viewing of graphics files downloaded from networks and bulletin boards, even if they come from other types of computers.

There are also applications that can read the native file formats of other machines directly. Adobe's Photoshop can read most Mac formats plus Amiga, Pixar, Targa and Scitex files.

Figure 5. Contributing more colors. In the first Mac version of the image, new colors were added to the original palette. The sky was replaced with a gradation of 32 shades of cyan, and new vegetation colors were introduced.

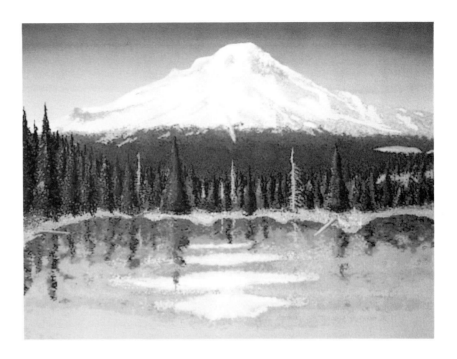

Figure 5. Contributing more colors. In the first Mac version of the image, new colors were added to the original palette. The sky was replaced with a gradation of 32 shades of cyan, and new vegetation colors were introduced.

(or Superdrive). This drive will read and write not only the 400K and 800K Mac disk formats but also the 1.44 MB Mac format as well as Apple II 3.5-inch disk format and IBM 720K and 1.44 MB formats.

On the Mac

After opening the PICT file in Studio/8, I enlarged the palette by adding new gradients of sky and vegetation colors. The larger number of colors available on the Mac II allows much subtler gradations, without having to rely as much on dithering (the intermixing of pixels of two colors to produce the illusion of a third intermediate color).

One of Studio/8's strengths (in contrast to programs such as PixelPaint) is the flexibility of its Mask function. You can mask any color or combination of colors. You can mask the last object selected or the current selection. You can then invert the mask, with all colors masked except the selected colors or with everything masked except the area you selected. Also, you have the ability to load and save masks for later use.

I used the Mask function to lock all but the old sky colors and painted them with the background color. The remaining picture area was selected and masked using the Mask Selection Only item. ∎ *Mask Selection Only, like several other menu choices, is "context sensitive" — it appears only when you have an area already selected.*

A rectangular area slightly taller than the sky area was created on the draft page, filled with the new sky gradient, and selected as a brush. Then the new sky was placed "behind" the mountain back on the document page. I also introduced a broader range of colors for trees and other vegetation (Figure 5).

The water was replaced with a vertically flipped selection of the top half of the picture (Figure 6). But there's more to drawing a specular (mirror) surface than merely duplicating what it reflects — you have to think of the incident angles of light coming from reflected objects. The trees on the shore and their reflections in the water are a good example. They are drawn in the reflection as the water "sees" them, not from the higher and more distant viewpoint of the observer. The easiest way to visualize this is to project your viewpoint to a point on the water surface and imagine what it would look like from there. This caused me to make the reflections of the trees taller than they were in the upper half of the picture. In general, the nearer a reflected object is, the taller its reflection will be, compared to the reflections of more distant objects. The look of the water surface was achieved by using the Blend and Smear modes of the brush tool selectively to produce the effect of a reflection off a gently rippled surface (Figure 7). ▮ *The process of drawing photorealistic images, especially those involving reflections, is similar to the process known as "ray-tracing." You may have seen some of these computer-generated images, most commonly several transparent or reflective spheres, seemingly floating above a surface. To produce these, various values are entered for each object's position, size and surface characteristics. Several other variables, such as the "camera" and light source position and chosen background, are considered in the actual rendering of the picture. For every pixel on the screen, the computer must decide what the "camera" is seeing. A picture can take from several minutes to several*

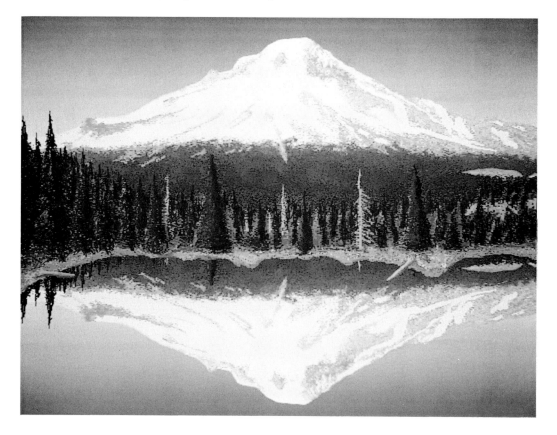

Figure 6. Developing the reflection. The water was replaced with a mirror image of the top half of the picture. Notice that at this point in the development of the image the reflections of the trees in the water are too short for this perspective.

hours to be rendered, depending on the complexity of the scene and the speed of the computer in completing many millions of calculations. Obviously, drawing by hand isn't as complex or precise, but the same optical laws are applied.

Also, some areas were blurred more than others to produce a "surface" that's not perfectly specular (Figure 8). This was done by using the Smooth mode brush, which averages the value of each pixel under the brush with its immediate neighbors (Figure 9).

Figure 7. Reworking the surface. The water surface was reworked with Blend and Smear mode brushes to produce the effect of moving water.

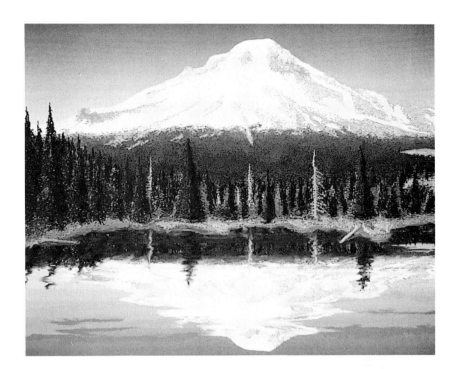

Figure 8. Blurring the reflection. This close-up of the water surface, shows some of the details in the water ripples. Notice that some areas are intentionally blurred, as if by wind ruffling the water surface.

The trees didn't look realistic, so I took a walk around the neighborhood to observe the way Douglas firs grow and redrew the trees accordingly. Most of the rest of the changes to the image from this point on were fine tuning, leading to the final version (Figure 10).

One of the things that enhances the apparent resolution of a picture is antialiasing, the smoothing of a high-contrast transition between two colors at an angle, removing the well-known "jaggies" or stair-stepping of an edge

Figure 9. Using a smoothing action. This close-up shows the action of the brush in Smooth mode. This mode averages the values of each pixel under the brush with each of its immediate neighbors, which has the effect of lowering the contrast where it has been used.

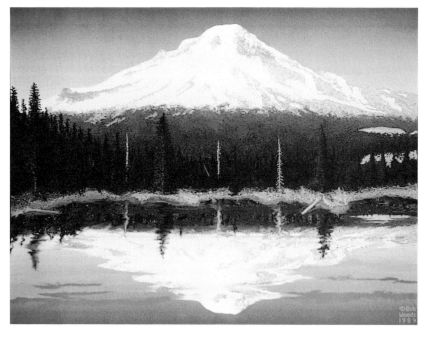

Figure 10. Cleaning up details. Here in the final version the trees have been redrawn more realistically, and many small details have been cleaned up.

(Figure 11). This is done by painting an ordered blend of the two ending colors across the transition using a single-pixel brush in the Blend mode. Sometimes I place the colors individually for finer control of the process.

In retrospect

Without the limitations imposed by the final output of the Amiga picture, particularly having only 22 of the total 32 colors left in the palette, it would have been possible to have done an image much closer to the Mac version. I don't hesitate to recommend the Amiga to those who have an interest in digital art, especially to those who have a limited budget — an entire Amiga system including monitor often costs less than an Apple monitor alone. The Amiga's greatest strengths, though, are in the area of animation. The Amiga was the first personal computer to run at an even multiple of NTSC video frame rate and to be able to send a decent signal directly to videotape. This, along with its other attributes such as Overscan — the ability to display graphics to the visible edge of the screen — makes it an ideal platform for "desktop video." Overscan allows objects to move onto the screen from off-screen without making their first appearance half an inch in from the edge.

In some ways, the Amiga is more fun than the new Macs are — the Amiga has more of an "underground" feel to it. I switched because, while the Amiga is great for animations, the Mac is a better still-graphics machine. It feels more precise. The Mac is definitely a professional-quality tool, and the improvements in its display capabilities have widened the gap between it and both the Amiga and the PC worlds.

Figure 11. Anti-aliasing the jaggies. "Before" and "after" views show the effects of antialiasing. This technique can raise the effective resolution of an image by smoothing the obvious "jaggies," or stair-stepping of edges.

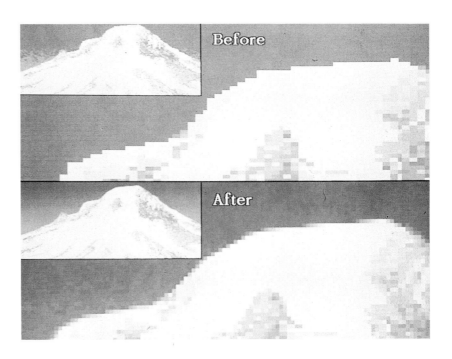

Bob Woods

"One of the things I like to do when finishing a piece is to try to add detail just beyond the conscious level — more as hints or suggestions that cause the observer's mind to add depth to the picture and accept the scene more readily. A good example would be shadows — I often put in some shadow detail even if it's so subtle that you don't notice it consciously. It suggests something more is present and heightens the apparent reality of the picture."

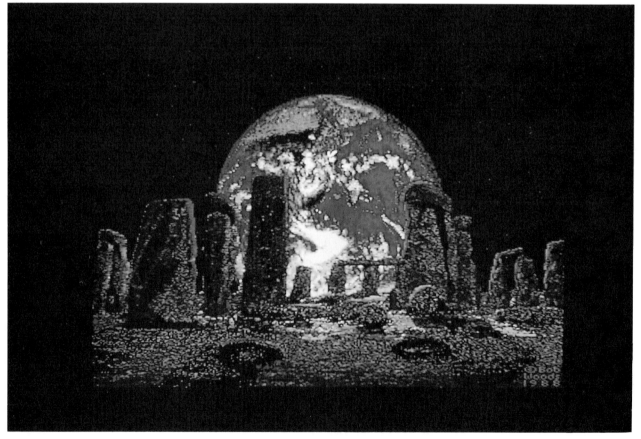

MoonHenge (above) was born when I was looking for something to draw late one night and glanced up at a poster of the Earth, an image that everyone has seen a thousand times. I decided to juxtapose it with something that would make an intriguing piece. So I did a picture of Stonehenge, also using a photograph as a visual reference, and then composited the two together. I worked on an Amiga 1000 using DeluxePaint II and PhotonPaint, with a 320 x 400 screen resolution and 4096-color mode.

Acid RainForest (top) was done expressly to enter in the "IMAGINE Tokyo '89" show, produced by *Verbum* magazine. I tried to illustrate an aspect of the show's theme — Nature and Ecology. I also decided to accentuate the artifacts of the computer — pixels and "jaggies" — rather than try to minimize them as I so often do. The picture is of a dead forest and the light streaming through it. The image was created in Studio/8 on a Mac II, 640 x 480 screen resolution with 256 colors.

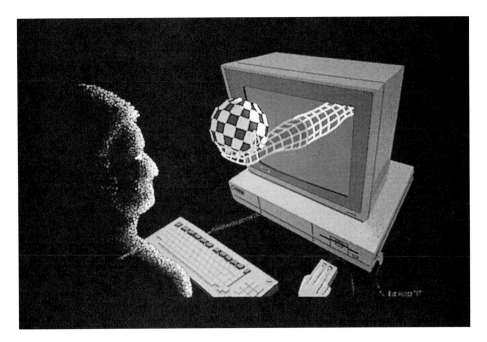

3D was commissioned as a user group newsletter cover illustrating 3D modeling and animation programs. The computer in this image was created in the modeling program Videoscape 3D. Originally done in black-and-white, it was later colorized on an Amiga 1000, 640 x 400 screen resolution and 8-color mode. DeluxePaint II was also used in this piece.

In **Synergy** the idea was to illustrate the concept of synergy (where the potential of the whole is greater than the sum of the parts alone) for a corporate newsletter. It was drawn as separate pieces and assembled using a Mac II, 640 x 480 screen resolution, 256-level grayscale in Studio/8.

For **Mythos: Judeo-Christian** I created the three elements in the cloud — the "god," "satan" and "fetus" — on Macs (both an SE and a Mac II) using ImageStudio (a grayscale editing and paint program) and output them on a LaserWriter. I scanned them into the Amiga 1000 and continued working on the rest of the picture, creating cloud textures and assembling the parts.

C H A P T E R 7

The Lizard King

Artist

Since 1984, Trici Venola has been blitzing the Macintosh industry with bizarre, exquisitely drawn images. To date she has created eight clip art packages, including the best-selling *Mac the Knife 3: Mac the Ripper* for Miles Computing, Inc. She created the modular characters for *The Comic Strip Factory* starring Fred Nerd, whose image continues to grace everything from catalogs to the AppleLink Guided Tour. In 1987, Venola acquired a Macintosh II and started working in color. Her first piece was the "Gazelles" image for the award-winning MacDraw II ad campaign for Claris with the BBDD agency. She went on to win several awards with other MacDraw ads. Her work was also featured in several commercials for Apple's Macintosh computer. Other projects in progress include work in film, comics and entertainment software, as well as fine-art images for her new "Brazen Images" clip art painting series (see the Portfolio section of this chapter).

Project

I'd made a decision that the clip art vocabulary I'd been working with needed a Southwest/Mexican flavor. Also, having recently returned from a vacation to Mexico, I felt like drawing iguanas. An iguana would be a nice touch in this series; I intended to call him the Lizard King in reference to the self-ascribed title of Jim Morrison, lead singer of the seminal 60s rock group the Doors.

I used Studio/8 to create the iguana image on a standard Macintosh II with one disk drive, a Jasmine Inner 90 hard disk, 8 MB of RAM and a standard Apple 13-inch color monitor. I have a 24-bit color video card installed in my Mac, but no scanner. Studio/8 works when the monitor is set for 256 colors. My hand tool is, by the way, a standard Mac II mouse on a glass desktop, with plenty of Windex and paper towels nearby.

The Lizard King is shown in color on the back cover.

**PROJECT
OVERVIEW**

The inspiration

This project, drawing the Lizard King, re-
sulted from a whim. I wanted to add to my
existing vocabulary of clip art elements in
order to create several same-palette paint-
ings and animations. Works from this se-
ries, titled "Brazen Images" and originally
started as fine art, have since been used
in commercial illustration.

The series is a portrayal of gods and
goddesses, inspired in part by the works
of writer/philosopher Joseph Campbell.
Images from this series have been used in
seminars, demos, start-up screens and
anything else requiring a Mac to look
good. Campbell divined the relation of the
gods to us and to each other, and their
ability to wear a different face for each cul-
ture. The Lizard King as enacted by
Morrison is a representation of Dionysus.
The Dionysus/Apollo duality, in which pas-
sion (the Dionysus force) and skill (the
Apollo principle) combine to make art, is
one of the strongest precepts in mythol-
ogy. The Doors' music is a good example
of this: superb musicanship coupled with
uncontrolled frenzy. Campbell himself
cited the Grateful Dead. If you're wonder-
ing what this has to do with how to use
Studio/8, the answer is: Everything. In or-
der to learn how to speak, it's necessary
to have something to say. That's the pas-
sion part, which can't be taught. The skill
part can be.

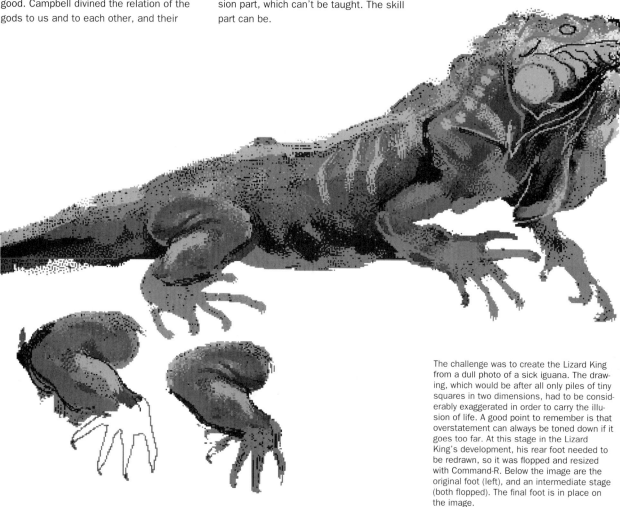

The challenge was to create the Lizard King
from a dull photo of a sick iguana. The draw-
ing, which would be after all only piles of tiny
squares in two dimensions, had to be consid-
erably exaggerated in order to carry the illu-
sion of life. A good point to remember is that
overstatement can always be toned down if it
goes too far. At this stage in the Lizard
King's development, his rear foot needed to
be redrawn, so it was flopped and resized
with Command-R. Below the image are the
original foot (left), and an intermediate stage
(both flopped). The final foot is in place on
the image.

The capability to zoom in and out of an image this detailed is invaluable, but the temptation is to stay too long and play "eat the dots." This can kill the spontaneity of the drawing, however. After zooming back out here, I pulled his right arm around a little and fattened the jaw. Lavender around the eyes made the green and yellow pop (see back cover).

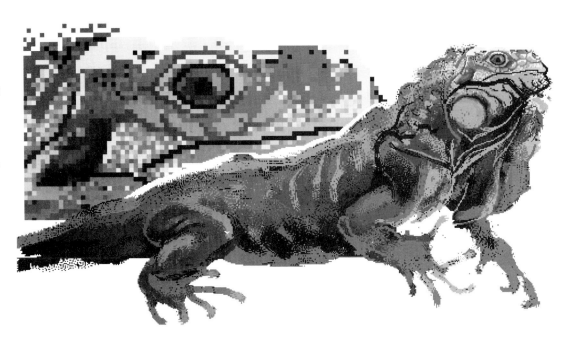

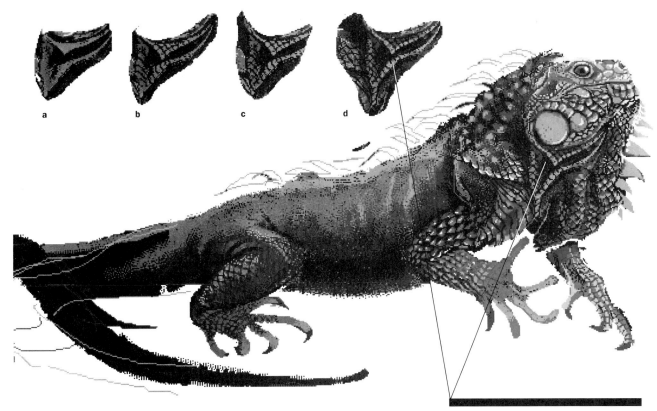

a b c d

With a "superreal" image like this, it was particularly important to "punch up" that strange dewlap so peculiar to iguanas. Shown is a section of the dewlap in four stages of progress: plain pencil (a), more pencil (b), tiny brush with Darker (c), and Tint (Command-5, Command-4) (d). At this stage the dry-straw scales on his back were added and the missing section of the tail was sketched in.

began by drawing from scratch. I did not use a scanner. Most of the images I need don't exist as scannable pictures and besides, hunting for exactly the subject I need in the right position is not my idea of a good time. Also, although I could draw it first and then scan it, I hate doing something twice. Drawing it right on the screen ensures that it won't lose anything in the translation. And I prefer to use the Mac as a primary art platform. Years ago when I started on the Mac, I thought it would be "cheating" to work from roughs, and there weren't any scanners. So I learned how to draw directly on-screen.

Why Studio/8?

I chose to work in Studio/8 because the extensive keyboard shortcuts, plus the thoroughness of the programming, make it possible to forget the machine and get right into the artwork. I suspect this means that I go directly into the right brain without any tedious warm-up. Learning Studio/8 took about a month of spare time back in November of 1988. On the strength of the piece I produced during the learning process, I was invited by Electronic Arts to demonstrate Studio/8 at the Macworld Expo in 1989 in San Francisco. I was mortified to learn from the programmers in mid-demo all that I had not known about this incredible program. Besides masking and perspective fills that I hadn't even suspected, virtually every command has a keyboard shortcut. ∎ *To put away the tool palette but leave the color palette out where you can contemplate colors, pull everything out and then choose Hide Tools from the Windows menu.*

With Studio/8 and 8 MB I can hit the space bar to enlarge the workspace to fill my screen. I can also open several documents at once. When I started with Studio/8, I had only 2 MB and could only open one document at a time to standard window size. This was a powerful incentive to upgrade to 8 MB.

Creating the color palette

Since I planned to add my iguana to a vocabulary of existing clip art images, I had to restrict myself to the same palette used in the other artwork. This promised to be no mean feat, since when working with 8-bit color (256 colors) one must be parsimonious with some color groups in order to spend lavishly with others. In this palette I wanted many flesh and blue tones for the Venus and Krishna figures that were part of the series. I also needed a full range of colors as well as several golds and deep reds. Something had to go and it was, alas, the greens. Iguanas tend to look best in green, so giving this one the right color scheme was a real challenge.

At the time I actually had six open spaces left in my Brazen Images palette. Experience tells me it's best to leave a few open spaces when building clip art; they may be crucial to a piece later. So I decided to start my iguana with what I had, see what I couldn't live without and, if necessary, add it later.

I pulled up a completed Brazen Images painting and saved it as "Iguana One." Then I erased the whole thing by double-clicking on the eraser. That left a clear window with the Brazen Images palette at my disposal. (Because I wasn't using a 24-bit drawing program, I took Apple's 32-bit QuickDraw out of the System folder. Just put it on the desktop until you need it. As of May 1990, Apple's 32-bit QuickDraw appeared to fight with some color programs, and Studio/8 was one of them. What happened to me was that I was unable to access two animations created in Director with Studio/8 art. When I removed 32-bit QuickDraw from the System folder, the problem cleared up. When I need to work in 16 million colors, I just throw 32-bit QuickDraw into the System folder and restart and all is well.)

Creating brushes

I started my work on the Lizard King with a custom brush. I've found it very handy to create a few random-dot paintbrushes, since it's easier to control them than the airbrush (Figure 1). Also, they work with all the brush commands.

Normally I use a key command to get to my paintbrushes. The up and down arrows at the lower right of the keyboard scroll through the paintbrushes. When creating my brushes, I group them as they're likely to be needed. There are several three- and six-pixel brushes scattered throughout the brush palette. This is because I use them so often, and it's irritating having to scroll through the entire palette.

Figure 1. Creating brushes. A palette of custom brushes was used to create the iguana. Double-clicking on a brush selects it (indicated by a square), so it can be edited and customized. The Edit Brush box is used to add or delete pixels.

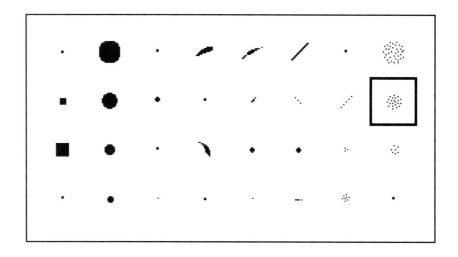

Reference material

For scrap, I had one bad color photo of an iguana's head and shoulders, plus a "generic guide to iguanidae" consisting of line drawings, and several lizard photos for hind legs. Plus memories of people's pets, all those Tennessee Williams plays and Gabriel Garcia Marquez novels, and some allusion, somewhere, to "jeweled iguanas." They *do* look jeweled, but not in my scrap. To start, I approximated the general shape.

Putting the lizard together

I wanted the lizard in a neutral color, so I pulled up my tool window, selected a neutral color, selected Shrink Transparent, lassoed the rough shape, typed Command-F for Fill, and continued on (Figure 2). I also selected a smaller brush.

I used the lasso to reposition unwieldy parts of the drawing. Toggling with the Tab key turns any tool into an eyedropper, which can pick up any color so it can be applied with that tool's stroke. Working back and forth with brushes and colors, I worked until it started to look like an iguana (Figure 3).

Then I put the reference materials away and proceeded on my own, backing up the image frequently for insurance. After some more drawing, I masked the rough shape with the Mask Selection Only command from the Mask menu. Then I smeared colors over and around the outline, while the masked portion remained intact. I hit Blend (Command-9) and rubbed the colors back and forth to create texture (the masked outline was not impervious to Blend, so I had to be careful — blends are tricky and can affect even masked colors). I removed the mask and changed the parts that are hard to see by

Figure 2. Shaping the iguana. In order to avoid getting caught in detail before capturing the gesture, broad brushstrokes were used to capture the general shape. The painter's axiom is "Start with a broom and end with a needle."

selecting Fill and tipping the paint can into them. Using Free Rotate from the Selection menu, I repositioned the iguana's front feet slightly (Figure 4).

Up to this point I had stayed in real size. ▌ *For a nightmare, go into close-up before you've "set the bones" of your drawing. It's possible to create the Sistine Chapel in close-up, yet when you come back to real size it looks like a smudge. Stay in real size until you can't anymore.*

Figure 3. Setting the bones. What makes it look like a lizard? It helped to think about real-life iguana experiences — the scuttling way they move, their freeze-frame quality. The bare essentials were drawn in.

Figure 4. Fleshing him out. This is a *big* lizard. Feel the weight, feel the dry cold scales. A fat dot brush was used to flesh him out, establishing the light source and stretching the shape. Using Free Rotate from the Selection menu made it possible to reposition the front right foot.

But, finally, with the Lizard King, it was time to go into close-up and work on details (see page 87). In Studio/8, I prefer the #4 close-up mode. ▌*Zooming in and out is fast and easy with the 1, 2, 4, 6 and 8 keys.*

I antialiased as I went except for the edges; since I was creating clip art, there was no telling how it would be used. It's best to leave the antialiasing of the edges until the piece is in place and you know the background color of the image's final context.

Doing the scales was tedious at first, but after a while I forgot I was there. I was working in close-up mode #4 a great deal at this point, using Blend (Command-9) with a four-pixel square brush. Using two or more colors of the same value makes for a richer, more dimensional tone than using one (Figure 5). Sometimes I find it more comfortable to draw in a different direction. I select the piece, flip it horizontally (Command-H) and draw until I have it. Then I lasso it, flip it back and insert it. At this stage I'd been staring

Figure 5. Creating scales. Because reptiles have scales that grow in a particular way, it was a good idea to have scrap photos and drawings. Using the scrap for reference made it possible to establish the scale pattern and start building scales. For added richness, the surface of his skin was made up of four colors.

at the iguana for so long I couldn't see him anymore, so I selected and flipped him using the lasso and Command-H (Figure 6). Flopping and resizing the rear foot (Command-R) made it easier to redraw it (see page 2).

There weren't any huge proportional problems, although he needed stiffening at the shoulder later. I was still in the scaling mode though; for insurance, I Option-dragged each selection before scaling. ▮ *When you hold down the Option key and then lasso and drag all or part of an image, you actually leave the original image in place and and drag a duplicate. This allows you to experiment without losing the original.*

Up to this point, I had drawn the scales one at a time with a tiny cross-shaped brush. But to rough in the folded skin on the back, I used strokes of color first and then added detail (Figure 7).

To complete the iguana, I filled in the top scales with a gold gradient, blended them using Command-9 and shadowed them with Command-5

Figure 6. Changing perspective. Traditionally, artists used mirrors to see the work from a fresh angle. Using Flip Horizontal made it easier to see what kind of adjustment his back leg needed.

(Darker). To lay in final scales, I created a field of scales, grabbed appropriate shapes with the lasso, dragged them to the correct position and contoured them with Blend 2, Distort and Shear from the Selection menu (Figure 8). A few added splashes of color and my Lizard King was ready to drop into a finished piece.

In retrospect

Most of what I've described as the painting process is barely conscious thought; rather than "Let's see, now it's time to, um, use the Blend command! There! All blended!", it's more like a continuing reaction to the piece as it's created. Most artists understand that a lot of the creative process is about listening to one's own instinct and not worrying about how it's supposed to be done. I know a great deal about drawing and very little about the computer. I admire the computer as a means, rather than an end. My aim is entirely to create art.

There's a belief afoot that the computer produces the art as it produces a straight line, that if my work isn't happening, there's some missing ingredient, some quick-fix magic combination of commands that will somehow make it all right. "Where is the tiger coming from?" asked a kid standing in the Miles booth at Macworld back in 1985, watching me draw a running tiger from scratch on a FatMac. He said after 10 minutes, "What program is that?" I said,

Figure 7. Making him real. Additional colors were used to rough in the dry folds of skin. The scales on the skin could then be altered individually as needed.

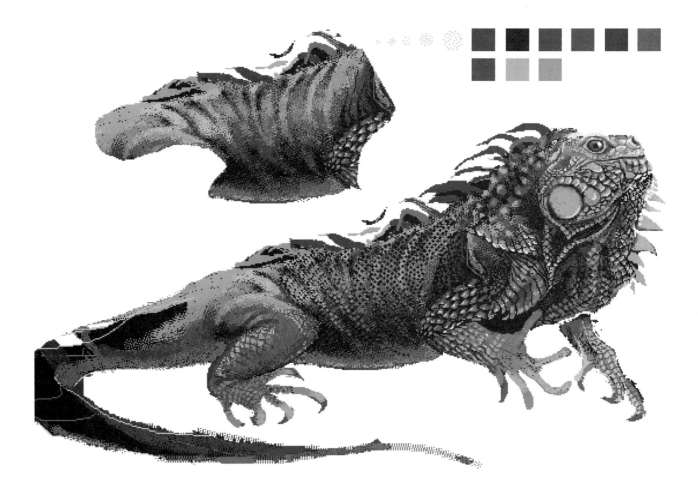

"MacPaint." "But where's the *tiger* coming from?" he asked in genuine bewilderment. "Isn't there a program for drawing the tiger, that you just tell it to and it draws one?" and he wandered away leaving me wondering forever, "Where *does* the tiger come from?" From memory? From ability? Is it mine? Is it Bill Atkinson's? He programmed MacPaint. How about Steve Jobs, who designed the Mac? How about all the people who built it? How about Eadweard Muybridge, whose 1899 motion study of a tiger taught me how a tiger moved. Is *he* responsible for the tiger? Is it from all of us? Is an artist a synthesis of everything he or she has ever felt or seen, like they said back in school? Is this Beginning Theology 101? Is this course required? Hello?

It's 1990, and I still don't know where the darn tiger comes from. But I do know that there's no program that will draw one from scratch, any size or pose or color or style, like I want it, without an artist at the helm. And there's no magic answer for us artists, *except* that we are each unique. We are the only variable. You can have two identical setups — hardware, software, memory, working conditions — and the artists, left to themselves, will create totally different work. So don't be intimidated by brilliant programmers, software publishers, technological wizards and hardware junkies. And if they sneer at your lack of computer expertise, ask 'em why they never bothered to learn to draw. We are none of us much without the others.

Figure 8. Speed scaling. Creating patches of scaled skin and wrapping them around the figure helped speed up the process of covering the image with scales. For a jeweled effect, a few points of light were added to individual scales. The file was too narrow to accomodate the complete iguana, so a portion of the tail was completed above the image and saved there for when it's needed.

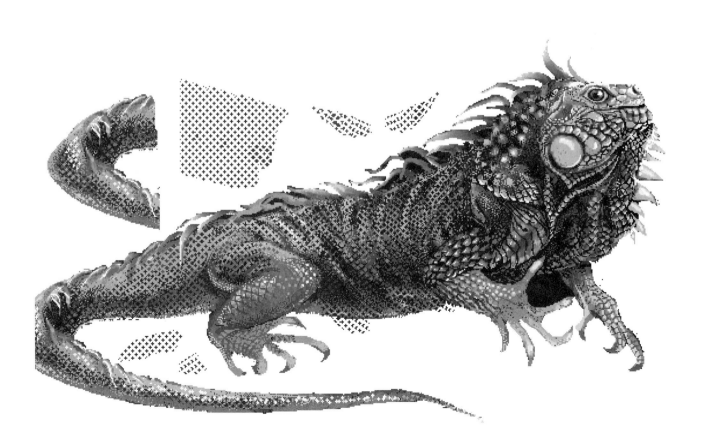

PORTFOLIO

Trici Venola

"When I started on the Mac in 1985 I didn't understand the lingo enough to benefit from any of the manuals, so my knowledge is entirely empirical. I learned how to use the computer in a rage of frustrated ability. This rage was my driving force and it pushed me so hard that I found, to my surprise, that my work had made a name for itself. So I want to encourage readers to concentrate on their art ability. If you get excited about the piece, you'll find a way to claw it out of the medium.

"There's one rule I've discovered about computer art: What's hard by hand is easy on the computer; what's hard on the computer is easy by hand. A gradient fill is difficult even with a good airbrush; it's relatively simple on the computer. But just try a quick sketch!"

The idea for **Some Tomato** came from the art director at BBDO, the advertising agency creating the "Change of Heart" TV spot for Apple Computer. The image, which was shown on TV as a screen shot, was created in Studio/8 on a Mac II with 8-bit color, 8 MB of RAM and an Inter 90 hard drive.

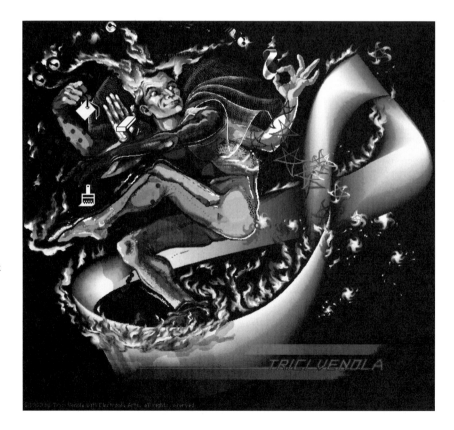

Dancing Fool, my first effort in Studio/8, earned me an invitation from Electronic Arts to demonstrate the program at a MacWorld Expo. Created on a Mac II with 2 MB of RAM, the image was modeled after my husband, the god Siva and a medieval joker, and was later used in a poster.

Bob Dylan is an image from the People, Places and Things category of the Mac the Knife Volume 5 clip art package I designed for Miles Computing, Inc. It was done on a Mac II in SuperPaint, my favorite black-and-white drawing program, and created with a mouse as the only input device, using many photographs for reference.

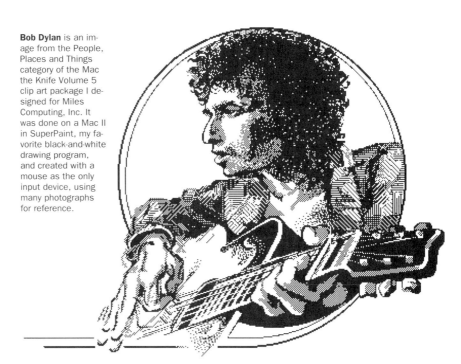

Sea of Krishnas with Jim shows the Lizard King in his element, as part of a clip art series I'm creating called "Brazen Images." The entire painting was drawn by hand. Each element was created separately, and then they were assembled in a Studio/8 file. The Krishnas were done by creating one image, copying it and using the Fill Perspective Plane command to make them into an ocean — the rest was all cut and paste. Once the Lizard King was dropped in, I used the Mask command to wrap his tail around the feet of Botticelli's Venus. The triangular patterns, Egytian dancers and heads were all done in MacDraw II with just eight colors, and were captured using the ColorCam function in Studio/8.

CHAPTER 8

The Subway Inn

Artist

Illustrator-designer Bert Monroy has worked in advertising for 20 years, first for several large agencies and more recently as owner of his own shop. He is also a principal of Incredible Interactivity, a firm specializing in the production of interactive and multimedia presentations. In 1984, Bert produced HumanForms, one of the first graphics packages for the Macintosh. HumanForms is a collection of over a thousand body parts that, when assembled, can create human figures in any possible position.

Monroy's illustrations have been published in *MacWorld, MacUser, MacWeek, Personal Publishing, Verbum* and *Byte*. His images have also been used to advertise several major graphics software programs, including ImageStudio and PixelPaint. Bert currently serves as a consultant to various advertising agencies, as well as major

financial institutions in the New York area. He is also on the faculty of both the School of Visual Arts and the Dynamic Graphics Educational Foundation.

Project

This project was done for no other reason than fun and relaxation. Commercial value was not a motivation, although the image has been used in several magazine articles to demonstrate the capabilities of paint programs.

The equipment used to create this image was a Macintosh II with 8 MB of RAM.

The software was a potpourri of different packages. PixelPaint was the "native" program used. LetraStudio was used to create the type on the signs. It was necessary to skew the type to achieve the right perspective. Skewing type in bitmapped programs like PixelPaint tends to break up the letters, but using LetraStudio solved this. Adobe Illustrator was used to create the "Subway Inn" sign because of its Bezier curves. An early version of Photoshop was used for its advanced airbrushing capabilities. The final image was output on a Montage film recorder.

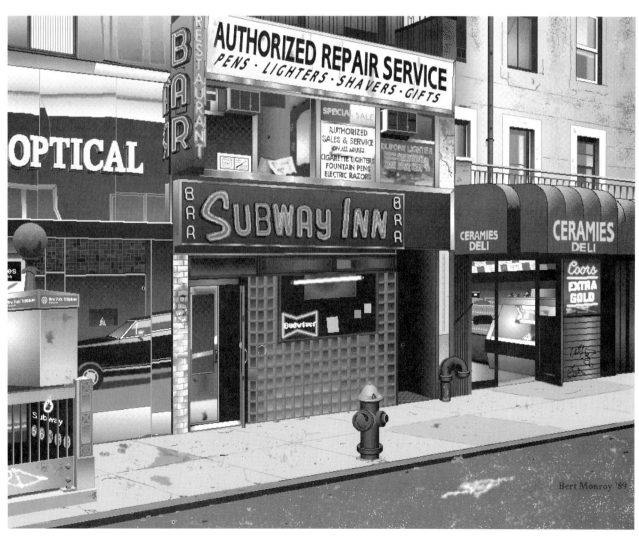

PROJECT OVERVIEW

The subject

I love street scenes. I'm a native New Yorker, and the streets have been my stomping grounds ever since I could walk. I consider myself a photorealist. I find great pleasure and challenge in re-creating life with all of its intricacies. Whether the scenes are real or imagined, they are filled with details that normally would be overlooked but are crucial to the "soul" of the overall image.

The image in "Subway Inn" is a real place in New York City. The dirt and grime are there; could it be real without them? The cracks and wear on the stones are also there; they are the emotional life, joy and pain of the city. As a photorealist, I feel my greatest tool is the power of observation. I must be able to see every detail in order to capture the true essence of the scene.

The Subway Inn has a special meaning to me. It's a place where an old friend and I spent much time unwinding many years ago. Unlike its neighbors, the Subway Inn has weathered the ravages of time, staying intact both outside and in. Inside, you seem to be caught in a time warp — even the faces look the same as they used to.

The medium

Many people have asked me why I don't just scan in a photograph. First of all, I'm not a photographer. But I do shoot various photos of my subjects from different angles. These photos are then used as reference. Close-ups are shot to study details.

I edit the photos to determine which of the shots will give me the best angle for the illustration. That shot from which I'll create the painting is taped to the edge of my monitor. Sure, I could scan in that photo, but my pleasure derives from the challenge of capturing the image by hand. Another factor is that I add little touches of my own — clearer skies, or other details I feel are necessary to enhance the total image.

It takes many hours of work to complete a project. This particular illustration took 26; it was left off and picked up again several different times. Each new step was saved as a different file with notations of .02, .03 and so on. This numbering helps to keep track of the work involved and to document the process. On the facing page are three of the steps in the production of "Subway Inn."

Version .02 shows the perspective lines drawn in and colors created for the Subway Inn sign and the neighboring awning.

PixelPaint's Pantone color selector window came in handy for choosing tones out of a visible range of colors for the various surfaces in the Subway Inn. It allows you to scroll through the entire color swatch book by simply passing the cursor over the multitoned bar below the swatch page. Clicking the edges of the swatch page, which seem to be pages behind it, will allow you to flip from page to page. The seven boxes to the left of the swatch page are used to store various colors before making a final selection.

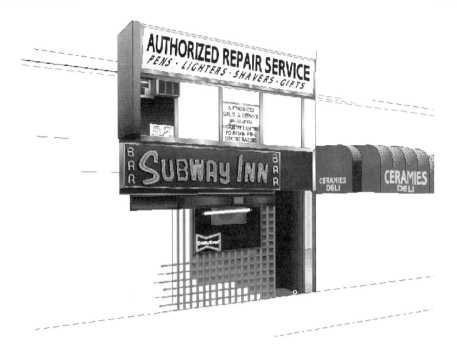

Version .05 shows development of the glass bricks, as well as the addition of skewed text for the signs and various gradated surfaces.

Version .08 shows still more development.

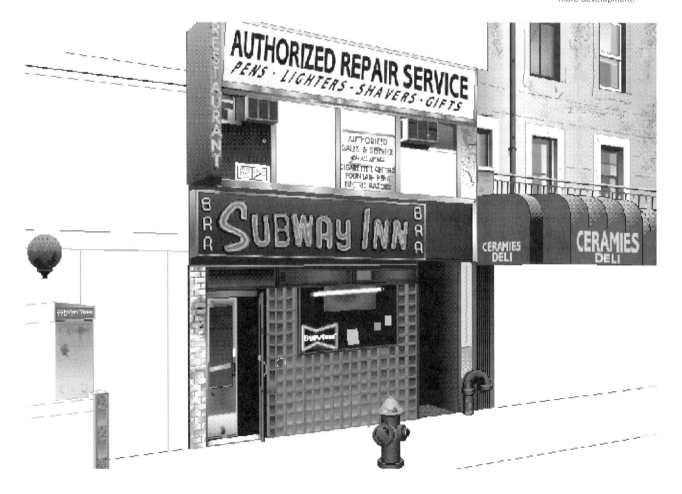

With the model photo chosen, the first task was to create the basic shapes and perspective. An artist with a canvas and oils would use a charcoal to trace out these angles and shapes. Working on the computer, I selected the pencil tool and a light gray tone. The viewing angle I chose was from the corner of the street. This is a very busy corner in New York. Bloomingdale's and a subway station are on the corner, and most people see the Subway Inn from there when passing.

Only one-point perspective was needed, since only the face of the street is within the frame and not the avenue that crosses it. I drew lines to follow the perspective, using an off-screen point of reference as a vanishing point. In this case, I used the tip of a shade's pull cord on the window beside my computer table. I drew lines on the screen that would run across the screen and visually converge on the pull-cord tip (Figure 1). These lines made up the sidewalks, tops and bottoms of the windows, signs, tops of the buildings and so on.

The need for gradients

The next element to add was the vertical lines. These lines would give final shape to all the main elements. The addition of the vertical lines also closed off the shapes, making it possible to pour gradient color fills with the paint bucket into segregated areas.

There are no solid-color areas in real life; everything we see is gradated due to the fact that light hits an object from different angles and distances. In some cases the gradient value might not be discernible to the naked eye, but it's there. For this reason I introduce a gradient, no matter how slight, into every fill. The use of gradient fills adds depth and realism to any image.

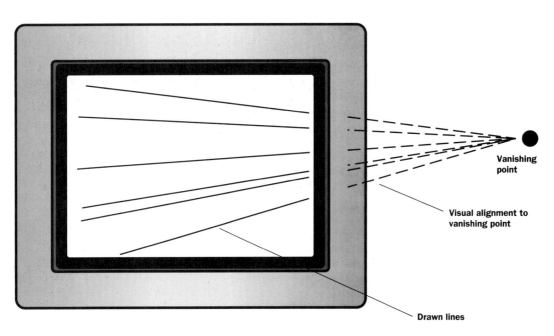

Vanishing point

Visual alignment to vanishing point

Drawn lines

Figure 1. Working with a vanishing point. As in all illustrations that require perspective, a vanishing point was established. Since the image would take up the entire screen, the vanishing point had to be established off-screen. Visually, all lines extend to the vanishing point. Starting at the same side as the point, each line was drawn to the other side of the screen. Before the line was released, it could be moved around so it was set to follow a straight line to the vanishing point.

With gradients in mind, I created my palette. Using the photos as reference, I modified the palette to accommodate the colors needed. The PixelPaint color palette can be modified in many different ways. My two favorites are the Pantone color selector and the standard Apple color wheel (Figure 2).

I chose the darkest tone based on the blue background of the Subway Inn sign. A few cells across from it in PixelPaint's Custom palette, I chose the lightest tone. Then by selecting one color and dragging it to the other and clicking the Blend button, the first gradient was created of tones in between the two tones (Figure 3).

Figure 2. Modifying a color palette. The Apple color wheel is one way to modify a color palette in Pixel-Paint. You can specify a color by reposition-ing the cursor in the color wheel or by en-tering numbers in the boxes. Further adjust-ment can be made by using the slider bar.

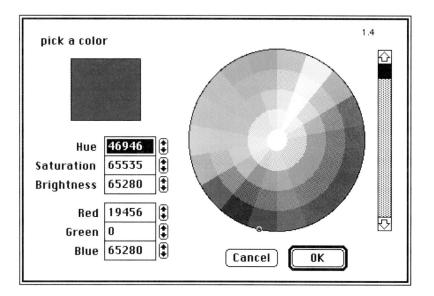

Figure 3. Creating gradients. In Pixel-Paint's Foreground Color window the 256 available colors are displayed. To create a gradient a starting and ending color were chosen and placed, leaving some cells be-tween them un-touched. Clicking on the starting color and dragging it over to the ending color selected these colors plus the cells in between. Pressing the Blend button then produced the gradient.

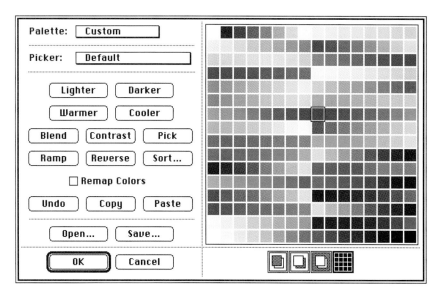

Double-clicking on the bucket tool brought up the Fill Effects window. Here I selected the type and direction of the fill (Figure 4). Then I clicked inside the sign area and the blue gradient filled it. I followed this same procedure for all the shapes throughout. In some places, a solid area might require two separate fills. For example, the metal door to the bar has a reflection of the sidewalk and street in it. The door section was split into the two areas and a fill was applied to each. All these fills, though gradient, appeared flat at this point. Texture and detail were added later. ∎ *If Window or Canvas is chosen in the Respect To list, any object drawn over a gradient background will be filled with the part of the gradient that the object is placed over. This makes it possible, for example, to draw a "hole" in a foreground object that lets the background show through.*

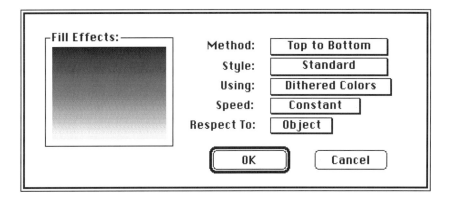

Figure 4. **Customizing fills.** The type of fill was selected in the Fill Effects window. The box showed the current effect. Method indicates the direction, in this case Top to Bottom. Style and Using controlled the way the color cycle would be laid down. Speed controlled the way starting and ending colors related to each other. Respect To determine whether the fill would affect an object in relation to itself, the window, or the canvas, which is the total working area. Some areas of "Subway Inn," such as the metal door of the bar, required two fills.

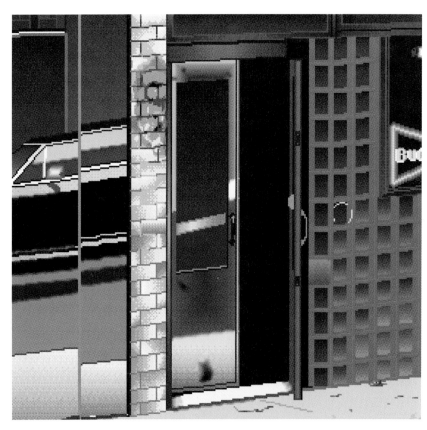

Achieving custom shapes and type

Next the neon of the Subway Inn sign was created. The tools in PixelPaint are excellent, but certain techniques are better achieved elsewhere. Bezier curves would make the sign easier to draw and more accurate. For this I turned to Adobe Illustrator 88, which allowed me to bend lines to get the desired shape of the stylized sign. The BAR and RESTAURANT neons were also done in Illustrator. Once they were finished, a screen dump was made with the art in Artwork Only mode (Figure 5). Artwork Only yields a line with single-pixel weight; since the outline was only for shape, that was perfect. No color was needed; the lettering would be colored in PixelPaint.

Figure 5. Making smooth lines. The Subway Inn sign required smooth curved lines. The pencil and paintbrush tools that create these types of lines in PixelPaint require the user to have a very steady hand. Illustrator has control over Bezier curves, thus making this procedure easier. The lettering was screen-dumped in Artwork Only mode and colored in Pixel-Paint.

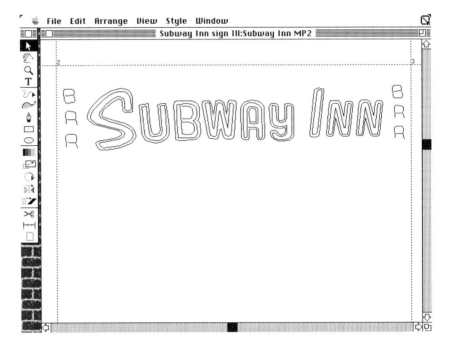

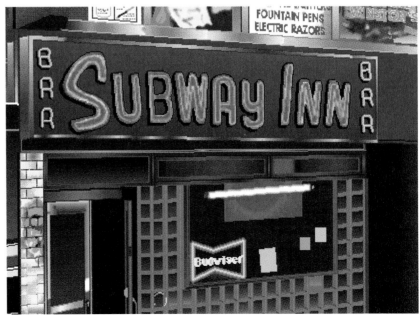

The sign for Authorized Repair Service that appears at the top of the Subway Inn building was a standard painted sign. All that was needed to create this sign was typing with a matching font. The sign, however, follows the perspective. One possibility was to create the type, then select it with the marquee tool and distort it to achieve the desired shape. A disturbing problem with this method is that skewing in a bitmapped paint program causes the pixel placement to be distorted (Figure 6). The sign was such an important part of the image that such a distortion would have detracted from the image overall. To avoid this problem I turned to yet another program: LetraStudio from Letraset. LetraStudio lets you modify type with a wide variety of effects.

With the image still in PixelPaint, I cut a square piece of acetate and taped it to the screen. With a crayon, I traced the area of the sign. Switching to LetraStudio, I then placed the acetate over the working area of the window. I typed the sign wordage and, using one of the distortion envelopes, skewed the type to fit the sign shape.

The Preferences menu offers a number of viewing options. I used High Resolution, which lets you view the type with antialiasing. This means the edges are blurred or blended into the background color, giving the eye the illusion that the type is clean and smooth, not stairstepped as is usual on a monitor. With the type in High Resolution mode, I made a screen dump to a PICT file (Figure 7). After opening the screen dump in PixelPaint, I selected the type with the lasso and copied it to the clipboard. Back in the Subway Inn file, I pasted the type into the appropriate area of the sign.

Figure 6. Distorting the image. Any distortion applied to text in a bitmapped paint program tends to break up the type, giving an overly pixelized effect.

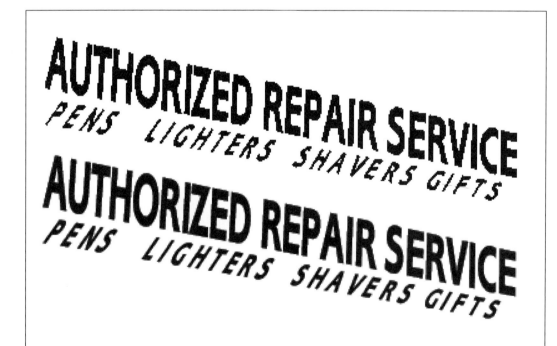

Figure 7. Distorting type. LetraStudio has the ability to distort type in a variety of ways. It also has an antialiased mode that makes the type appear smooth on the screen. The difference between the normal and antialiased modes is shown here. The type, in antialiased mode, was screen-dumped to a PICT file and copied into the artwork.

Adding the gritty details

With all the tones and lettering on the signs in place, weathering was the next task on the agenda, to give the street and buildings that aged, lived-in look. Cracks were made using the line tool. In Special Effects mode, the line tool has a Fractal line choice. The fractality of the line can be set to vary the randomness (Figure 8). This tool comes in handy for lightning, for tree branches or any time a jagged line is needed. With the setting for a rough line and the color of the particular wall or sidewalk section selected, I drew lines that the program turned into cracks.

Texture was added with the airbrush. Using values darker than those covering a wall overall, a fine spray was applied, leaving behind a light texture. Using a paint brush in Smooth mode, some of the texture and outline areas were softened to take away that bitmapped, hard-edged quality.

Figure 8. Creating fractal lines. With PixelPaint's line tool in Special Effects mode, Fractal Line is an option. In the Set Fractality window, the randomness of the line was established. The higher the number, the more jagged the line. This made cracks a snap.

The glass bricks that adorn the front of the bar were no easy task because there were so many of them. First the blue grout was done with vertical lines. The horizontal lines had to follow the perspective of the street, so they were done using the same procedure as the other perspective lines (refer to page 102). Next gradient fills — different shades for different bricks — had to be laid down. Using the bucket with a Top To Bottom fill effect, I filled each brick individually, lightening the values of the grays as the bricks got closer to the sidewalk (Figure 9). Each of the bricks that reflected the sidewalk also had value changes in it.

The fire hydrant was fairly simple to create. The gray tones were chosen and a Dual Blend was selected as a fill effect (Figure 10). Dual Blend splits a fill into a mirror of itself. In other words, a dark tone blends to a light one and then back again to the dark. Using the rectangle tool with this fill effect, I created a cylinder. The top and valves were drawn with the circle tool.

The final touches were the graffiti and dirt. The grime that appears on the large white sign and the graffiti required a smooth airbrush. At the time, I had just received an early version of BarneyScan XP, which has gone through considerable changes and is now published by Adobe as Photoshop. This program has the ability to open PICT files, so the PixelPaint file was saved as PICT and reopened in XP. In BarneyScan XP there was an airbrush that laid down a smooth tone unlike the pixelized tone of the other paint programs' airbrushes. With this airbrush, I laid down the tones of the grime and graffiti (Figure 11).

Figure 9. This close-up of the glass brick detail in progress shows how a gradient fill was applied to each brick individually. As the bricks got closer to the ground, they got a lighter fill since they picked up a reflection from the sidewalk.

Figure 10. Building the fire hydrant. PixelPaint's Dual Blend effect was used to create a "cylinder" look for the rectangle that makes up the main body of the fire hydrant.

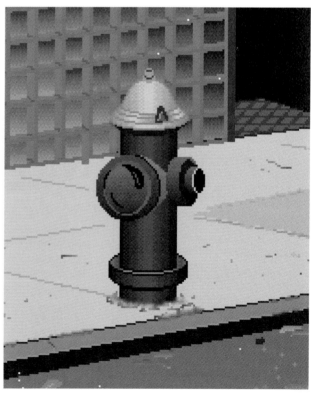

In retrospect

When I created this image, I was pushing existing technology to its limits. The image took a total of 26 hours to complete. Today, the programs have come light years ahead. Now there are 24-bit video boards, 32-bit QuickDraw and software that addresses this added power. The limit of 256 colors has been replaced with over 16 million. The scenes I create now take about the same amount of time, but the detail and realism are far greater. The diagonal lines that make up the shapes of the structures, signs and the like no longer have those jaggies synonymous with computer imagery. Gradients of color are much smoother. To a photorealist, the limitations have for the most part disappeared.

I still create street scenes, but today I can do them totally within one program — Photoshop. One of my hopes in creating such complex images is to demonstrate the capabilities of the computer, thus inspiring other artists to embrace the computer as a medium.

Figure 11. Adding grime. The smooth airbrush feature of an early version of Photoshop was used to add the appearance of dirt to the white sign.

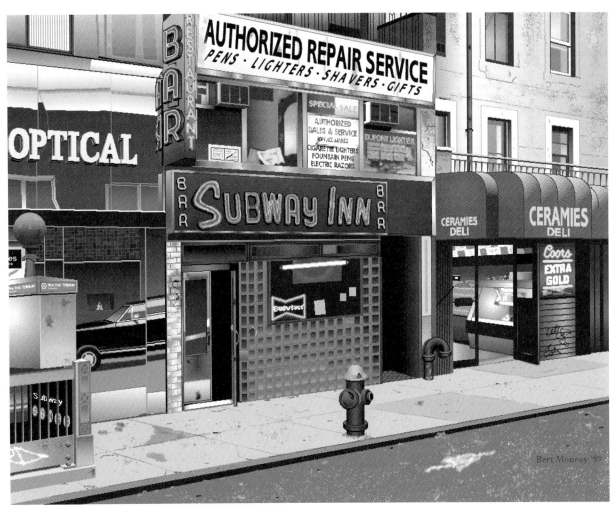

PORTFOLIO

Bert Monroy

"Many people have asked me why I spend so much time in front of my computer. Do people ask the same of painters and their canvas, or sculptors and their clay? The computer has become such an integral part of the average person's workday or work experience that it's equated with work. To the techno-artist, the computer is the medium. Hours spent in front of the computer are filled with passion and creative fulfillment.

"Just like other media, the computer allows for many different styles. There are programs to suit everyone's taste. The paint programs are so chockful of special effects that any artist can emulate any style already mastered with traditional methods. The computer provides the artist with a completely equipped studio in one box. An airbrush, paint brushes of any size or shape, pencils, tone sheets, charcoals, templates, colors beyond imagination and much more. The only thing missing is the imagination and skill. In the hands of an artist, the computer opens many doors."

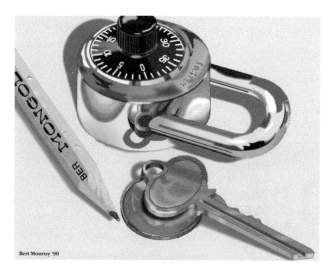

Lock was painted in Photoshop. Like "Objects on Cloth," it's a study of reflections and textures, playing the reflections of the various metal objects off one another.

Objects on Cloth, a study of light and reflections, was painted in Photoshop with the objects set up right next to the computer — basically, it's a digital still life.

Sam's was painted in Photoshop from photo studies with the same techniques used for the "Subway Inn" painting.

Guild 45th was painted in Photoshop from a photograph taken at night. It's an experiment with lights in dark areas, trying to create a feeling of luminosity in a night scene.

C H A P T E R 9

Regina's Rose

Artist

Michael Scaramozzino created his first computer graphics in 1981 with "ArtSketch," a program he wrote while studying computer science at the University of California, San Diego. He earned a Bachelor of Fine Arts in illustration from Rhode Island School of Design and became director of their newly founded Academic Computer Center. He served as vice president of software development for a computer consulting company before founding DreamLight, Incorporated in 1986 in Providence, Rhode Island. DreamLight is an exclusively digital design, illustration and animation studio whose commercial focus is on corporate identity and logo design, illustration ranging from simple black-and-white line drawing to full-color photo-realistic rendering, and computer visual interface design. One of DreamLight's main objectives is to help establish computer graphics as a valid artistic medium. One means of accomplishing this is by marketing high-quality prints of many of the studio's works.

Project

Since most of our design and illustration is done in PostScript, which is very precise but not very spontaneous, we find it necessary to loosen up periodically. Our favorite medium for this is bitmapped painting. Rather than having to plan out an illustration logically and then construct it with an object-oriented program, we can simply let go and paint freely. So sometimes at the studio, if we've been spending quite a bit of time using one type of software or style, we switch to another and create an image for its own sake. This constant exploration of different aspects of the digital media helps keep us from falling into a rut and becoming locked into any one particular look or style. It also helps keep our creativity flowing by allowing the artist to develop an image without any client or production restraints. When the results from these ex-

plorations are interesting enough, we use them as promotional pieces for the studio. "Regina's Rose" is such a painting.

This particular work was done on the studio's Tech Graphics-II color paint system. It's an IBM PC/AT Clone with an 8-bit Imagraph board, a 19-inch RGB Mitsubishi monitor, a 40 MB hard disk, a Summa-Sketch tablet, and New England Technology Group's TG-II software. The image was then photographed directly off the screen with a Nikon 35mm camera. In creating "Regina's Rose" I used techniques and principles that can be applied in any 8-bit paint system. For example, we've begun doing similar work on the Mac with Pixel-Paint Professional. One of the Mac's biggest advantages is its ability to combine the output of many programs into a single project, along with the easy access to Post-Script typesetting and output.

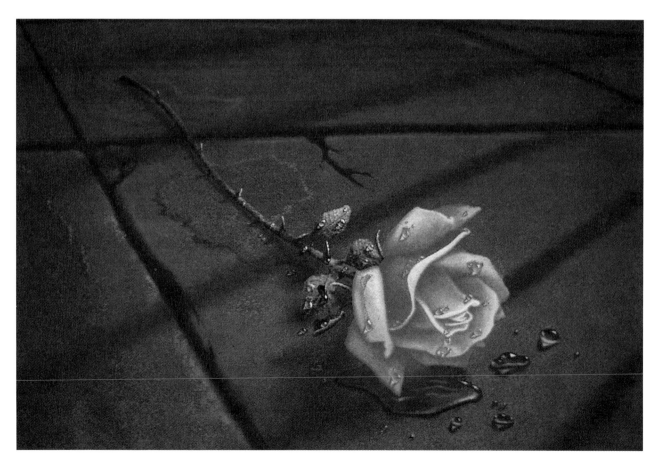

Background

Sometimes after doing quite a few logo design or product illustration jobs that are more analytically than emotionally creative, I need to let loose and do something more from the heart. Over a period of three months I had this image forming in my mind. Once it had crystallized, it took only about 15 hours to paint — over a couple of weekends.

Symbology of the painting

Some time ago I had produced fantasy illustrations for fairy tales in watercolor and oils. I wanted to show that I could do a similar kind of illustration in our new digital

medium. I decided to create a painting as if it were an end-piece to a fairy tale using much of the flavor and symbology of the genre. "Regina's Rose" is a fantasy illustration of a shattered romance and unfulfilled love. The pink rose represents the innocent blossoming of the romance — soon to wither and fade, as it's been carelessly removed from the water of life and left exposed. The flower has a warm glow from the love within that fights a brief, fierce battle with the icy brilliance of the moonlight flooding the scene from the outside. The cold, hard floor is an ancient and worn foundation that has been cracked but remains unbroken and unwilling to support

the growth of the rose. The cracks in the floor symbolize the rose's attempt to break through and the broken heart that resulted. Along the stem and leaves of the rose, the perspiration of the battle can be seen, as well as the thorn that drew three drops of blood from the one who offered it. The rose now lies dying in a pool of tears that reflect on both the cold moonlight and the warm rose. The shadows of the bars falling across the scene hint at the unspoken elements that prevented the rose from releasing the other's love. The rose, however, refuses to be embittered and so no shadow obscures it — even in the end.

a

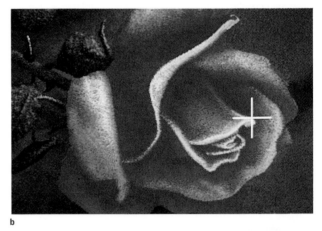

b

c

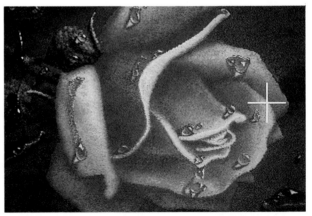

d

The rose began as a red and pink form (a). The color map was adjusted to give the rose a softer look (b). Drops of water were added (c), and finally secondary colors were introduced to create subtle color changes (d).

Just as an artist using traditional media sets up a color palette before beginning to paint, it's important to preset the color palette within the computer. The color map for "Regina's Rose" is read from left to right and top to bottom.

• In this system the first eight colors are reserved by the system for drawing controls on the screen and should not be used in the image because you're not allowed to change them.

• The rest of the top three rows, used for the background's stone floor colors, "ramp" or wash between a deep blue and a light blue.

• Rows four and five consist of the primary rose wash, from a deep, cool purple through a warm pink to a cool light pink.

• The sixth row consists of the secondary rose wash; the colors are very similar to row five, but a little cooler for some visual variety.

• On row seven we have four short washes. The first is from deep blue to deep red, which will be used for the blood on the stone floor. The sec-

ond is a light blue to light pink wash used for the rose reflections in the water drops. The third wash, from deep green to deep pink, is for the reflected rose light that falls on the leaves. The fourth wash on row seven is the deep red to light pink used for the three drops of blood.

• The eighth and final row consists of the primary and secondary green washes for the stem and leaves. At the bottom of the screen are the color map editing tools.

O nce I had the general theme and image for my painting in mind, I made a trip to the Rhode Island School of Design clipping room to gather some source material. Although I knew what I wanted to paint, I still needed some reference materials to help me visualize the details. I found some photos that were exactly what I needed; roses for their structure, flowers that had particularly interesting lighting, and stone floors found in ancient castles. Armed with these materials I returned to the studio and began work.

Initial sketches

When I work on a digital painting, as opposed to a digital drawing, I prefer to work in the dark. With the studio lights out, I can see the colors on the screen much more accurately and become absorbed in the painting more directly. I keep one desk lamp on so I can also see my source material as I paint. The source material in this case was used for reference only. Nothing was scanned or traced and I did not make any pencil sketches first. I prefer to paint by hand on the tablet and spontaneously work and rework the painting directly in the computer, taking advantage of the medium's inherent flexibility.

Working with the color map

The first step in making any 8-bit image should be setting up your color map (or palette) (see "8-bit color systems" on page 124). Although 256 colors may sound like a lot, that includes all shades and variations of every color you want to use, so if you don't think about the map first you're likely to run into a dead end. At this stage it's not necessary to determine exactly what every color will look like — I changed the colors in the rose quite a bit as the project progressed. What *is* important is to allocate space in the map for different parts of the image (see pages 114 and 115). Most of the map was taken up by the shades for the background and the rose itself. The water, stem and leaves used up very little room. I made sure to allocate enough room for what I call secondary color washes. ▪ *Many 8-bit images suffer from a plastic look that comes from working with monochromatic ranges of color. To avoid this problem, set aside secondary color washes and spray-tint them onto the image when it is finished.*

Perspective grid

With the colors established, I worked on setting up the perspective of the scene. The TG-II system has a Perspective Grids function that's ideal for what I needed. Using the keyboard, I could tilt, swivel and rotate the camera's viewpoint until it was just right. I then set the size of the blocks that I wanted and saved the 3D view as a 2D image to use as a template for the painting (Figure 1). ▪ *The same process could be accomplished with any of the 3D programs available for the Macintosh, saved as either a PICT or a bitmap and used similarly.*

Figure 1. Setting the perspective grid. The TG-II's Perspective Grids function was used to set up the exact perspective for the stone floor. When the 3D view looked right, it was saved as a 2D view and used as a template for drawing the floor.

Beginning the painting

I started with the background and worked forward. The background was painted by first pouring a middle blue from the background section of the color map into all the squares created by the perspective program. I then used a feature of the paint program called Average, with the airbrush turned on. This allowed me to take a lighter shade of blue and pull the highlights out. Then, taking a darker blue I could work the shadows in. The process is very similar to painting with oils, working other colors into the paint that's already on the canvas (Figure 2). Since the system relies on the color map, the Average feature doesn't really average the colors on the painting — that's not possible. What really happens is that other colors from the map are applied to the image. For instance, when I took the light blue and made an averaged brush stroke on the middle blue, what really happened was that the area under the brush changed to the next color on the map in the direction of the light blue that I had on my brush (see page 115). Each time I made another stroke, the area under the brush took another step toward the color on the brush. When the colors are laid out appropriately on the map, this process gives the visual illusion of mixing the colors on the painting. This is one reason it's so important to lay out the map beforehand. ▍ *With the newer 24-bit systems, the map is discarded and the colors can actually be mixed directly from the information in the image because each pixel holds its own color information.*

The shadows falling across the scene are painted the same way — by taking dark blue and averaging it into the image in broad airbrushed strokes across the entire background. To increase the dynamics of the relatively calm scene and to bring the eye back to the center of the image, I made the shadows fall diagonally opposite to the perspective of the floor.

Figure 2. Painting the background. The background was painted over the perspective wire frame that was generated with the grid function. First, a middle blue was poured into all the squares. With the paint program's Average and airbrush features, light and dark blues were worked into the middle blue, much as would be done with oils.

I zoomed in on the image to work on the details (Figure 3). To give the effect of a rough stone surface, I turned the Average feature off, set the air-brush to wide and painted thin layers of lights and darks over the entire back-ground. This gave a much rougher texture than using Average (Figure 4).

At this point I sketched in the stem with a middle green and the rose with a middle pink. Then the basic structure of the rose was worked in the same way the background was painted, with one addition. I used the airbrush and Average features as before, but this time I also used a masking function called Sticky Colors. I told the computer that the only colors I wanted to be affected by my brush strokes were the colors in the pink wash in the map set aside for the rose. This way I couldn't accidentally paint on the background or the stem. I used the photos of the roses as a guide as I roughed in the flower's structure (Figure 5).

Figure 3. Keeping it loose. This crack in the floor was painted to suggest an in-verted broken heart. The stray pixels and broad brush strokes added to the "loose," painted effect.

Figure 4. Roughen-ing the stone. The airbrush was used to paint the worn sur-face of the stones and to give the edges a broken look. The Average function was turned off to en-hance the roughened effect.

At this point I thought the flower was too red and heavy looking — I wanted it to look soft, luminous and light. I went back to the color map and edited the rose's colors a bit. I added some white and then cooled it down a bit with a touch of blue. As the colors in the map were changed, the computer changed the colors in the painting to match. I zoomed in and continued to work on the rose area. I then reset the Sticky Colors to mask out the rose and back-ground colors, allowing me to work freely on the stem and leaves. Once again I reset the Sticky Colors — this time to mask out the rose and stem colors. Now I could use the airbrush and Average to paint the deep blue shadow beneath the rose without worrying about messing up the rose or stem (Figure 6). At this stage, most of the modeling of the shapes was complete but a plastic, "computerized" feeling was evident, since each part was made of a single monochrome wash of color — a problem that would be corrected later.

Figure 5. Masking. The stem and leaves were roughed in with a solid middle green, and the rose's shape was painted with a solid middle pink. Once the rose's basic silhouette was down, the airbrush, Average and Sticky Colors features allowed me to mask out the entire image except for the pink range of the rose and to freely work on the structure of the flower in the same way the background had been painted, without worrying about stray brush strokes affecting the background or stem colors.

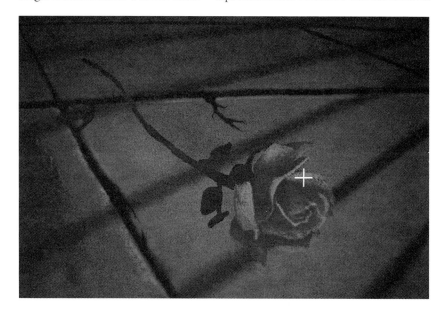

Figure 6. Changing the color map. The color map was adjusted to give the rose a softer, lighter look. A shadow was painted under the rose by using the Sticky Colors feature to mask the rose itself.

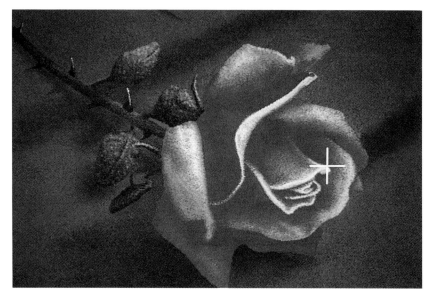

Adding reflections

Next I wanted to add the pool of tears on the floor around the rose. I filled a cup with water and sprinkled some drops on the table next to me. I shined the desk lamp on the water drops to use as models as I painted this portion. The water drops were painted with the same colors and in the same way that I had pulled the highlights out of the stone floor itself — with the Average feature. I simply zoomed in and used a much smaller solid brush rather than the airbrush to produce sharper-edged shapes and to push and pull sharp highlights and shadows out of the drops. Once the drops were painted, the stone floor modeling was complete and ready to receive a tint to help remove some of the plastic look (Figure 7). I took a broad airbrush and applied a thin tint of pink over the area around the rose. This produced the effect of light reflected from the rose onto the stone floor. When painting some of the smaller drops, I had used a brush that was only one pixel in size, giving me amazing control over the small details (Figure 8).

I then used the same method to pull water drops out of the rose itself. I first sprinkled some water on a fine-toothed paper and tilted it into various positions to study how the drops reflected the light in various shapes and angles. Painting the water drops on the rose was one of the most enjoyable parts of producing this image.

I zoomed in and used a one-pixel brush to work on the drops (Figure 9). I experimented quite a bit, really taking advantage of the computer's flexibility. I would paint a drop, and then if I didn't really like it, simply wipe it away. I did so by using a feature called Image Brush, which is similar to using a rubber stamp. Using the Image Brush and Average together, I was able to blend the surrounding part of the rose right back over the water drop, thereby making it vanish. Then I would try again until I was satisfied with the way the drops looked. By using the same Image Brush without Average turned on I

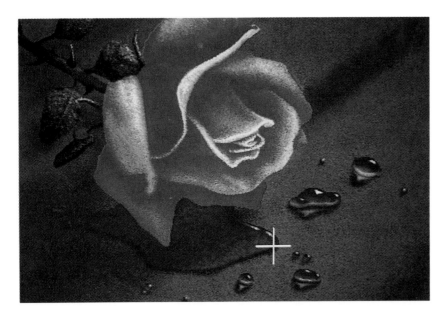

Figure 7. Putting water drops on the floor. A small solid brush and the Average feature were used to pull water drops right out of the stone floor. The water has no color of its own. It was painted simply as sharp highlights and shadows on the stone surface with colors from the stones' own color range. Once the drops were done, the structure of the floor was complete, and a thin airbrushing of pink was applied onto the area immediately around the rose to help break up the isolated, plastic feeling of the monochrome washes.

could pick up a finished water drop, copy it to another part of the rose and then rework it a bit.

Next I painted a dark blue from the second range of colors on row seven of the color map into the small puddle under the rose. This allowed me to use the airbrush and Average features to pull the reflections of the rose out of the puddle. By using this blue-to-pink range on the map, I was able to make the pink reflections seem to fade right into the water (Figure 10).

Next I reset the Sticky Colors to work only on the greens of the stem area and pulled water drops out of the leaves and stem. I also decided to change the color of the rose again, making it even more luminous, so I edited the color map as I had done before. At this point I added the three drops of blood to the stem, leaf and floor (Figure 11). (These I painted strictly from my

Figure 8. Working at high magnification. Some of the smaller drops were painted with a brush that was only one pixel wide. This control over the small details helped add to the realism of the overall image. The pink that was applied to help break up the monochromatic colors of the stone floor shows here as single stray pixels.

Figure 9. Painting drops on the rose. As with the drops on the stone floor, most of the drops on the rose itself were painted by zooming way in and using a one-pixel solid brush with the Average feature to get very fine, sharp highlights and shadows. Pink reflections were "pulled" out of the puddle on the floor.

imagination, as I didn't really feel like drawing any actual blood.) I find that most people don't even notice the blood in the scene unless it's pointed out to them or they view the image more than once. I always like to include in my illustrations elements that are subtle but significant. That way, the more one studies the image, the more he or she will get from it, since many of the details are overlooked the first time it's viewed. Other meanings come out of the work only after the image becomes familiar. The significance of the entire painting changes when the viewer first sees the blood on that sharp thorn (Figure 12). I decided to put a drop of blood immediately adjacent to a drop of water on the leaf so I could contrast the ways the two different substances reflect the light that falls on them and make the blood a bit easier to recognize (Figure 13).

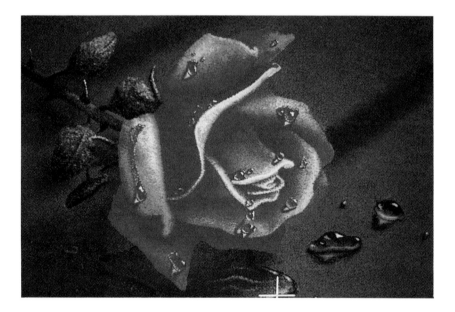

Figure 10. Reflecting the rose. The range of colors from blue to pink on the color map was used to paint a reflection of the rose in the puddle beneath it and to have the reflection fade away into the water.

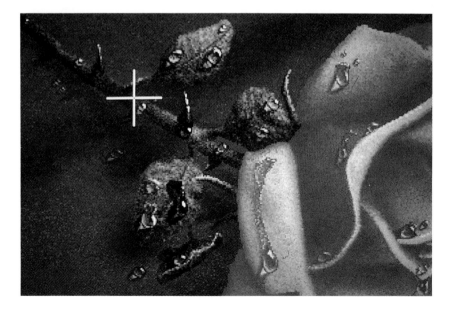

Figure 11. Adding drops of blood. The Sticky Colors were reset to affect only the green stem colors, and more water drops were pulled out of the stem and leaves using the same technique as before. Then the three drops of blood were added to the stem and leaves by first painting the silhouette of each drop in solid middle red and then averaging highlights and shadows out of the silhouette.

Adding secondary colors

For the final step, I added the secondary colors to both the stem and the flower. The color differences are very subtle: The secondary colors of the stem are a bit more on the warm yellow side, and the secondary colors of the rose are slightly cooler than the rest of the rose (Figure 14). To apply these colors to the rose and stem, I set the Sticky Colors to work on the rose alone, turned on the airbrush and set up tint parameters. Tinting with this system gives the feeling of adding a thin layer of a transparent wash to the image. What's really happening is that one wash of colors is being substituted for another. So wherever my brush hit, I was switching the colors on the image from the range on row five to the range on row six of the color map. The substitute color kept the same relative placement in the range. For instance, if the color of a pixel

Figure 12. Sharpening the thorn. To make the thorn with the first drop of blood look sharper, I placed it in front of one of the bar's shadows and added a very sharp white highlight along the length of it. This thorn has one of the greatest contrast ranges of the entire image and falls near the center of the composition.

Figure 13. Using contrast. One of the drops of blood was placed next to a water drop to contrast the different ways each picked up the light and to help make it clear that it was not water picking up red light from the rose, but a very different substance. Less light passes through blood, one can't see the leaf behind it and it holds together more tightly.

under the brush was the third from the right in range one, it would switch to the third from the right in range two (Figure 15). So if a map is set up with two similar ranges but one slightly bluer, it will look as if a transparent blue wash is being painted wherever the brush goes.

Output

Once the image was finished, some sort of output was required. (It's a bit difficult to lug a 19-inch monitor around to show.) We first tried to use a service bureau's Matrix film recorder but found the color reproduction too far off to be useful. If the film recorder had been our own, we could have

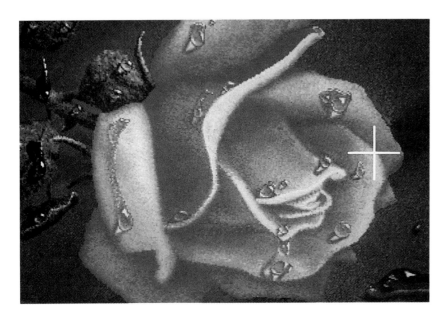

Figure 14. Adding secondary colors. The secondary colors were added to the stem and rose areas. The color changes were very subtle but helped give the image its life.

8-bit color systems

Most color display systems are built around an RGB or red, green, blue model because the monitor creates colors on the screen with these three colors of light. Inside the monitor there are three electron beams, one each for red, green and blue. By varying each of these beams' intensity between on and off in 256 increments, any of 16.7 million colors can be created on the screen at any pixel, or picture element, location. The number *256* is used because it is very conveniently represented in the binary number system with 8 bits or binary digits (2^8).

If we used 8 bits for each color (red, green and blue) we would need to keep track of 8 x 3, or 24, bits for every pixel on the screen. Since that much information takes up an enormous amount of video memory, early systems were developed using what's known as a color lookup table, or color map. Rather than storing 24 bits for every pixel on the screen, which could number in the millions of pixels x 24 bits each, developers instead created a color map that has 256 slots, each of which can hold one color value consisting of 24 bits. Thus, all that is necessary is 256 x 24 bits for the color map and 8 bits for 256 possible slots for each pixel on the screen. This allowed early manufacturers to produce affordable video boards.

The way the map works is exactly how a paint-by-number set works. Imagine the screen as a blank white canvas with a tiny square for every pixel. Each square or pixel on the screen can have a number from 0 to 255 in it. It's just a number, not a color. This number refers to one of the slots in the color map exactly as the numbers in a paint-by-number set refer to a little pot of paint in the plastic strip of color paint pots. So in an 8-bit system we don't actually put colors on the screen. We just write down the numbers and the computer then looks up the appropriate slot in the map and paints the color on the screen. Hence, there are two ways to change a color in the final image: One, we can change the number on the screen so that the computer fills that area with a color from a different slot in the map; or two, we can remix the color in the slot that that pixel refers to.

recalibrated it to match our monitor or run enough tests to adjust our images for the film recorder, but in a service bureau setting this was impractical. Instead we decided to shoot the images ourselves, directly off the monitor. After shooting quite a few test rolls and doing various experiments, we got the best results by using Kodachrome 64 film with an f-stop of 1.8 and bracketing around the camera's meter reading.

We used a Nikon N2000 camera with a 50mm Nikon lens on a tripod with all the studio lights out. To reproduce the colors properly on the Kodachrome film, we found that we needed to adjust the colors of the images before shooting. With an 8-bit system this is extremely easy. We simply corrected the entire color map of each image by increasing the blue component three notches, the value one notch and the saturation one notch on the sliding bars (see page 115). Once we had done all this, it was relatively easy to produce good slides. The only drawback in shooting off the screen is that some distortion and softness occur near the extreme edges of the screen due to its curvature. (See "Shooting a color monitor" on page 147.)

In retrospect

One of our studio's biggest hurdles has been getting publishers and art directors at major ad agencies to start considering computer graphics as a valid artistic medium. Until recently, computer graphics have been pigeon-holed into spinning logos on TV and low-end desktop publishing. Hopefully, books like this one, computer graphics exhibits and an abundance of promotional images will help break down the misconceptions and barriers that now prevent the medium from being considered as valid as any other.

Figure 15. Zooming in. This view shows some of the bluish pixels from the secondary rose wash. When zoomed all the way out, they blend into the image to produce color changes the same way the tiny printed dots on a magazine photograph blend together to produce images.

PORTFOLIO

Michael Scaramozzino

"I really love working with computers for illustration and design. They've come such a long way since 1981 when I created my first computer illustrations with ArtSketch. ArtSketch worked like an Etch-a-Sketch. Images were drawn by using the arrow keys on the keyboard and were produced on a standard PC character monitor. You can imagine how crude the illustrations were. Now we use a 24-bit system that can produce incredibly photorealistic images. It's so exciting — there are major developments and improvements almost every day. We caught this wave at the beginning and intend to ride it as long as it continues."

Yule '88 was produced by Dan Casey, one of our associates, and me for the 1988 Christmas season. At DreamLight, instead of putting up a real Christmas tree (we don't have any room), we paint one on the TG-II and animate it by cycling the color map. We leave it up on the 19-inch monitor, twinkling away, whenever the monitor isn't needed.

Genesis was a fun image to produce. I had black-and-white photos of clouds and a winter landscape that I scanned into the TG-II where the color map was posterized. It was created purely as an exercise in special effects. The image represents the beginning of life on an imaginary planet.

Upright Man was painted at the studio by one of our associates, Brad Foltz. It was a cover illustration for the paperback book *Upright Man*, published by Ballantine Books. For this image Brad scanned in a photograph of a model supplied by Ballantine's art director, Don Munson. The photograph was then solarized, posterized and colored in the TG-II. The background was created by scanning in a photo of trees and applying the same special effects.

Looker is a futuristic painting of a woman's eye that reflects the earth's sunrise as seen from space. It represents that first magic moment of falling in love, when a man looks deeply into a woman's eyes and sees the entire universe. I painted it by hand on the TG-II in a style very similar to "Regina's Rose," using the airbrush and Average features extensively. Photos were used as visual reference but were not scanned.

CheckMate is a detail from a painting of the final move in a game of chess. It's an illustration of the novel *The Once and Future King*. We have Guinevere and Lancelot, red with passion, leading to the tragic fall of the innocent King Arthur. Off-screen is a rook that represents Merlin and fate, which contributed to the final checkmate.

For this image I designed an entire 3D chess set on a CADD (computer-aided design and drafting) system. Next, I set up the board and moved the viewpoint around until I had the view I wanted. Then I output a wire-frame image of the scene on a pen plotter and scanned it into the TG-II, where I painted it by pouring solid colors into each of the areas created by the wire frame.

In **Pride** we have a painting of a full-maned African lion. It's an image of the pride exhibited by the king of the jungle. This was also painted by hand on the TG-II. Here I used a large circular brush with Average on for the textured background and the line tool with Twirling or Color Cycling on to produce the texture of the lion's fur. I used some photographs I had taken at the San Diego Zoo as reference, and again, nothing was scanned.

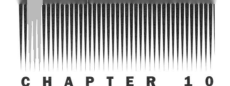

CHAPTER 10

The Evolution of a Fine Art Print

Artist

Sharon Steuer is a freelance artist and illustrator living in Bethany, Connecticut. After receiving a B.A. from Hampshire College she went on to study painting and drawing at the Portland School of Art, the Yale School of Fine Arts and the Vermont Studio School, as well as computer graphics at New York Institute of Technology.

For the past six years Steuer has produced computer fine art, illustration, articles and reviews for clients including Apple Computer, Letraset USA, SuperMac Technology, Electronic Arts, Ashton Tate, Silicon Beach, *Verbum, MACazine, Publish, Computer Currents, Macworld, The Weigand Report*, American Express and Travelers Insurance. She is a private consultant and instructor, and her drawings, paintings and computer art have been exhibited nationally.

Project

This image began as a portrait of my husband. By using the stylus (pen) of a digital tablet, I "painted" the portrait directly into the computer.

Treating the image as a printmaking plate, I created many variations of the portrait. From the original and one other version of the portrait the concept of a grid was born. Through extensive experimentation, many versions of the image were developed — some were rejected, and others were incorporated into additional finished pieces.

This final grid of portraits was printed to 4 x 5-inch film and placed in the 1990 edition of *American Showcase,* a listing of artists and illustrators represented by Bookmakers, Inc.

The image was produced with the following system: PixelPaint 2.0, Studio/8 and ColorStudio running on a Macintosh II with 5 MB of RAM, a Jasmine 140 MB hard disk drive, a Sony 13-inch color monitor, and both a Summagraphics MacTablet and a GTCO Macintizer digitizing tablet. It was proofed on a QMS 100 color printer and output to a 4 x 5-inch transparency through the Genigraphics service bureau. Microsoft's PowerPoint software was used to set up the image for film output.

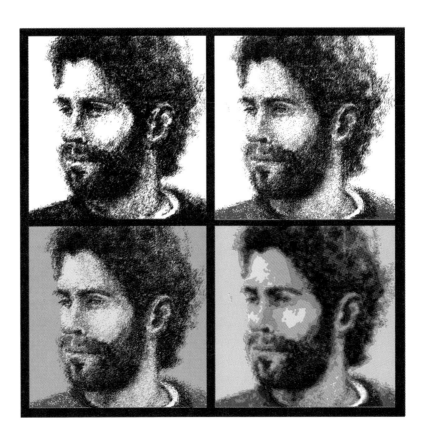

The computer as a tool

For me, computers are printmaking tools. As in the conventional printmaking methods, images can be proofed in various stages. Unlike all previous printmaking methods, the computer allows me to save the various developmental stages of an image to return to. I can use them as final, finished pieces and even develop new pieces from an earlier version, which would be impossible if I were working in an intaglio or lithographic process.

When I work with the computer I usually imagine that I'm working in a more traditional material — this helps me to maintain a continuity of approach that unifies the piece. For this portrait, I worked in a manner most similar to the way I work with pastels on rough-grained paper. Other times, for example, I may think to myself: pen and ink, oils, pencil or magic markers.

Experimenting with the image

I love to work on the computer because I can experiment freely with an image that I'm already pleased with, just to see how far I can push it. In most circumstances with the Mac, it's possible to "Undo" my last move, which lets me take risks with a finished or nearly finished piece — risks that I would be unlikely to take were I working in a traditional medium. Often, too, I save lots of experimental versions of an image and combine them — the eye from #4 and the back of the head from #2, for example.

As I was working from "Jeff version #1" to "Jeff version #2," I had the feeling I was transforming the portrait from an open, stippled pastel look to one incorporating "washes" of color as in watercolor.

The 3D version was the most unusual image developed from the portraits of Jeff. It was created by sandwiching transparent prints of the first two versions between pieces of Plexiglas and hanging them in front of a light source.

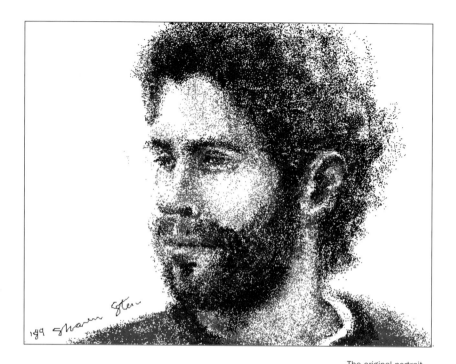

The original portrait was the size of the PixelPaint window stretched as large as possible on a 13-inch color monitor: 8 x 6 inches.

"Jeff version #2"

"Jeff version #1"

Lightbox White
Glass

Plexiglas

Plexiglas

The first portrait and a second version were combined to produce a 3D version. It was constructed by sandwiching the images between pieces of Plexiglas (the darker "Jeff version #2" in the back) and mounting the combined image in front of a lightbox frame.

Integrating the images for print: a grid

I had an opportunity to place an ad in the *American Showcase* and I really wanted to use the Jeff portraits, but the 3D version proved very difficult to reproduce in print. After several experiments with side-by-side images, I decided to place the first two versions into a four-figure grid. I cropped the portraits so that they fit a square, rather than rectangular, format, then went to work creating two more versions to fill out the grid. Ultimately I settled on a simple monochrome version for the first square of the grid and a "posterized" version for the final portrait.

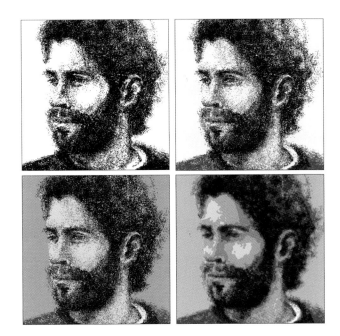

Although it's the first figure in the grid, this one was actually created third. The original portrait was saved in a monochrome format to create this black-and-white version.

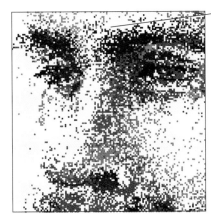

The original version of the portrait was "warmed" with a "wash" of light pinkish-gray to be less contrasty next to the monochrome version.

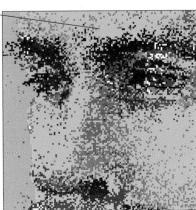

PixelPaint's Paint On Lighter Colors feature transformed the original portrait of Jeff from an open, stippled pastel look to one incorporating a watercolor type of effect.

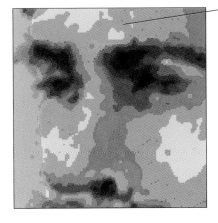

Altering and manipulating "Jeff version #2" in ColorStudio by using different kinds of image transformations, including color correction and posterizing, created the fourth image for the grid.

For the past few years I have been drawing portraits of people with my Mac Plus. But having just set up my new color Mac II, I was dying to start making "art" in color. After nine years of my husband, Jeff, sitting for portraits drawn in pencil, crayon and charcoal or painted in pastel and oils, he was not too anxious to sit for me. As an enticement we set up the Plus at the other end of my long computer table so that Jeff could play "MacFootball" while I drew him.

I had recently demonstrated PixelPaint 2.0 for SuperMac at a MacWorld Expo (creating caricatures of passersby), so I was very comfortable with the program. I hooked up my Summagraphics MacTablet with an ADB adaptor so that I could draw with the pen-shaped stylus I had grown accustomed to (instead of that clumsy mouse).

In PixelPaint, I constructed a palette of custom colors. Then using mainly the spray can tool, I tried to "pull" Jeff's image out of the white of the monitor first with loose, then tight strokes (Figure 1).

Almost as soon as the image was completed, I began working on it again (Figure 2). At first I was uncertain whether I would keep the initial portrait, but working in the computer makes it simple to keep both the original and experimental versions. Eventually I decided I liked both the original, now called "Jeff version #1," and the new one, which became "Jeff version #2." By printing both versions on transparencies, I created "Jeff 3D" (see page 130).

Switching to Studio/8

Because this 3D portrait proved difficult to reproduce in print, I decided to construct my images into a grid for an advertisement in *American Showcase*. I made a screen dump of "Jeff version #1" by using Exposure (a Control Panel

Figure 2. Transforming the original portrait. "Washes" of color were placed "underneath" the portrait by using PixelPaint's Paint On Lighter Colors option from the Special Effects menu. This effect lets the artist paint colors seemingly underneath the darker colors. A few new flesh tones were custom-mixed, and colors were applied with a fairly large, solid brush. The original portrait was transformed from an open stippled pastellike look, to one incorporating color in a watercolorlike manner.

Figure 1. Painting the original. In PixelPaint 2.0, the portrait was gradually built up with the spray can tool from general strokes to fine detail, much the same as a pastel would be constructed.

Device [CDev] installed in the System folder that takes a "snapshot" of the on-screen image). This created a black-and-white PICT file of the portrait. I opened the screen dump in Studio/8, another color painting program that, unlike PixelPaint, allows more than one document to be open at a time so I could view many different effects at once.

In Studio/8, it's easy to change the background and foreground colors of an image so I played with a variety of options. And I could instantly mask any number of colors (Figure 3), allowing me to try out even more combinations (Figure 4). Although easy to use, Studio/8 did require some patience because the effects options are a bit more sophisticated than PixelPaint's. Finally, I decided that the simplest, monochrome version would be the best complement to the two color versions I already had, and the portrait in black-and-white became the first image in the grid (Figure 5).

Figure 3. Masking. This screen capture shows the dark blue being masked and a solid cyan square being placed "behind" the color. If the white background had been masked instead, the cyan would be replacing the dark blue, leaving the white.

Figure 4. Manipulating the colors. Studio/8's 256-color palette is accessed by selecting the Current Color, Outline Color or Background Color (at the bottom of the tool palette [see Figure 3]) and dragging to the new color. The movable and enlarged floating window at the lower left corner stores the last 16 colors used (so the artist can easily reselect them).

Figure 5. Simplifying the original. Despite much experimentation with the foreground and background colors in Studio/8, this simple black-and-white version was ultimately chosen for the first image in the grid.

Some changes to the original image

Because I had chosen the very contrasty black-and-white version as the first image in the grid, I wanted to reduce the contrast of "Jeff version #1" which would be the second image within the grid. Going back into PixelPaint, I mixed a very light pinkish gray and placed a "wash" of this color underneath the image using the Paint On Lighter Colors effect (Figure 6). Though the color change was very subtle, it warmed the image, especially in comparison with the harsh, monochrome portrait in black-and-white (see page 131).

Figure 6. Reducing contrast. PixelPaint's Special Effects with the paintbrush to Paint On Lighter Colors, put a "wash" of gray "underneath" Jeff to reduce the contrast of the original portrait.

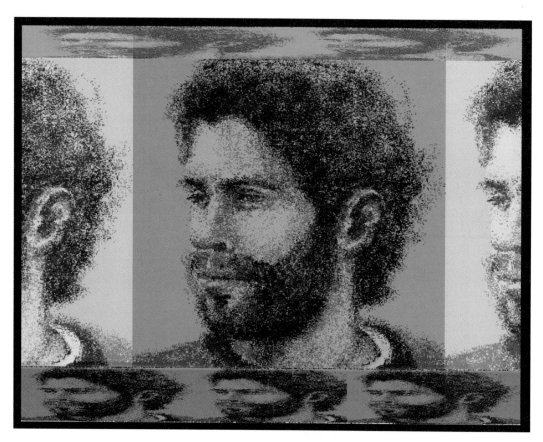

Figure 7. Following inspiration. "Multiple Blues" is a piece that evolved out of artistic exploration with the computer interrupted by a system crash. Unlike traditional media, moving in a completely different direction than first intended can assist the original quest, not simply pre-empt it. This piece was created using Color-Studio functions and effects like Tint, Color Correction, Dynamic Effects and Color Change.

Figure 8. Posterizing the image. The fourth portrait was the result of extensive free experimentation, which would have been impossible in any medium other than the computer; the freedom and flexibility afforded by a full-color computer program are unparalleled in the history of art.

Full-color painting

I was now ready to work on the fourth and final version of Jeff's portrait for the grid. I wanted to use Letraset's ColorStudio for its "full color," 32-bit painting. ColorStudio allows the artist to work intuitively with color. Instead of having to preconstruct a palette that would limit me to only 256 colors at a time (as in PixelPaint and Studio 8), I was able to mix colors realistically; blending, blurring, correcting color, airbrushing (very impressive airbrushes), and painting in transparencies. I was using what the computer industry terms a "beta" version of the software — in other words, a not-yet-released, still-working-out-the-bugs version. I experimented with functions such as Tint, Color Correction, Dynamic Effects and Color Change on a variation of "Jeff version #2." While increasing the blue content with the program's Color Correction mode, I crashed (that is, my computer froze and refused to respond to my attempts to recover control). The on-screen image was a beautiful tapestry of bluish distortions of Jeff's portrait. I later attempted to re-create it and the result is a piece called "Multiple Blues" (Figure 7).

After days of painting and applying various effects, I stumbled upon a computer effect that transformed an existing version of the portrait into the fourth component of the grid. Using a copy of "Jeff version #2" I tried "posterizing" the image. *Posterization* compresses a range of colors and in this case, created a "silkscreened" type of effect (Figure 8).

In retrospect

The three color paint programs I used for the portraits of Jeff are quite different in feel. PixelPaint operates very much as you would expect a Macintosh program to. In fact, the program is almost identical to what a color version of MacPaint ought to look like. PixelPaint's interface is easy to figure out even without a manual. But, I wasn't happy with the way the program deals with portions of an image beyond the confines of the current window so I limited the size of my image to the largest window possible for my 13-inch monitor. For freehand drawing of images that are the same size or smaller than my monitor, the program works quite well.

Where PixelPaint fell short, Studio/8 was able to fill in. Since I wanted to experiment freely while creating the portraits, I needed a program that allowed more than one file to be open at a time and could more easily manipulate the background and foreground colors as well as provide a floating window that "stored" the 16 most recently used colors.

ColorStudio provided full-color painting with over 16 million colors available to be used on any one screen (not the mere 256 of PixelPaint and Studio/8). As a result, mixing and choosing colors is not restricted to choosing from the color palette. It also allowed me to select portions of the image beyond the confines of the Macintosh window. ColorStudio is a complex program, fairly simple to work superficially, but requiring a rather long learning curve to master its power.

Sharon Steuer

"For me, the computer is indeed a new printmaking tool. As in any printmaking medium, I can develop a series of images starting from one germ of an idea. With "traditional" printmaking media, an image is transformed through a series of "states" in order to achieve a final solution. Only with the computer, however, can each of these states be preserved for me to return to for further development. And, only with the computer do I have the freedom to take such risks with altering images that I feel are in the final or finished state, because only with the computer can I both keep and alter an image from any state. Someday, when computer output technology is more fully developed, I plan to collect my favorite images on disk and print them traditionally as fine art limited editions."

Giraffe, Hippo and Ostrich are the initial sketches for a multimedia "animatics" presentation of Rudyard Kipling's ***The Elephant's Child*** commissioned by IMT, Inc. of Scottsdale, Arizona. To create these portraits of the Elephant's Child's "aunts and uncles," I drew the figures freehand into the computer using Letraset's ImageStudio and my Macintizer Tablet. Though they were created entirely with the computer, I can't help but think that texturally, the marks feel like chalks and charcoal. In the final project I used Color-Studio to integrate color and scans into some of the illustrations, helping me to bring to life for others one of my favorite children's stories: the tale of *How the Elephant Got His Trunk* as shown opposite in **The Stretch** and **The Long Stretch.**

On the Bus. This simple little drawing was my first "fine art piece" produced on the Macintosh. Using a 128K Mac, MacPaint and a mouse, I reinterpreted a pencil sketch I had drawn on the bus (one of thousands that I have drawn on buses and trains). Because of the limitations of such a prehistoric Mac I limited the size of the image to that of the MacPaint window of the Mac (4 x 5½ inches) — perhaps not coincidentally the size of the small sketchbook that I carry with me everywhere.

CHAPTER 11

Portfolio Day Poster

Artist

Manhattan illustrator and designer Pamela Hobbs was born and educated in England, where she studied the fundamentals of illustrative techniques at the Beaconsfield Secondary Modern School in Buckinghamshire. She moved to the United States in 1984 and studied installation art, photography and painting at North Carolina School for the Arts, a visual and performing arts college. She earned her Bachelor of Fine Arts degree at the Maryland Institute's College of Art, majoring in illustration and minoring in visual communications.

Hobbs is proficient on several different computer systems, including the Macintosh, with such programs as PageMaker, PixelPaint, Studio/8, SuperPaint and MacDraft. She works with scanned and digitized video imagery as well as animation. As computer operator at Sparkman & Bartholomew, Inc. in Washington, D.C., she used the Lightspeed System 20 in coordination with a 35mm Matrix 3000 film recorder and a thermal printer. She is currently teaching illustration workshops at the School of Visual Arts as well as the New School for Social Research (a Parsons School of Design affiliate).

Project

The assignment to design a poster announcing the review of potential students' portfolios was given to me through the Maryland Institute College of Art by a group of designers. The title for the project was Portfolio Day, a straightforward concept to be approached with a new twist — the art director, Deborah Rhibino, was excited about the digital art medium. My illustration was created with TGA TIPS 16, with version 4.0 software. Hardware was an IBM PC; output was through a Matrix PCR film recorder.

The Portfolio Day poster appears in color on page 176 of this book.

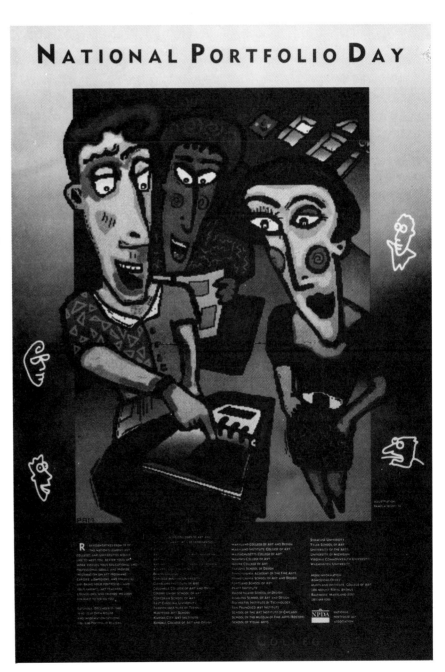

Design process

This project was most challenging and ex-
citing because it gave me the opportunity
to test my talent on the Targa 16-bit
computer paintbox system. The designers
wanted an innovative new poster to catch
the attention of prospective art students.
"Do what you feel will work best," they
told me.

My job as illustrator was to portray the
enthusiasm and excitement associated
with Portfolio Day in a way students could
relate to. The idea was to convey a sense
of fun and humor to help them avoid feel-
ing intimidated during these portfolio
reviews. I chose bright, cheerful colors
that projected the fun and creativity of an
artistic environment. The Targa 16 gave
me an opportunity to push the concept —
not only technically and visually, but also
creatively — with over two million color
options. I drew by hand six different
concepts — preliminary pencil sketches
that I presented to the designers for their
approval.

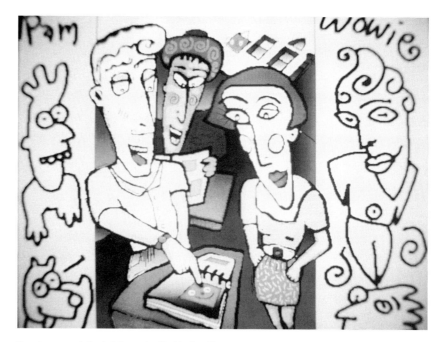

Based on one of six sketches submitted to the clients,
this electronic version is somewhat more spontaneous
and not as straightforward as the one they finally se-
lected. The hand-drawn sketches were scanned on a How-
tek 32-bit scanner so I would have on-screen versions for
scaling and positioning. The idea of doing the sketches
was to give the designers a variety of "feels" to choose
from, and this sketch is a bit more playful than what they
were looking for.

Color testing and
balancing the pro-
cess colors for the
poster was a matter
of taking out some
colors and adding
others. The on-
screen color adjust-
ment sliders made it
possible to see the
results of color ex-
perimentation imme-
diately.

Working with the client

After a second meeting with the designers, they chose one of my six sketches. We discussed the details of final adjustments that were to be made, still in the sketch stage, before I would scan in the final version as a basis for the electronic artwork.

Budget uncertainties demanded that I come up with options of black-and-white line art and three-color and four-color execution for the final image, which gave the project an interesting twist. The Targa system I used was accommodating, however; I was able to reload my original image and add new color. So the project turned out to be three versions of the same image, each requiring different artistic techniques and using various features of the Targa system.

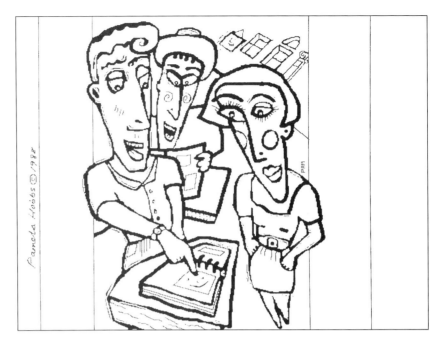

This black-and-white version of the poster is like a framework for the final four-color version. It's a finished drawing that could be used as a reference point for all the other versions. Once completed, it was available to fall back on if new directions didn't pan out. And the client reproduced this version in a number of ways, one of which was as a logo for the school.

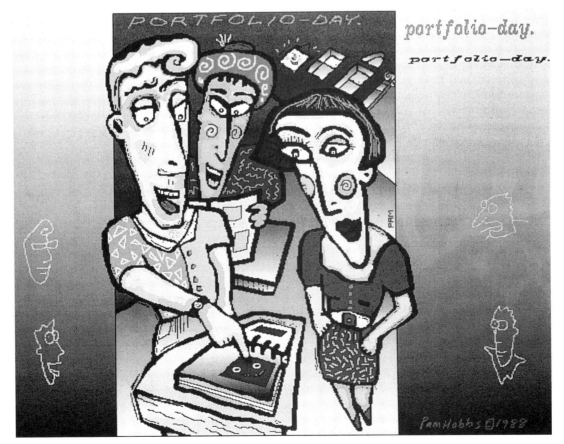

This final version was used as a promotional poster and as an 8½ x 11-inch promotional flyer for the school. The clients opted not to go with the type shown here, but this preliminary version inspired them to use type on the poster, which they chose later and stripped in. They liked the four-color art so much that they expanded the project's budget to produce it.

O nce I had my approved pencil sketch I was ready to roll. The first step was to position my sketch correctly on the Howtek flatbed scanner, a 32-bit scanner that allowed me to place my drawing on the computer paint system screen, preview the placement each time and then scale my image on the screen. With the sketch on-screen I could begin my first black-and-white line art drawing.

Because of the way the Targa TIPS software is set up, I could manipulate my image with the many different tools the program provides. I began to build up texture and line quality. Starting with my sketch as the foundation, I chose a black charcoal line with the intensity scale set at 5 (on a scale of 1 to 10), selecting my drawing tools from the menu: a fat brush, a flat line and a connected line. Choosing the tool I wanted, I carefully drew over my scanned-in sketch, covering the scanned pencil line.

Once I had completed the rough outlines of my image, I zoomed into it and touched up areas like the eye and fingers, and added details like the smiling watch, windows and so forth (Figure 1). I then created a final gradation spread for the outside background area in a neutral gray. Then I selected the rubber band tool, which allows the artist to choose one point, stretch a line across the image and then locate the second endpoint. I used it to create a straight line in the portfolio sleeve pages, and repeated the process for the other pages (Figure 2).

To complete the black-and-white artwork I used the Fill command. Selecting white from my colors, I chose Boundary Fill from the menu. ▌ *Bound-ary Fill allows the user to select the boundary of the area to fill by drawing a line like a corral (or like the lasso in Macintosh paint programs), so any area (inside or outside the boundary) can be filled. Boundary Fill will let you refill again over a gradation to a solid hue, for example, or vice versa.*

Figure 1. Touching up the sketch. It's the fun extras, the little nuances that really make a drawing. Elements like the smiling face on the watch contribute the added dimension necessary to pull off a light-hearted, whimsical effect to help dispel potential students' nervousness about having their art juried for acceptance to the school.

Adding color

My next step was to take the black-and-white line art and create a three-color piece (black plus red and blue). The fantastic thing about working in the computer is that, instead of going back to the drawing board and reworking a new image, I can simply reload my first image and add new color. From the color bar at the bottom of my screen I first selected the colors I wished to work with: a variation of cyan and a magenta.

Once I had chosen these two colors I was able to go into the toolbox under the Special Effects menu, into the subdirectory to select Tint. I then rechose the magenta and created a variation from it. The variations of any of the two million colors can range anywhere from a fraction of 1 percent to 100 percent. Next I selected the Blend icon to manipulate the colors further (Figure 3). When I had two colors I was happy with, I used the Tint icon again to create a full-color menu of variations of my own colors, from the first magenta to the last cyan.

Figure 2. Drawing the pages of the book. The pages of the portfolio were drawn with the rubber band tool, which stretches a line between two endpoints placed by the user.

Figure 3. Blending colors. I selected the Blend function from the TIPS toolbox to mix various shades and blends of magenta and cyan for the three-color version.

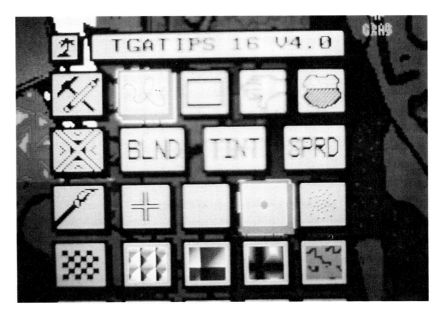

I was now ready to go into the Fill menu icon. I selected colors and directional spreads for the various areas of the drawing. Next, I chose the pencil tool from the drawing menu and drew over the graduated color to create a textural pattern in the shirt. The image was then finalized and saved as a PIC image (Figure 4).

Creating full-color art

The last of the three pieces I created was the full-color version. I first reloaded my original black-and-white line art and then went into the color menu bar and adjusted the colors to produce the palette I wished to work with, heightening the contrast and adjusting the values to give me the luminosity and vibrant variations I needed. Next I selected Pattern Editing from the toolbox menu (in which there are 16 preset pattern options done in a three-dimensional format). To create the textural elements of the table side, the woman's skirt pattern and the man's hat (three different patterns and edits), I decided to select one of the preset patterns for each area and edit it to my liking. Once I had these patterns, I could simply return to Seed Fill and select the areas I wished to fill. I went into the RGB (red, green, blue) palette of the color menu and made some slight color adjustments to intensify the hues after I had placed them into the drawing (Figure 5).

Using the Zoom command, I then went into the eye, portfolio, watch, cheeks, lips and other detailed areas to create a subtle color difference within the graduated colors. By painting over the top of what was already there, I was

Figure 4. Completing the three-color version. After cyan and magenta colors had been assigned to all elements of the drawing, a neutral gray graduated background was added.

able to place one color next to another with precision, zoom back out, check the results, and continue to add to or take away from the previously colored image. I could sneak in a few fun extras that not everybody would notice at first, like the spiral on the cheek (Figure 6). Finally, I put in the neutral graduated background.

Figure 5. Customizing the palette. With over two million color possibilities, selections were made among them and the contrast was changed to fit the illustration — it's like extremely fine tuning. The color bar here shows some of the intensities possible.

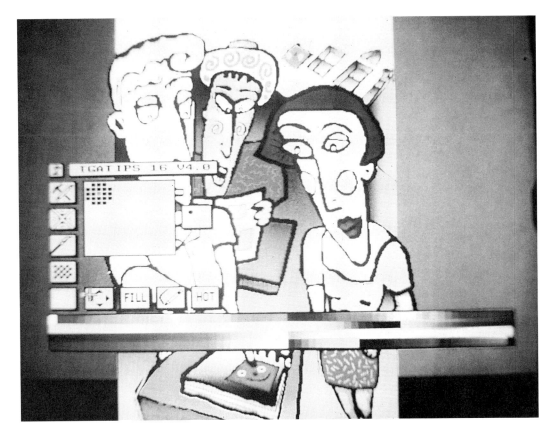

Figure 6. Adding detail. By zooming in, it was possible to add fine detail like the spiral in the cheek.

I had scribbled some doodles in the margins and unintentionally left them there (Figure 7). However, the designers must have liked them, because they showed up on the final poster (see page 176). I placed the italic typeface last, and added a hand-written title at the top of the image as an additional option (see page 141).

Finalizing output

My three images were able to fit onto one 5¼-inch disk. To get the final hard copy for color separations, I loaded 100 ASA Fujichrome daylight film into the Matrix PCR film recorder with a 35mm camera attachment. The film recorder offers a high resolution, exposing each process color separately and producing the final full-color image on one slide. I shot several different exposures, bracketing the film up one, and then down one, changing the aperture to give me several versions to choose from. The final full-color image took about 10 minutes to shoot. (For an alternative to using a film recorder to output on-screen art, see "Shooting a color monitor" on page 147.)

In retrospect

Although I did my own film recorder work for this poster, today I typically use service bureaus to produce film for a project like this, cutting out the time it takes me to load the film recorder and so forth. I charge the service bureau cost as an additional expense to the client along with my fee. Given plenty of time, however, I still prefer to be in full control of the film production.

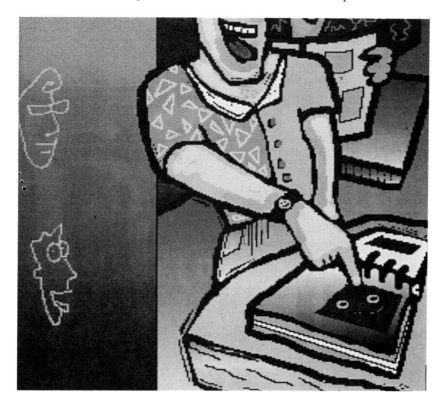

Figure 7. Designing by accident. "Doodles" left in the margin by accident were incorporated into the final poster (see page 176).

The following techniques will help you get good results using a 35mm camera to photograph artwork displayed on the computer screen. These procedures offer a low-cost alternative to using film recorders.

Before you start, you should be aware that:
• The clarity of your slides will depend on the resolution of your monitor.
• The quality of your slides will depend upon your camera lens and your ability to focus sharply.
• If photographed with a 50mm camera lens, vertical and horizontal lines extending toward the edges of the computer screen will bow slightly due to the curvature of the screen.
• If the camera and screen are not absolutely parallel, "pyramiding" (rectangular images taking on angles other than 90 degrees) can occur.
• Light reflections on the computer screen will degrade the final slide images.

Creating your artwork

If you know in advance that you'll be reproducing your digital paintings by photographing the screen, some preplanning can improve your final images. First, use a monitor with the highest resolution available. Next, determine the largest area of the screen that you can use with the least distortion. Try to contain your slide art to that area in the center of the computer screen where the straight lines and rectangles do not appear to bow. Avoid creating art with straight lines that border the outside edges of the image area of the computer screen.

Get your equipment together

You'll need an SLR 35mm camera with a manual mode and a 50mm (or better yet,

an 85mm or longer telephoto-type lens). The longer lenses tend to flatten out the curved image of the screen when you set up the camera 10 feet back from the screen. You also need a sturdy tripod and a cable release.

Check your film. Kodak Ektachrome 100 Plus Professional Daylight film works best. Fuji films, while okay for geometric images, tend to add contrast to subtle shades, and to warm up the colors. Kodak Ektachrome 100 has a bluish tonality, so the addition of color-correction filters helps bring slide results closer to screen colors. Choosing the right filter to use is based on your sense of color. Many images (especially those with strong blue palettes) don't require a filter, and most others can be corrected with a Kodak 20 Red or an FL Day filter (fluorescent).

Set up your shoot

Mount your camera with the telephoto lens installed on a tripod and aim it squarely at the center of the computer screen. The camera and the screen should be parallel. Use bubble levels to check both the monitor and the camera to make sure they're level. Load the film. Bring your graphics up on the screen. Align the image in the camera by moving the image on the screen, not by moving the camera. Be aware that what you see through the viewfinder will not exactly match the dimensions of the final slide — most 35mm cameras only show 95 percent of the picture. Set brightness on the monitor to full. If you have an automatic camera, make sure your flash is turned off.

Make sure all extraneous light in the room has been turned off or blocked out. Totally darken the room or shoot at night if necessary.

Your monitor scans and refreshes every $\frac{1}{30}$ of a second. To avoid scan lines in your

photo, set the shutter speed of your camera to 1 second. Connect the shutter release to the camera.

Set the camera meter for the ASA of the film used. To set your exposure, fill the monitor screen with a medium gray field and adjust the camera f stop.

Ready? Shoot

When you're ready to begin photographing your artwork, have a pencil and paper handy to make a record of each exposure. The relevant information you'll want to record for each slide will include: *slide #, f stop, speed, filter used, image description, date, film type,* and (to be completed after processing) *results.*

"Bracket" your shots by making additional shots at ½-second and 2-second shutter speeds. Additional exposures of ¼ and 4 seconds would be wise on your first test roll. Bracketing will simply extend your chances of obtaining the best results.

Processing

View the slides on a color-corrected light box. You should see lighter and darker versions of each image if you bracketed your shots. Refer to your notes and check which f stops worked best for you. This information may come in handy the next time you need to produce slides of your computer graphics.

With the Polaroid Instant Slide System (costing about $70) and the necessary chemicals, you can process your slides in-house in less than a minute. But the results may not approach professional E-6 processing.

Adapted from Verbum *magazine, Volume 2.2, Summer 1988.*

Pamela Hobbs

"Teaching now at The New School and The School of Visual Arts, I feel very excited and optimistic about what is being created in the illustration field today. I feel I am a member of the 'new media' and part of a new generation of artists. Looking back, it's inspiring to see how far we've come in the past eight years! I want to take this medium far beyond its current boundaries and to help correct the general public's misconception of the computer medium — as cold, impersonal and lifeless — and hopefully exhibit a little humor and grace along the way."

Created on the Light-speed System 20, this is an **editorial illustration** for *Psychology Today* about education in public schools. The Light-speed's color-manipu-lation capabilities were used to create the tricky blends and gradations. Art direc-tors were F. O. Wilson and Jennifer Gilman.

Created for *V* maga-zine on the Light-speed System 20, this image was de-signed as a **header for a monthly column** on video disks. It's a simple but effective piece, with crazy color combinations serving to accent the movement within the visual. Alice Cooke was the art director.

Another commercial piece, this one was commissioned by Hugh Smyser's Art Machine. The Targa 16 was used to create this center visual for a health spa poster titled **Futuristic Foods.**

These additional spot illustrations were designed into the **Futuristic Foods** poster. Bruno Nesci was the art director for the project.

Gallery

This Digital Painting Gallery showcases a wide range of exemplary works by talented "light painters" from around the world. The first section, pages 151 to 166, consists of black-and-white reproductions of works that are mostly black-and-white (or grayscale) originals. The works are organized from simple bitmapped illustrations, to more complex paintings with 256 shades or colors, to scanned-image montages. The color section, pages 167 through 182, is organized in a similar fashion, from simpler to more complex works, including some examples of 3D images, combined media and, near the end, fine artworks for exhibit in galleries.

The works shown here are chosen as much for their content as for their effective and innovative use of the digital art tools. We hope you enjoy this stunning selection of pioneering art forms, and that it helps stimulate ideas for your own work.

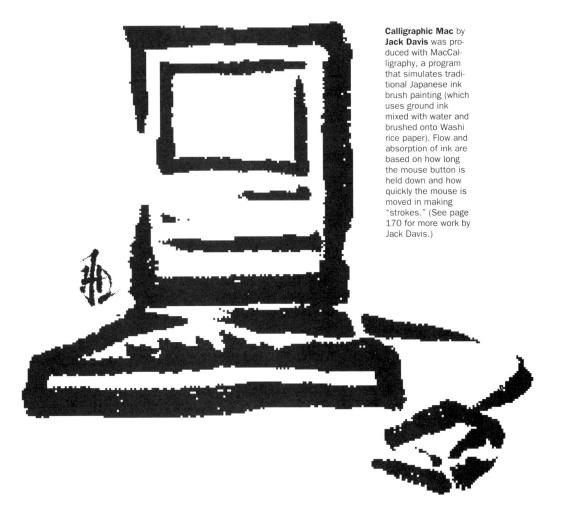

Calligraphic Mac by **Jack Davis** was produced with MacCalligraphy, a program that simulates traditional Japanese ink brush painting (which uses ground ink mixed with water and brushed onto Washi rice paper). Flow and absorption of ink are based on how long the mouse button is held down and how quickly the mouse is moved in making "strokes." (See page 170 for more work by Jack Davis.)

Guernica (above) and **Melancholy and Mystery of a Street** are part of the "Master Series" of famous paintings interpreted in the bitmapped painting medium by **Martin Speed.** Created on a Macintosh using FullPaint, these simple but elegant bitmapped paint compositions were enhanced with standard and customized patterns from FullPaint's patterns menu. Included here are his renditions of Pablo Picasso's 1937 work and the 1914 painting by famous surrealist Giorgio De Chirico.

Portraying creatures fleeing from a polluted city,
Exodus is a painstakingly drawn, pixel-by-pixel
illustration that makes effective use of the
vertical, horizontal and 45-degree angle align-
ment of the screen pixels that are used in
bitmapped painting.

 Nathan Weedmark is a San Diego fine artist
and musician who has created commercial and
fine art on the Macintosh for years. (More work
by Nathan Weedmark appears on pages 154–
155 and 166.)

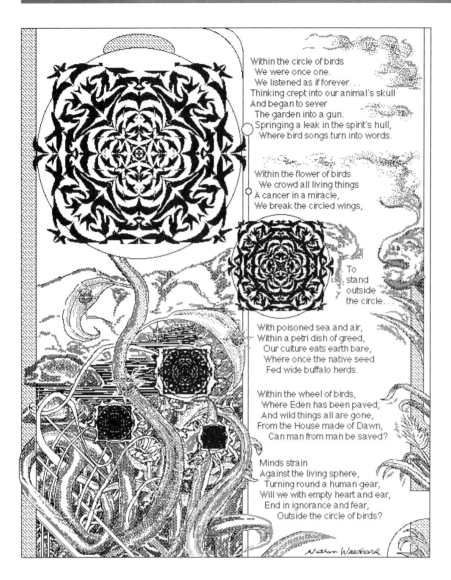

Within the circle of birds
We were once one.
We listened as if forever. . .
Thinking crept into our animal's skull
And began to sever
The garden into a gun.
Springing a leak in the spirit's hull,
Where bird songs turn into words.

Within the flower of birds
We crowd all living things
A cancer in a miracle,
We break the circled wings,

To
stand
outside
the circle. . .

With poisoned sea and air,
Within a petri dish of greed,
Our culture eats earth bare,
Where once the native seed
Fed wide buffalo herds.

Within the wheel of birds,
Where Eden has been paved;
And wild things all are gone,
From the House made of Dawn,
Can man from man be saved?

Minds strain
Against the living sphere,
Turning round a human gear,
Will we with empty heart and ear,
End in ignorance and fear,
Outside the circle of birds?

The flower shapes in **Circle of Birds** by **Nathan Weedmark** were created in Crystal Paint, a package that composes symmetrical designs, and were then brought into SuperPaint's object layer and reduced in size to achieve a higher resolution. The surrounding art was done in the paint layer with the standard paint tools. (Other works by Nathan Weedmark appear on pages 153, 155 and 166.)

Ed Roxburgh used SuperPaint's special effects to paint this abstract composition, **835.** Standard patterns in the program were copied and repeated to create these dynamic textures.

Roxburgh is a San Diego painter who is also involved in graphic design and theater set design. He uses the Macintosh primarily as a fine art tool. (See page 155 for additional work by Ed Roxburgh.)

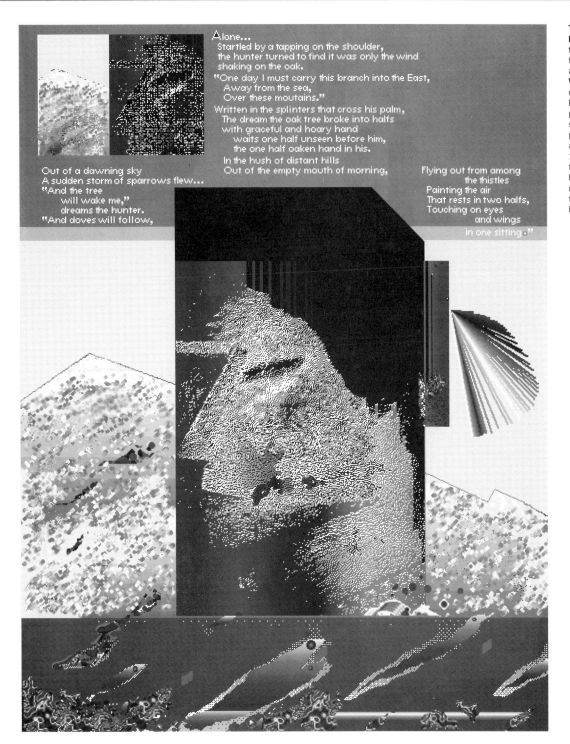

Alone...
Startled by a tapping on the shoulder,
the hunter turned to find it was only the wind
shaking on the oak.
"One day I must carry this branch into the East,
 Away from the sea,
 Over these moutains."
Written in the splinters that cross his palm,
The dream the oak tree broke into halfs
with graceful and hoary hand
 waits one half unseen before him,
 the one half oaken hand in his.
In the hush of distant hills
Out of the empty mouth of morning,

Out of a dawning sky
A sudden storm of sparrows flew...
"And the tree
 will wake me,"
 dreams the hunter.
"And doves will follow,

Flying out from among
 the thistles
Painting the air
That rests in two halfs,
Touching on eyes
 and wings
 in one sitting."

The Hush of Distant Hills is a collaborative piece, with art from **Ed Roxburgh** and text by **Nathan Weedmark.** Created on a Macintosh in PixelPaint, it was painted around a scan of the artist's pencil illustration of a face. (See pages 153–154 and 166 for additional work by Nathan Weedmark; see page 154 for additional work by Ed Roxburgh.)

Airbrush by **Daryl Isaacs** shows off the illustration and type capabilities of Adobe Illustrator, as well as the paint features of PixelPaint. The airbrush image and the type were first created in Illustrator, then brought into PixelPaint. There, they were colorized and the "airbrushed" background was added.

Isaacs is an Australian-born fine artist, now working as a San Diego-based illustrator. Coming from a background in comic book illustration, he works exclusively on a Macintosh system and is currently involved in designing PostScript typefaces.

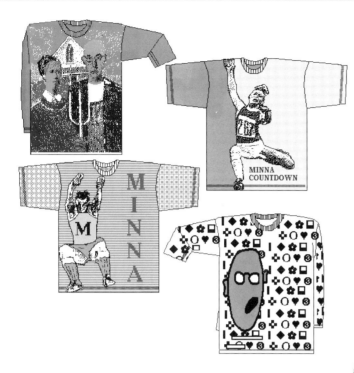

Fashion designer **Jackie Shapiro** used PixelPaint and MacPaint on the Macintosh to create full color design fashion studies, titled **Assorted Tees** and **Assorted Sweaters**. These are examples of actual work from Minna Women's Wear in New York City, where Shapiro uses her computer as a tool to develop new fashion ideas.

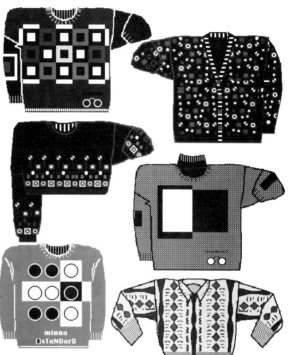

These illustrations, **Package Layout** and **Shelf Stack** by **Phil Gordon**, were created from elements brought into PixelPaint from two sources: images of fruit scanned on a flatbed scanner, and type and label elements composed in Adobe Illustrator. For Shelf Stack, the scanned elements of the flat layout were skewed and assembled to create the appearance of a 3D box, and then duplicated and manipulated to form the shelf display.

Phil Gordon is a San Diego-based illustrator who uses electronic art and design tools increasingly in his work.

Miriam Yarmolinsky created **Visages** from a scanned photograph imported into FullPaint, where it was duplicated, traced, flopped and manipulated with various other effects to produce the end result.

Yarmolinsky is a Washington, D.C. illustrator who recently began using Macintosh art tools to create fine art.

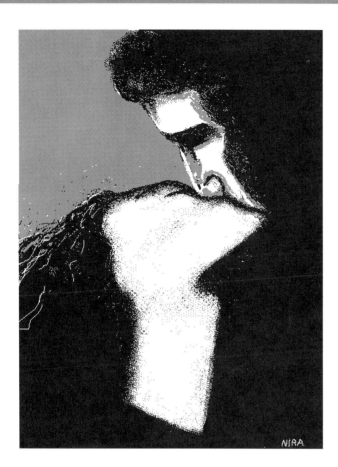

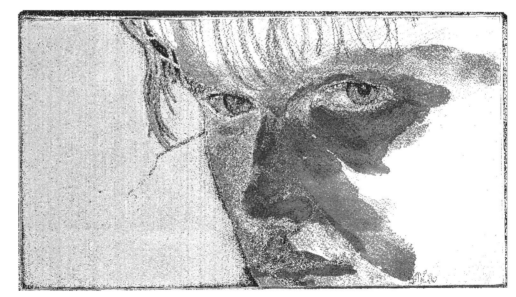

Kiss by **Nira** was created in MacPaint and modified with Image-Studio. The first image, above left, was drawn freehand in MacPaint. The high-resolution version, above right, was created by importing the bitmapped image into ImageStudio and re-painting it with gray-scale screens using the paintbrush, charcoal and paint bucket tools. (See page 165 for more work by Nira.)

Sylvia, a self-portrait by **Sylvia Egers,** began with a still video photo that was digitized and manipulated using Studio/8. Egers is a fine artist with a background in graphic design. She currently lives in Kansas.

M. Mouse (far left) and **Get 1** (near left) by **Paul Rutkovsky** are "redigitized illustrations," created by scanning hand drawings, printing them out and then scanning them again as many times as necessary to achieve the desired pixellized effect, and finally manipulating them further in MacPaint.

Rutkovsky, of Tallahassee, Florida, is a concept artist who creates large-scale installations in outdoor environments. He has also exhibited computer-assisted artwork since 1985.

Triplane by **David Brunn** began as a hand-drawn illustration. The image was scanned, outlined and enlarged 1000 percent for the exaggerated bitmap effect and then colored in PixelPaint.

Brunn is a Seattle-based photographer and illustrator working extensively with digitized imagery and multimedia.

Charlie Unkeless's Hummingbird was painted in Deluxe-Paint III on an Amiga. A photo was scanned using a DigiView video scanner, then duplicated, colored and manipulated in the paint program. It's reproduced here from a Xerox 4020 inkjet print.

Unkeless is a multimedia artist specializing in work on the Amiga. His elaborate stage presentations for the rock group Oingo Boingo include Amiga-generated animations.

Horse 4 by **Bengt Berglund** exemplifies yet another of the effects an artist can achieve by manipulating a scanned photograph in a paint program. In this case, a photograph of a face was scanned on a four-color scanner before it was colorized and manipulated with PixelPaint's array of paint tools.

Berglund is a Swiss artist and desktop publishing expert whose wife, **Dominique de Bardonneche-Berglund,** is a widely acclaimed computer fine artist; her works appear on pages 171 and 172. They have collaborated to solve technical problems, and together they have developed a unique creative synergy.

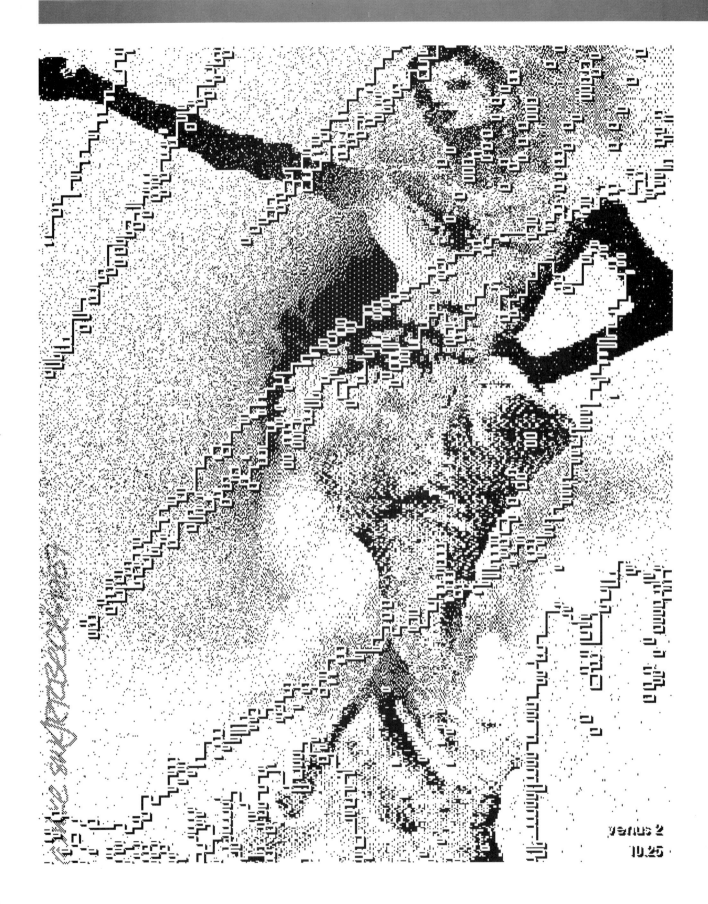

By scanning photographs and manipulating them in the GraphicWorks paint program, **Mike Swartzbeck** was able to add painted elements in various layers to **Venus 2** (opposite page), **Ghost Tribe** (above) and **Visitors** (right) to create these scanned-image montages.

Swartzbeck is a cartoonist, graphic designer and fine artist. Originally from Washington, D.C., he has recently relocated to San Diego.

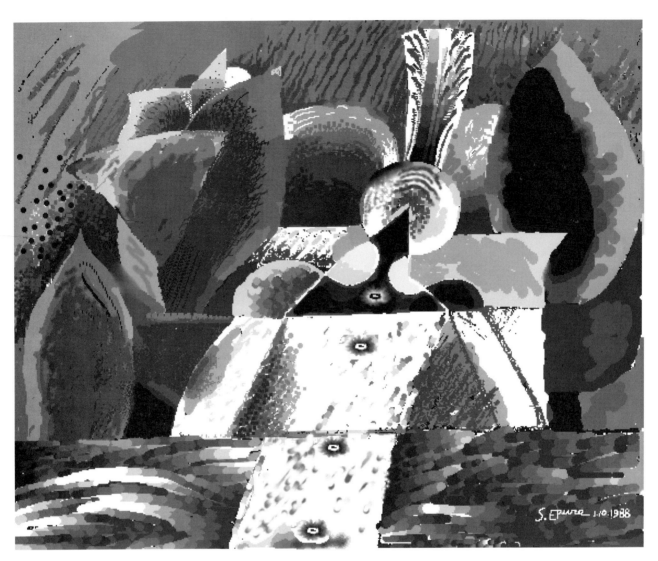

King Arjuna by **Serban Epure** was painted entirely on-screen with the gray-scale image editing program Image-Studio. It was output as a high-resolution negative with 256 shades of gray and a 133-line screen. Epure is a Woodside, New York artist who has been involved with digital painting since 1986.

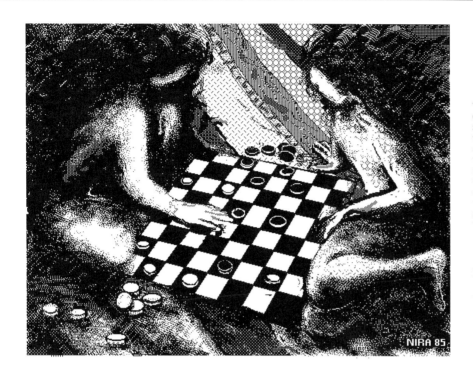

These two works, **Checker Game** and **Sunset,** illustrate different effects achieved by painting from scratch on the screen. Checker Game was created entirely in MacPaint using two shades of gray (black and white). Sunset is a product of Photon-Paint, a four-color Macintosh paint program. Both works were created by **Nira,** a Los Angeles artist who has been painting on the Macintosh since it was introduced in 1984. (See page 159 for more work by Nira.)

THE VERBUM BOOK OF DIGITAL PAINTING 167

Persistence of History (opposite) by **Nathan Weedmark** started out with a slide taken of a dancer; the "ruins" behind her are actually real sand castles that were part of the photo. The scanned image was brought into ImageStudio, where it was manipulated using fills, duplicating, resizing and so on. The elements at the top (sky) and bottom of the image were generated in ImageStudio to create a piece suggesting the associative process of culture. (See pages 153–155 for additional work by Nathan Weedmark.)

Mandara '89 is a PixelPaint composition that began with hundreds of individual black-and-white elements, many of which were derived from electronic clip art created by **Tomoya Ikeda** and others at the Japanese software company Enzan-Hoshigumi. Once assembled in the final composition, these images were then fully colorized and enhanced. This shining illustration also includes many new images created for the piece by Ikeda.

Originally from Tokyo, Ikeda now resides in Berkeley, California. He was the art director for Enzan-Hoshigumi.

John Odam's Armada image (right) is a unique coupling of scanned objects, assembled and enhanced in PixelPaint. The earth is from a Thunderscan file of an old NASA photo. It was encircled in black, then painted over with blue. A video camera was used to scan the corkscrew, and the fishes came from clip art. The pencils are the only mouse-drawn objects in the image; they were painted with an orange-to-yellow blend to create a roundness effect.

Cover art for the Titan Corporation Annual Report (opposite) is actually a ray-trace rendering, done in StrataVision, that can be viewed in a bitmapped program like PixelPaint. A purple stripe was projected and "mapped" onto a transparent ball to give a 3D interpretation of the Titan Corporation's logo. StrataVision lets the artist project light sources onto the object, taking into account shadows and reflections. The 3D object was touched up in PixelPaint, where the background was added.

One of today's foremost electronic designers, Odam is a British-born artist and illustrator who began working with the Macintosh in 1986. He is the art director of *Verbum* magazine, and heads his own design studio.

This piece, **Afternoon on Titan**, is a study for an alien landscape (Titan is a moon of Saturn) showing a remarkable "painterly" feeling. Created in PixelPaint by **Ron Cobb** on a Mac II, it won first place in a PixelPaint promotional contest.

Cobb is a well-known cinematic set and character designer who uses the Macintosh as a "sketch pad."

Jack Davis' Ocean Couch (above) was assembled from three objects — the reclining figure, the "geo furniture," and the moon — all constructed in Swivel 3D. The human figure consists of "linked" 3D objects, allowing for the realistic movement of the arms, legs, head and so on. Each of the three objects was given its own image "wrapper" — a turkey sandwich, water and sunset, respectively — which had been scanned on a Sharp JX-450 color scanner from photos. After being saved as PICT files, the three objects were brought into PixelPaint for the final composition, and the cloud background was added.

Hokusai vs. Godzilla (left) began with scans of the original woodcut Great Wave and 1950s clip art of a reptile. The black-and-white bitmapped images were combined in SuperPaint, gray shades were added with the paint bucket in ImageStudio, and then the image was brought into Photoshop for experimentation with transparent colors and graduated ramps for the background. It was originally created as a tee-shirt design for Gordon & Smith surf clothing manufacturers.

GoldMan (top left) was built from a model that comes with the Swivel 3D Professional package. Custom environment maps were created in Photoshop and then applied to the model in Swivel 3D to simulate reflectivity and to give the impression of gold. This image is part of a series that has been animated for an interactive version of *Verbum* magazine.

Originally a graphic designer, Davis has worked in high-end computer animation since the Macintosh was introduced, and has proven to be one of today's more prolific digital artists. He has been involved in major experimentation in illustration with electronic design tools, served as director of computer graphics for San Diego's Platt College and is currently graphics editor for *Verbum* magazine. (See page 151 for additional work by Davis.)

La Mesure (above) by **Dominique de Bardonneche-Berglund** incorporates scanned images, but also shows extensive use of PixelPaint's special effects and color palette manipulation to achieve the abstract, multicolored pixel patterns used in the composition.

de Bardonneche-Berglund is a French painter now living in Geneva, Switzerland, who has been painting on the Macintosh since 1985. She has exhibited her work throughout Europe. Although known primarily for her freehand mouse painting, she has only recently begun to incorporate scanned imagery into her paintings. (See page 172 for additional work by de Bardonneche-Berglund.)

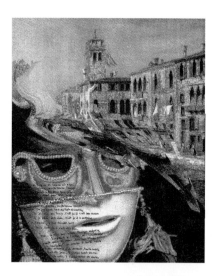

The **Metamasque** series by **Dominique de Bardonneche-Berglund** combines manipulated scanned images with hand-drawn imagery. It was created on a Mac II using a 256-color flatbed scanner to scan the mask images, which were brought into PixelPaint.

The **Autoportrait series** (beginning at the bottom of page 171 and continuing at the bottom of this page) was mouse drawn in FullPaint on a Macintosh computer, and shows the use of a number of standard paint effects such as cutting and pasting, skewing and modifying fields of pixels in various ways.

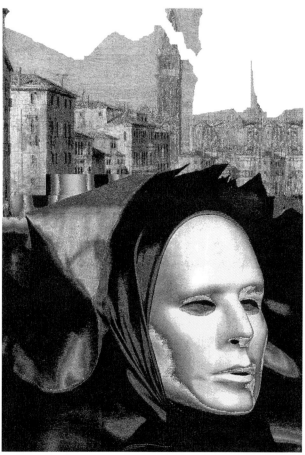
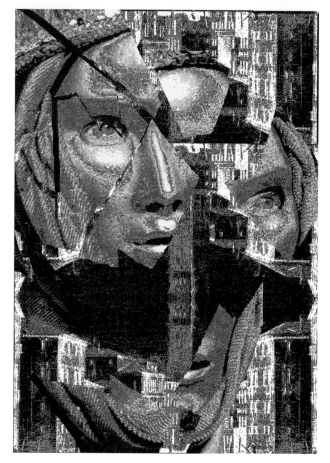

Mother Universe by **Jun-Ichi Matsuda** was created in Studio/8 on a Mac II with images scanned on an Epson GT-4000 run by the Color Magician II scanner driver software. The painting was output on a Canon FP-510SPA inkjet printer.

Angieyes by **Michael Gosney** was originally created on a Macintosh 512K with Mac-Paint and the inexpensive Thunderscan scanning system. A photograph was scanned and given a high-contrast treatment with the scanning software, then touched up in MacPaint. The model's right eye was duplicated and modified in various ways. Originally printed as a color silkscreen in 1985, the version presented here was colorized in PixelPaint.

Gosney is the founder and publisher of *Verbum: The Journal of Personal Computer Aesthetics*. He also heads The Gosney Company, Inc., a creative marketing group based in San Diego and specializing in desktop publishing and personal computer art.

Buddha (above) and **Wa** (harmony) (left) by **Izuru Satsuki** were both created in PixelPaint. Wa uses simple forms and color blends along with "airbrushed" textures, while Buddha incorporates a scanned line-art image into the composition, using simple shapes, blend and airbrush techniques.

Satsuki is president of Holonet, a Japanese graphic design agency specializing in Macintosh design. The agency was co-sponsor, with *Verbum* magazine, of the 1989 *Imagine Tokyo* exhibit of digital art.

Out of This World (left) by **Brentano Haleen** was created with OvalTune, a hybrid painting/music program, on the Macintosh. The image was enhanced in PixelPaint and output as a large-format, limited-edition four-color lithograph from a digital transparency.

Renaissance (below) was created in PixelPaint with the use of a scanned image, and also reproduced as a large-format lithographic print.

Haleen is a fine artist living in Rancho Santa Fe, California, who has been working with computers since 1984, beginning with work on mainframe systems.

Break the Barriers (below) was created by **Pam Hobbs** on an IBM PC with a Targa system, and Truevision software. **Portfolio Day Poster** (right) is described in detail in Chapter 11.

Hobbs is a commercial illustrator and fine artist specializing in computer-assisted works. Originally from London, England, she now resides in New York City.

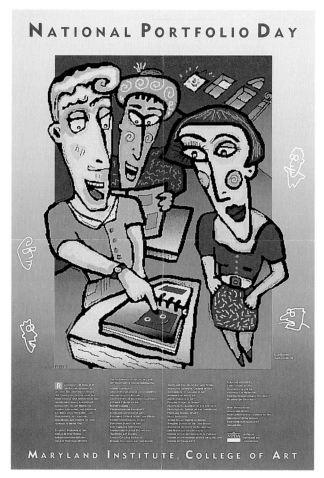

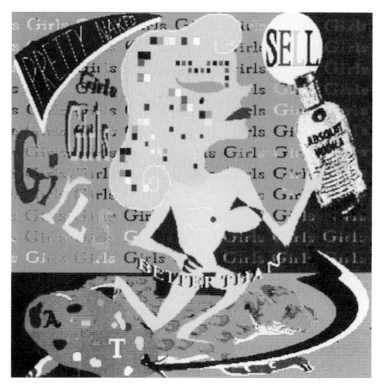

Absolut, by Los Angeles artist **Georganne Deen,** was painted on an Amiga with Deluxe-Paint software. The work is reproduced here from a Xerox 4020 inkjet print.

Deen has been working on the Amiga for several years while also painting with traditional media. Her computer works have been exhibited in galleries, used for animated stage shows by the rock group Oingo Boingo, and incorporated in software programs developed by Timothy Leary.

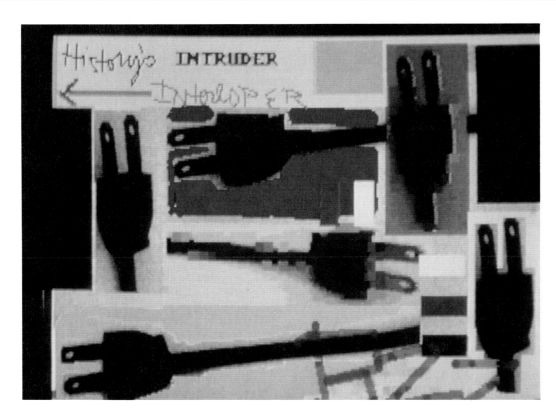

Roz Dimon of New York City is a fine artist who has been showing her digital paintings in galleries extensively since 1987. She has created a distinct look with her large-format Cibachrome prints — usually 36 x 48 inches — mounted flush on custom black laminate frames. The colorful works play up the "bitmapped look" and include scanned and painted elements. Dimon uses an Amiga computer with Digivision, DeluxePaint and other software packages.

History's Interloper: Intruder (left) includes scanned images which have been manipulated. **Splash Lilly** (below) is typical of many of Dimon's works, which resemble her oil paintings, such as **Frezia** (below left).

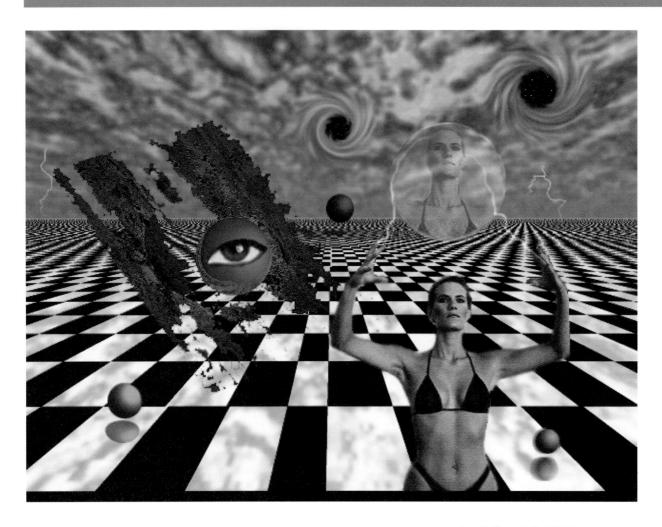

Cosmic Circus by **David Palermo** was cre-
ated by scanning one of his photos and then
colorizing the scan in Photoshop, where the
rough edges were smoothed out. He experi-
mented with various textures created in Stu-
dio/8 and Photoshop until the right color
and feel for the background and other as-
pects of the image were achieved.
Photoshop's filters were used for special
effects, such as the swirls, and StrataVision
3-D was used for creating 3D objects.
 Palermo is a photographer, a systems
engineer for INAComputer in Carlsbad, Cali-
fornia, and (in his spare time) a computer
artist.

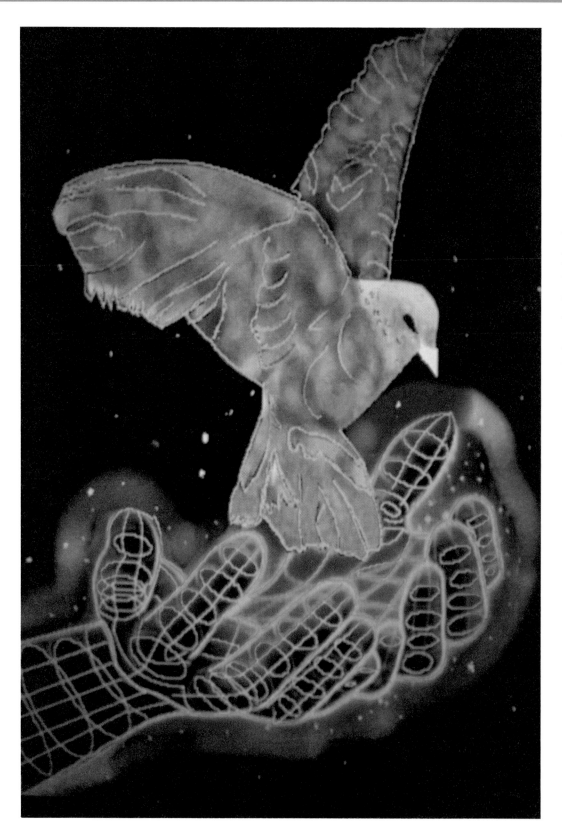

Serenity of Flight by **Laurence Gartel** was commissioned for a cover of *Forbes* magazine. The work was developed on an AT&T PC equipped with the Targa True-vision system. Gartel merged a 4 x 5-inch transparency of a hand (which he re-drew) with a black-and-white photocopy of a one-winged bird. He then colored and manipulated the im-age, adding highlights and a second wing to the bird.

New York City na-tive Gartel has been working with comput-ers as fine art tools since 1975, and has exhibited his digital paintings all over the world. He works with mainframe systems and Amiga, IBM/Targa and Macintosh systems.

Rites of Passage (right) **General Systems Theory** (above) and **Sensitive Mass** (top) by painter **Sandra Filippucci** are part of her Stone Age Series of "digital monotypes," one-of-a-kind computer paintings that combine printed sheets from a color inkjet printer with hand assembly and painting. Filippucci created these works on an Amiga computer using the DigiView video digitizer system to scan a photo of the surface of the moon and "map" the texture on forms in the paintings.

Filippucci lives and works in New York City, and has exhibited her large-format works at many galleries.

Headshot/Guardian (above) by **Marius Johnston** began as a Macintosh painting. The color dot-matrix printouts were combined with newsprint, photocopies and oil paint, and then mounted on a 24 x 19-inch board. A similar collage treatment was used to create **Eden** (right) a 32 x 30-inch work.

Johnston, of Berkeley, California, is a fine artist who has been working with the Macintosh as one of his primary tools for several years. His works often combine several media, even wood, plastic and metal screen assemblies with color computer prints and painting.

Barbara Nessim's bold painting, Hand Memory, was executed on an NEC PC 100 with Basic Graphics software. The final 24 x 30-inch piece was printed on cotton paper with a large-format inkjet printer.

Nessim is a New York City illustrator and fine artist who has in recent years become widely recognized for her mixed-media works that combine computer-drawn images with handpainted printouts.

8-bit color — a description of systems that allocate 8 bits of information for each *pixel* (spot) in the image. This provides 256 possible colors or levels of gray. (Black-and-white systems are 1-bit.)

24-bit color — a description of systems that allocate 24 bits of data to each *pixel* (spot) in the image. Usually, the bits are allocated as 8 bits each for the three additive primary colors (red, green and blue). That arrangement provides over 16.7 million color possibilities.

additive color mixing — producing colors by mixing colors of light rather than by mixing pigments.

alignment point — the point in a block of copy or art used as the reference point for lining up the block.

alpha channel — **1.** in video systems in general, and particularly the new 32-bit color system recently adopted by Apple, an extra signal or set of bits that provides control information. Alpha-channel information is used primarily for controlling special effects such as transparency and overlay. **2.** in some graphics programs, a grayscale version of an image used to make special effects.

anchor point — for many types of curve-drawing programs, the endpoints of a segment that stay fixed while the curve is drawn or changed.

animate — to provide the illusion of motion by presenting a succession of slightly different images. To produce animation on a computer display, the system must be able to paint pictures rapidly enough so the human visual system perceives the changes as motion (at least several dozen pictures per second).

antialiasing — in video and graphics, efforts to smooth the appearance of jagged lines (jaggies) created by the limited resolution of a graphics system. The most common antialiasing technique is to add extra dots (phantom pixels) at random points adjacent to sloping lines or to use shading to simulate partial dots.

auto scroll — on some drawing and graphics programs, a feature that appears to move a large document to make more of it visible on the screen when the mouse pointer or a tool reaches the edge of the visible region.

auto trace, automatic trace — a mode in some drawing programs that creates a set of vectors to represent apparent outlines on a bitmapped image. It is used to create draw-style images for graphics programs starting from a paint-style image.

average — a function on some types of painting programs that moves one or more points to the weighted middle of a group of selected points.

baseline — a reference point used for the vertical alignment of characters. Except for characters with descenders (such as "y"), the baseline is normally the line crossing the bottom-most part of the character.

bevel join — a treatment of the area created when two line segments of appreciable thickness meet at a point. The bevel join cuts off the inner corner of each line segment.

Bezier — a type of curve used in some drawing programs, defined by specifying four control points that set the shape of the curve.

bitmap — a type of graphics format in which the image is made up of a large number of tiny dots (bits) arranged on a closely spaced grid.

blend — a feature on many digital painting programs that lets you soften the edges or mix colors where two objects or regions meet.

brightness — the perceived amount of light emitted or reflected by an object.

byte — 8 binary bits of data grouped together to store a character, digit or other value. The term was popularized by IBM in connection with their 360 Series computers, and is now universally used in the industry. In most recent devices, each byte can be used to store one character of alphanumeric data, so the size of such items as memories can be interchangeably given in bytes or characters.

cast — **1.** a tint or overemphasis of one color in a color image, particularly an unintended one. Also called *color cast;* **2.** in some Macintosh animation programs, the elements that can be moved around the screen.

chroma — **1.** in general, color (hue) information; **2.** with respect to video signals, the portion of the signal that carries the color information.

chroma key — a color-based video matting (overlay) system that drops all areas of a selected color (usually blue) out of the foreground image, and substitutes instead the corresponding areas of a second image. This allows a person in a studio standing before a blue background to appear to be standing in front of a weather map or any other image. Similar computer systems are often called *color key.*

chrome — a color transparency, particularly one larger than a 35mm slide.

clip — **1.** (also *crop*) to select a part of a graphic to show on the screen or place into a document; clipping is used to select a region of interest rather than scaling the entire image, or to prevent the possible confusion that might be caused if the image were allowed to overflow its area or wrap around from one edge of the screen to the other. **2.** to cut off the extreme part of a value, such as the extremes of color or brightness.

closed path — **1.** a path that returns to its starting point. **2.** A complete loop.

CLUT — *see* color lookup table.

CMYK — a color model based on the cyan, magenta, yellow and black inks used in color printing. The first three inks are used to form all the available colors by subtractive color mixing, while the black is used to change tones or define edges.

color correction — the process of changing the color balance of an image to more closely approach the desired values. Images are color-corrected to make up for the differences between the response of the film and ink and the human eye and to compensate for the effects of the printing process.

Color Key — **1.** a proof sheet showing one of the colors of a color printing job. **2.** a 3M brand name for proofs made with a system of color-sensitive acetate overlays.

color lookup table (CLUT) — an ordered list of active colors (or pointers to color values) for use in a graphic display, where each color in the list is selected from a much larger possible set (the palette). Because the lookup table is much smaller than the full color palette, it takes fewer bits to describe each color, a factor that becomes important when displays use from thousands to millions of bits.

color model — a method for representing colors, usually by their components as specified along at least three dimensions. Common models include RGB (using red, green and blue light), HLS (hue, lightness and saturation), HSV (hue, saturation and value) and CMYK (using the common printing colors of cyan, magenta, yellow and black).

color separation — the process of dividing a colored image into a corresponding series of single-color images. Since color printing is done by printing four single-color images, color pictures and drawings must first be made into separate images for each of these colors (cyan, magenta, yellow and black). Until recently, color separation was

done by photographing the image three times through different color filters. Most computerized separation systems work on the digital representation of the image rather than a photo.

color space — an imaginary area or volume containing all the points whose positions represent the available colors in a system when those points are graphed on a set of axes. Color spaces are associated with companion color models, such as HLS, HSV and RGB.

color spectrum — the range of colors available on a particular device or system, usually presented in the same order as the colors in the normal visible spectrum.

color wheel — a diagram in circular form that shows hue (color) as the angle around the circle and saturation as the distance from the center; colors opposite each other are complements.

comp — as used in graphic arts, short for comprehensive layout; this a mock-up of the final product made by sketching in the headlines, blocks of text and illustrations all in the correct size and position. Some newer page layout systems can produce a sort of automated comprehensive, using blocks or wavy lines in place of the planned text.

complement — referring to colors, the matching color that will combine with a specified original color to make white for light, or black for pigments; complement pairs are opposite each other on the color wheel, and can be paired for contrast or vibrancy.

constrain — to place limits on an operation, its inputs or the results. Drawing operations are often deliberately constrained by various options to produce circles, squares or vertical or horizontal lines.

continuous tone — said of a photograph or illustration containing a range or gradation of tones in black-and-white or color. Continuous-tone images cannot be reproduced by most printing or digital display technologies, which either place ink or color at a given point or do not. Consequently, images with such tones must be broken up into small dark and light areas or series of different colored dots. See also *screen*, *halftone* and *dither*.

contrast — **1.** the ratio in brightness between the lightest part of an image and the darkest part. High contrast is desirable in computer displays and printed text, but excessive contrast causes eyestrain. For pictorial and graphic matter, too little contrast causes the picture to look dull or flat, while too much makes the picture seem stark and overexposed. **2.** in letterforms, the differences in thickness and darkness between parts of the letters. Some typefaces have a lot of contrast, while others are more even-toned. **3.** in layouts, the changes in brightness between different areas of the page or spread. Too little contrast produces a dull, flat-looking page, while too much may look garish. **4.** the control on a video display that alters the ratio of brightest to darkest part of the image; it should not be confused with the brightness control, which makes all areas brighter.

cool — referring to color images, ones that have a bluish tint; also called *cold*. Those that are more red are referred to as *warm*.

corner point — a point at which a line changes direction. A meeting point for two or more line segments that are not collinear.

corner radius — for rectangles with rounded corners, a value that determines the size of the rounded portion; it is the radius of the circle with the same arc as the rounded portion.

crop marks — marks that are drawn on a photo or other piece of artwork showing which parts of the image are to be cut off before the remaining part is included in a layout. The marks are most often made in the margins, but may sometimes be made on the image itself.

cutout — **1.** an area deleted from a background image to allow for the printing of an overlay color. **2.** an image or element extracted from its original image for use in building up another image.

dash pattern — the sequence of dots or line segments and spaces that make up a dashed line. Many drawing programs let you pick or construct a dash pattern; also called *line pattern.*

direct color — said of systems that store an actual color value for each point or object in an image rather than using a color lookup table; sometimes called *true color.*

direction line — in some types of drawing programs (particularly those using Bezier curves), a straight line from the endpoint of a curve segment to the nearest direction point. It is tangent to the curve at the endpoint.

direction point — with certain types of curves (such as Bezier curves), a point that specifies the shape of the curve between endpoints. Also called a *control point.*

dither — to place small dots of black, white or color in an area of an image to soften an edge, to visually smooth a jagged line, or to simulate a shade or tone.

dpi — an abbreviation for *dots per inch,* a measure of the resolution of printers and other output devices.

EPSF — short for *encapsulated PostScript format,* a combination of PostScript page description language statements needed to create a PostScript image, along with an optional bitmap version for quicker display.

feather — to blend or smooth the edge of a region or shape into a background or other object, especially in a slightly irregular fashion to achieve a naturalistic effect.

fill — **1.** a color or pattern occupying a defined region **2.** to place color or pattern in a region.

flip — to reverse an image side to side (to flip horizontally) or top to bottom (to flip vertically).

four-color — said of printing processes that use the three subtractive primary colors (cyan, yellow and magenta) plus black to create full-color images; also called *process color.*

gamma correction — changing the way an image is captured, transferred or displayed by modifying the shape of the gamma *histogram* or curve. This is done mostly to improve the appearance of images with improper contrast or color balance.

GCR — short for *gray component replacement,* the process of substituting black for the gray component that would have been created in an area of a printed image where all three process colors combine.

gradient fill, graduated fill — a feature on some graphics programs that adds color or a shade of gray to a region, varying the color or shade smoothly in a defined direction.

halftone — the technique of showing shades of intensity by combining differing sizes of tiny full-intensity dots. This is the method used to reproduce tones in most kinds of printing, since the printing process can only deposit or not deposit ink at any given point.

hidden surface removal — in speaking of a computer image of a three-dimensional scene, the deletion from the image of the surfaces and lines that would not be visible from the viewer's perspective.

hide — to temporarily remove an element of a drawing or block it from affecting the resulting image.

highlight — the lightest area on an image being photographed (and therefore the darkest area on the negative).

histogram — a chart showing the distribution of color or brightness in an image. Histograms are used mainly to provide the information needed for adjusting the settings of scanners or the characteristics of graphic filters in image editing.

hit — in graphics, to reserve an area in which an image is not drawn. Conceptually, it is similar to clipping a drawing at the outside edges, except in this case the drawing is omitted inside the boundary.

hot — as applied to images, very bright or excessively bright.

hotspot — the point or region on a graphic, icon or cursor that is active, responding to inputs or representing the position of the object.

HSV — short for *hue, saturation* and *value*, a color model used in some graphics programs. HSV has to be translated to another model for colored printing or for actually forming screen colors.

hue — the property of color corresponding to the frequency or wavelength of the light. This is what makes red different from green or purple different from yellow, for example.

image assembly — the creation of a page image by combining pieces or negatives on a flat or mechanical.

imagesetter — a high-resolution output device used to set type and pictures. Most current models use a laser to write the image directly on photosensitive film or paper.

indexed color — a color system that uses information from the user or from programs as a pointer to a table of output colors, rather than specifying the color directly. This is the system used in the Macintosh for *8-bit color,* allowing programs to pick up to 256 colors at a time from a palette of over 16 million possibilities.

jaggies — the jagged edges formed on raster scan displays of diagonal lines. See *antialiasing* for more details.

join — **1.** to combine two or more paths (sequences of line segments and curves). In some drawing programs, the result is still treated as two components, while in others the two are merged to a single path. **2.** to connect the current endpoints of an open path to create a closed path; most drawing programs have a closed shape mode that draws this last line automatically. **3.** the treatment of the meeting point of two or more curves or line segments; common joins include beveled, rounded and mitered.

landscape — an orientation for paper or a rectangular image with the long way horizontal. The complementary orientation is called *portrait.*

lasso — on many graphics programs, a tool that selects irregularly shaped regions from the image for further processing.

lpi — an abbreviation for *lines per inch,* a figure used to indicate the spacing of the dots making up a halftone image.

luminance — **1.** the intensity of a light source or object. **2.** in video signals, the intensity signal without the color information.

marquee — a rectangular area, often bounded by blinking dashes or dotted lines, used to select objects or regions in a drawing or CAD program.

mask — **1.** to block out part of an image, either to get rid of unwanted detail or to facilitate the addition of another image. **2.** to block out part of an image or deselect it so it won't be affected by a change or operation. **3.** a shape or region used to block out part of an image for the above purposes.

miter limit — on drawing programs that switch among line join treatments depending on the angle at which the lines meet, the angle at which a change is made between a miter joint and another treatment.

moiré — a type of interference pattern created when two or more images with regularly spaced features overlap. Through proper adjustment of images and selection of patterns, moiré dots and lines can be minimized.

monochrome — **1.** literally one color, but in practice a single color plus black. **2.** the term is often used to describe monitors that show images in black-and-white (or black-and-green or black-and-amber).

montage — **1.** a composite image, especially one made up of elements that are distinct or would normally not be placed together. **2.** a type of video sequence made up of many short images where the symbolic meaning of the images or their relations are the message, rather than any literal temporal or spatial sequence.

opacity — **1.** as applied to paper, the amount that it prevents an image on the reverse side or an adjacent sheet from showing through. **2.** as applied to a graphic element, the degree to which an element will hide anything in layers below it.

open path — in some graphics packages, a line or curve with endpoints (rather than one that makes a closed figure with no endpoints).

paint — as applied to graphics programs, ones that treat images as collections of individual dots or picture elements (pixels) rather than as compositions of shapes.

paint — on many drawing programs, to give a path or shape visible characteristics, such as by filling it with color or gray or by giving visible characteristics such as weight and color to the path.

palette — the collection of colors or shades available to a graphics system or program. On many systems, the number of colors available for use at any time is limited to a selection from the overall system palette.

Pantone Matching System — also known as *PMS*, a system of color samples, licensed coloring materials and standards developed by Pantone, Inc. for use in specifying and checking colors for reproduction.

path — **1.** in an imaging system, a route along which characters or graphic elements are placed. **2.** particularly in a drawing program, a combination of lines, points and curves that can be drawn in one operation.

photorealistic — said of images that look like they could have been produced by a photographic process. For a computer image, this usually means one with good spatial resolution, sufficient color depth (number of colors) and accurate rendition of a real or imaginary object.

pica — a printing-industry unit of measure, equal to approximately ⅙ of an inch. There are 12 points to a pica. Pica measurements are often used for the width and sometimes height of page areas and columns of type.

PICT — the standard file format used to pass images back and forth between Macintosh applications and the main format used by the clipboard. PICT files consist of collections of the Macintosh QuickDraw routines needed to create the image.

pixel — short for *picture element*, the smallest object or dot that can be changed in a display or on a printed page.

place — to put a block of type or pictorial element at a particular position on a page.

plate — **1.** the metal, paper or plastic sheet containing the image to be placed on the printing press. At this point, most methods of electronic composition and layout still produce a final paper mechanical or film negative, which is made into the plate by a photographic process. **2.** an illustration, particularly one printed separately from the text of a volume.

posterize — to transform an image to a more stark form by rounding tonal or color values to a small number of possible values.

PostScript — **1.** a trademark of Adobe Systems, Inc. for the firm's page description language used to describe images and type in a machine-independent form. **2.** loosely used to refer to the interpreter program that translates PostScript language files to the actual sequences of machine operations needed to produce the output image.

PostScript Level 2 — an updated version of the PostScript language that adds support for color, forms handling, data compression and many other features.

primary — as applied to colors, the minimum set of colors that can be mixed to produce the full color range. For inks the colors are yellow, magenta and cyan; for light they are red, green and blue; for pigments they are red, yellow and blue.

process-color — color images that are created by combining four standard printing inks (cyan, yellow, magenta and black) in patterns that allow almost all colors to be represented.

progressive proofs — the sequence of proofs (test images) showing how a printed color image looks as each ink color is added to the image. Traditionally, a full set includes one proof of each color plus the successive combinations of yellow/magenta, yellow/magenta/cyan, and yellow/magenta/cyan/black.

projecting cap — a treatment for the end of lines or curves the extends the line one half its current width beyond the nominal endpoint. This leaves the endpoint equally distant from the three nearest edges. Also called *square cap*.

QuickDraw — an Apple trademark for the set of drawing routines provided by the Macintosh operating system. The routines can be used by individual programs, and are also used as the basis for the PICT file format.

raster image file format — also known as *RIFF*, a file format for graphics developed by Letraset USA that is an expanded version of the TIFF format used by many scanner makers.

rasterize — to change a drawing held in a drawing or CAD system in vector (line and shape) form to the raster (collection of individual pixels) form used by most video displays and printers.

reflect — to make a mirror image of an object around a specified point or line.

regeneration — the production of a new screen image after a change in scale, position or elements; also called *screen refresh*.

register — **1.** the alignment of the printed image with its intended position on the page. **2.** the alignment of parts of an image with other parts, especially with parts that are printed separately, as in color separation.

register marks — small marks, often in the shape of crosshairs, that are used to make sure successive images printed on the same page line up with one another. They are usually placed outside the main image area and are trimmed off prior to binding or distribution.

renderer — a program or function that takes a geometric model or description of a scene and produces the corresponding images. Usually, the renderer can add solid surfaces, tonal or color shading, transparency effects and so on.

render — to produce an image from a model or description. Usually, this means filling in a graphic object or image with color and brightness (or just shading for monochrome systems). Realistic rendering takes a lot of computing power and advanced techniques.

RenderMan — a Pixar trademark for that firm's line of software for drawing finished photorealistic images.

resolution — **1.** in general, how many different values are distinguishable. **2.** for graphics output, it's usually spatial resolution (the tightness of the spots making up an image), measured in dots or lines per inch. **3.** for displays, it may be the output density (in dots or pixels per inch) or the screen resolution (measured in total dots wide by dots high) or the video resolution (measured in horizontal lines) or the color resolution (measured in the number of colors in the palette or the number available on screen at any one time) **4.** in typesetting, the size of the smallest change that can be accurately controlled or noted. Used mostly in conjunction with digital typesetters, which construct each character from bit patterns in memory. A finer resolution means smoother, sharper characters. **5.** for television graphic systems, the ability to produce small details. It is usually specified as the rise time (transition time) of the edges measured in nanoseconds.

retouch — to change an image, especially by painting on a photographic negative.

RGB — **1.** as a color model, a method of representing all colors as the combination of red, green and blue light that would create that color. The RGB color space is usually represented as a square, with one corner black and the opposing corner white. Although this model is mechanically simple and fits in well with RGB video systems, it is hard to work with artistically or conceptually. **2.** as applied to video systems, short for red, green and blue, three color signals that can between them create a complete video image. RGB systems can be digital (each of the three signals can only assume a number of defined states) or analog (each signal can vary smoothly over its range). **3.** a characterization of video systems that work with picture information carried on three signal (red, green, blue) lines rather than combined in a single line (composite color).

RIB — an abbreviation for *RenderMan Interface Bytestream*, a file format defined by Pixar for information sent to the firm's line of RenderMan products.

RIFF — see *raster image file format*.

rotate — to revolve an object around a specified point.

round cap — a treatment for the endpoints of curves or lines that places a hemisphere with a diameter equal to the current line width around the endpoint.

round join — a treatment for the meeting of two lines or curves that places a curved segment with a radius equal to the current line width at the intersection. On some drawing programs, the rounding takes place only on the outside angle of the intersection, while the interior angle remains a straight intersection of the inner edges.

saturation — when referring to colors, the extent to which a color is made purely of a selected hue rather than a mixture of that color and white. It is the property that makes pale pink different from bright red of the same hue.

scale — **1.** to change in size, particularly to change proportionally in both dimensions. **2.** the amount by which an image should be enlarged or reduced. **3.** as applied to type, to change in size proportionately, and in many cases to adjust the resulting character forms to fit the new size.

scan — **1.** to convert an image from visible form to an electronic description. Most available systems turn the image into a corresponding series of dots but do not actually recognize shapes. However, some attempt to group the dots into their corresponding characters (optical character recognition) or corresponding objects. **2.** particularly, to use a scanner (an input device containing a camera or photosensitive element) to produce an electronic image of an object or of the contents of a sheet of paper. **3.** a scanned image.

scanned image — an image in bitmap form produced by a scanner. Many layout programs can scale or crop scanned images before placing them into a page.

scanner — **1.** an input device that converts a drawing or illustration into a corresponding electronic bitmap image. In the graphic arts industry, sometimes called an *illustration scanner*. **2.** an input device that converts a page or section of text into the corresponding characters in memory or a computer file. Also called an *OCR (optical character recognition) scanner*.

scrapbook — a special file on the Macintosh and some programs on other systems that is used to store copies of images or sections of text for possible use in documents.

screen — **1.** to take images that have continuous tones and break them up into patterns of tiny saturated dots, with the darker tones represented by larger or closer dots. This is a necessary step for most printing technologies, which cannot directly print intermediate tones; the dot pattern used in such a process. See also *halftone*. **2.** a ruled or patterned piece of film, glass or plastic used to break up an image in to a series of dots.

screen angle — the rotation of the direction of the lines or major direction of the pattern in the screen used for making halftones. In four-color process printing, the screen angle is usually set to 45 degrees for black, 75 degrees for magenta, 90 degrees for yellow and 105 degrees for cyan, or 45 degrees for black, 75 degrees for magenta, 15 degrees for cyan, and 0 degrees for yellow.

screen frequency — the number of lines or dots in a stated distance for halftone (screened) images; often measured in lines per inch (lpi). A 60 lpi screen is very coarse, while a 200-line screen is fine.

select — to choose an item or a location on screen for the next action.

shade — a mixture of a pure color plus black.

shading — **1.** as applied to graphic objects, the way light reflects off a surface. **2.** changing the brightness and color of parts of an image to simulate depth or otherwise enhance definition. Common techniques include facet shading, linear shading, Gouraud shading, Phong shading and ray tracing.

shadow — **1.** the darkest area of an image that is being photographed, and therefore the lightest area on the negative. **2.** as a graphics tool, one that inserts a partial copy or dark outline behind a selected object, producing the appearance of a shadow.

shear — in some drawing programs, to slant an object along a specified axis (much the way a type of simple italic might be made by slanting a normal upright roman character).

smooth point — in drawing programs that use certain types of curves, a meeting point at which the ends of the lines or segments lie along the same straight line.

smudge — a feature on some graphics programs that blends colors or softens edges that are already in place in an image. The effect is supposed to resemble what would happen if the image was made of wet paint and you ran a finger over the area.

solarize — to change the intensity levels in an image in a way that particularly brightens or transforms the middle levels.

spot — **1.** in referring to the output of an imagesetter or film recorder, the smallest element that can be written. Also called a *dot* or *pixel.* **2.** to retouch a small area of an image, particularly using a brush.

spot color — color that is applied only as individually specified areas of a single hue; compare *process color,* whereby colors may be mixed and each dot of printed color must be determined by a more complex overall color-separation process.

stroke — **1.** to draw a line segment or arc as part of a graphic or letter form. **2.** a single line segment, arc or curve drawn in one continuous operation as part of a letterform or piece of art. **3.** in a drawing program or page description language, to make a defined path part of the image by giving it visible characteristics such as line width or color.

subtractive color mixing — producing colors by combining pigments or other colorants to absorb light.

subtractive primaries — the three process printing ink colors that can form all other colors (except pure white) when mixed together in the right ratios. They are cyan, magenta, yellow.

tagged image file format — also called *TIFF* for short; a file format developed by Aldus and Microsoft to represent bitmap images, particularly those produced by scanners. TIFF is an open-ended standard with several variants: uncompressed TIFF essentially is a bitmap of the image; compressed TIFF formats use encoding methods to remove redundant information from the file; grayscale TIFF includes information about the lightness of each point (normally from among 64 or 256 levels); and screened or halftone TIFF carries tonal information represented as patterns of black dots and white dots.

tangent — as a property of a line or segment, lying along a specified curve and meeting it at a single point.

template — **1.** a document or image used to establish the format of new documents. **2.** an image used as base or guide, particularly once used to trace over.

TIFF-24 — a version of the *tagged image file format* (TIFF) that encodes 24 bits of information for each point in the image.

TIFF — see *tagged image file format.*

tile — **1.** to fill an area with small, regular shapes, creating an effect that looks like a wall surfaced with individual tiles. **2.** the individual shape that is repeated to fill an area. **3.** a single sheet or portion that will be combined with others to assemble an oversize

page. **4.** a method of showing multiple windows on a display screen that puts images side-by-side instead of overlapping the windows like a stack of paper (called *overlapped windows*).

tint — **1.** a mixture of a particular color plus white. **2.** a solid area of color, particularly one of a specific hue but at less than full intensity or saturation. **3.** in printing, a light or screened color applied over an area.

tonal range — the spread between the lightest and darkest parts of an image.

tone — regarding light and color, a shade of gray.

toolbox — **1.** a set of standard routines provided by a program or operating system that can be called on by other programs or by the user. **2.** an on-screen array of images representing these routines.

transparency — for a graphics object or image, the attribute of letting an underlying image show through. Transparency can be partial or total.

true color — **1.** color systems in which the color information in the image is used directly to create the output color rather than as an index to a table of colors in a palette. **2.** said of color systems that have enough available colors to make the choices seem continuous to the human eye; 24-bit color (about 16 million available colors) is usually considered to be true color.

UCR — see *undercolor removal*.

undercolor removal — also known as *UCR* , in color printing, the full or partial replacement of overprinted dark colors during the making of separations or the printing *plate*.

value — regarding color or shades of gray, the degree of lightness or darkness.

warm — referring to color images, ones that have a reddish tint. Those that are more blue are referred to as *cool* or *cold*.

window — a selected portion of a file or image displayed on-screen.

zoom — **1.** to change the size of the area selected for viewing or display to provide either a more detailed view or more of an overview. Some systems allow any amount of zoom, while others only zoom in discrete steps. **2.** in computer graphics, to change the apparent magnification or scale factor of a region, window or display to provide a more detailed view or more of an overview.

THE VERBUM BOOK OF DIGITAL PAINTING 195

Resources

This appendix lists hardware, software and other resources of use to artists using digital paint programs. The resources are grouped in categories in the following order:

Paint Programs

Image-Processing Software

3D Programs

PostScript Illustration Software

Draw Programs

Page Layout Programs

Clip Art

Fonts

Graphic Tablets

Utilities, Desk Accessories and INITs

Scanners and Digitizers

Monitors

Color Calibration

Prepress Systems

Storage Systems

Printers and Imagesetters

Large-Format Output Services

Film Recorders

Periodicals

Books

Bulletin Board Services

Communication Software

Paint Programs

Color MacCheese
Delta Tao Software
760 Howard Avenue
Sunnyvale, CA 94087
408-730-9336

DeluxePaint 3.0
Electronic Arts
1820 Gateway Drive
San Mateo, CA 94404
415-571-7171

DigiPaint
NewTek
115 W. Crane Street
Topeka, KS 66603
800-843-8934

MacPaint
Claris Corporation
440 Clyde Avenue
Mountain View, CA 94043
415-962-8946

PC Paintbrush IV Plus
ZSoft Corporation
450 Franklin Road #100
Marietta, GA 30067
404-428-0008

PixelPaint 2.0
SuperMac Technology
485 Potrero Avenue
Sunnyvale, CA 94086
408-245-0022

PixelPaint Professional
SuperMac Technology
485 Potrero Avenue
Sunnyvale, CA 94086
408-245-0022

Studio/8
Electronic Arts, Inc.
1820 Gateway Drive
San Mateo, CA 94404
415-571-7171

Studio/32
Electronic Arts, Inc.
1820 Gateway Drive
San Mateo, CA 94404
415-571-7171

SuperPaint 2.0
Silicon Beach Software
9770 Carroll Center Road, Suite J
San Diego, CA 92126
619-695-6956

UltraPaint
Deneba Software
7855 N.W. 12th Street
Miami, FL 33126
800-622-6827

VideoPaint
Olduvai Corporation
7520 Red Road, Suite A
South Miami, FL 33143
305-665-4665

Image-Processing Software

ColorStudio
Letraset USA
40 Eisenhower Drive
Paramus, NJ 07653
201-845-6100

Digital Darkroom
Silicon Beach Software
9770 Carroll Center Road, Suite J
San Diego, CA 92126
619-695-6956

ImageStudio
Letraset USA
40 Eisenhower Drive
Paramus, NJ 07653
201-845-6100

PhotoMac
Data Translation
100 Locke Drive
Malboro, MA 01752
508-481-3700

Photoshop
Adobe Systems, Inc.
PO Box 7900
Mountain View, CA 94039-7900
800-344-8335

Picture Publisher
Astral Development Corporation
Londonderry Square, Suite 112
Londonderry, NH 03053
603-432-6800

3D Programs

MacRenderMan
Pixar
3240 Kerner Boulevard
San Rafael, CA 94901
415-258-8100

MacroMind 3D
MacroMind, Inc.
410 Townsend Avenue, Suite 408
San Francisco, CA 94107
415-442-0200

StrataVision 3D
Strata
2 W. Saint George Boulevard
Ancestor Square, Suite 2100
Saint George, UT 84770
801-628-5218

Super 3D
Silicon Beach Software
9770 Carroll Center Road, Suite J
San Diego, CA 92126
619-695-6956

Swivel 3D
Paracomp, Inc.
1725 Montgomery Street, Second Floor
San Francisco, CA 94111
415-956-4091

Zing
Mindscape
3444 Dundee Road, Suite 203
Northbrook, IL 60062
708-480-7667

PostScript Illustration Software

Adobe Illustrator
Adobe Systems, Inc.
PO Box 7900
Mountain View, CA 94039-7900
800-344-8335

Aldus FreeHand
Aldus Corporation
411 First Avenue S.
Seattle, WA 98104
206-622-5500

Corel Draw
Corel Systems Corporation
1600 Carling Avenue, Suite 190
Ottawa, ON K1Z 8R7 Canada
613-728-8200

Smart Art, Volumes I, II, III
Emerald City Software
1040 Marsh Road, Suite 110
Menlo Park, CA 94025
415-324-8080

Streamline
Adobe Systems, Inc.
PO Box 7900
Mountain View, CA 94039-7900
800-344-8335

Draw Programs

Canvas 2.0
Deneba Software
7855 N.W. 12th Street
Miami, FL 33126
800-622-6827

MacDraw
Claris Corporation
440 Clyde Avenue
Mountain View, CA 94043
415-962-8946

Page Layout Programs

DesignStudio
Letraset USA
40 Eisenhower Drive
Paramus, NJ 07653
201-845-6100

FrameMaker
Frame Technology Corporation
1010 Rincon Circle
San Jose, CA 95131
408-433-1928

PageMaker
Aldus Corporation
411 First Avenue S.
Seattle, WA 98104
206-622-5500

Personal Press
Silicon Beach Software
9770 Carroll Center Road, Suite J
San Diego, CA 92126
619-695-6956

QuarkXPress
Quark, Inc.
300 S. Jackson Street, Suite 100
Denver, CO 80209
800-543-7711

Ready,Set,Go!
Letraset USA
40 Eisenhower Drive
Paramus, NJ 07653
201-845-6100

Ventura Publisher
Xerox Product Support
1301 Ridgeview Drive
Lewisville, TX 75067
800-822-8221

Clip Art

Adobe Illustrator Collector's Edition
Adobe Systems, Inc.
PO Box 7900
Mountain View, CA 94039-7900
800-344-8335

Artagenix
Devonian International Software
Company
PO Box 2351
Montclair, CA 91763
714-621-0973

ArtRoom
Image Club Graphics, Inc.
1902 11th Street S.E.
Calgary, AB T2G 3G2 Canada
403-262-8008

Arts & Letters
Computer Support Corporation
15926 Midway Road
Dallas, TX 75244
214-661-8960

ClickArt EPS Illustrations
T/Maker Company
1390 Villa Street
Mountain View, CA 94041
415-962-0195

Clip Art Libraries
Stephen & Associates
5205 Kearny Villa Way, Suite 104
San Diego, CA 92123
619-591-5624

Clip Charts
MacroMind, Inc.
410 Townsend Avenue, Suite 408
San Francisco, CA 94107
415-442-0200

Cliptures
Dream Maker Software
4020 Paige Street
Los Angeles, CA 90031
213-221-6436

Designer ClipArt
Micrografx, Inc.
1303 Arapaho Road
Richardson, TX 75081
800-272-3729

DeskTop Art
Dynamic Graphics
6000 N. Forest Park Drive
Peoria, IL 61614
800-255-8800

Digiclips
U-Design, Inc.
201 Ann Street
Hartford, CT 06102
203-278-3648

Digit-Art
Image Club Graphics, Inc.
1902 11th Street S.E.
Calgary, AB T2G 3G2 Canada
403-262-8008

Illustrated Art Backgrounds
ARTfactory
414 Tennessee Plaza, Suite A
Redlands, CA 92373
714-793-7346

Images with Impact
3G Graphics
11410 N.E. 124th Street, Suite 6155
Kirkland, WA 98034
206-823-8198

Photo Gallery
NEC Technologies, Inc.
1414 Massachusetts Avenue
Boxborough, MA 01719
508-264-8000

PicturePaks
Marketing Graphics, Inc.
4401 Dominion Boulevard, Suite 210
Glen Allen, VA 23060
804-747-6991

**Pro-Art Professional
Art Library Trilogy 1**
Multi-Ad Services, Inc.
1720 W. Detweiller Drive
Peoria, IL 61615
309-692-11530

Professional Photography Collection
disc*Imagery*
18 E. 16th Street
New York, NY 10003
212-675-8500

PS Portfolio, Spellbinder Art Library
Lexisoft, Inc.
PO Box 5000
Davis, CA 95617-5000
916-758-3630

The Right Images
Tsunami Press
275 Route 18
East Brunswick, NJ 08816
800-448-9815

TextArt
Stone Design Corporation
2425 Teodoro N.W.
Albuquerque, NM 87107
505-345-4800

Totem Graphics
Totem Graphics
5109-A Capitol Boulevard
Tumwater, WA 98501
206-352-1851

Type Foundry
U-Design, Inc.
201 Ann Street
Hartford, CT 06102
203-278-3648

Vivid Impressions
Casady & Greene, Inc.
26080 Carmel Rancho Boulevard
Suite 202
Carmel, CA 93923
800-359-4920

Works of Art
Springboard Software
7808 Creekridge Circle
Minneapolis, MN 55435
612-944-3915

■

Fonts

Adobe Type Library
Adobe Systems, Inc.
PO Box 7900
Mountain View, CA 94039-7900
800-344-8335

**Bitstream fonts and
Fontware Installation Kit**
Bitstream, Inc.
215 First Street
Cambridge, MA 02142
800-522-3668

CG Type
Agfa Compugraphic Division
90 Industrial Way
Wilmington, MA 01887
800-622-8973

**Corel Headline, Corel Loader,
Corel Newfont**
Corel Systems Corporation
1600 Carling Avenue, Suite 190
Ottawa, ON K1Z 8R7 Canada
613-728-8200

18+ Fonts
18+ Fonts
337 White Hall Terrace
Bloomingdale, IL 60108
312-980-0887

Em Dash fonts
Em Dash
PO Box 8256
Northfield, IL 60093
312-441-6699

Fluent Laser Fonts
Casady & Greene, Inc.
26080 Carmel Rancho Boulevard
Suite 202
Carmel, CA 93923
800-359-4920

Font Factory Fonts (for LaserJet)
The Font Factory
13601 Preston Road, Suite 500-W
Dallas, TX 75240
214-239-6085

FontGen IV Plus
VS Software
PO Box 165920
Little Rock, AR 72216
501-376-2083

Font Solution Pack
SoftCraft, Inc.
16 N. Carroll Street, Suite 500
Madison, WI 53073
608-257-3300

**Hewlett-Packard Soft Fonts
(for LaserJet)**
Hewlett-Packard Company
PO Box 60008
Sunnyvale, CA 94088-60008
800-538-8787

Hot Type
Image Club Graphics Inc.
1902 11th Street S.E.
Calgary, AB T2G 3G2 Canada
800-661-9410

**Kingsley/ATF typefaces
(ATF Classic type)**
Type Corporation
2559-2 E. Broadway
Tucson, AZ 85716
800-289-8973

Laser fonts and font utilities
SoftCraft, Inc.
16 N. Carroll Street, Suite 500
Madison, WI 53703
800-351-0500

Laserfonts
Century Software/MacTography
326-D N. Stonestreet Avenue
Rockville, MD 20850
301-424-1357

Monotype fonts
Monotype Typography
53 W. Jackson Boulevard, Suite 504
Chicago, IL 60604
800-666-6897

Ornate Typefaces
Ingrimayne Software
PO Box 404
Rensselaer, IN 47978
219-866-6241

Typographic Ornaments
The Underground Grammarian
PO Box 203
Glassboro, NJ 08028
609-589-6477

URW fonts
The Font Company
12629 N. Tatum Boulevard, Suite 210
Phoenix, AZ 85032
800-442-3668

Varityper fonts
Tegra/Varityper
11 Mt. Pleasant Avenue
East Hanover, NJ 07936
201-884-6277

VS Library of Fonts
VS Software
PO Box 165920
Little Rock, AR 72216
501-376-2083

Graphic Tablets

Kurta Graphic Tablets
Kurta
3007 E. Chambers
Phoenix, AZ 85040
602-276-5533

Summagraphics
Summagraphics Corporation
325 Heights Road
Houston, TX 77007
713-869-7009

Wacom Digitizing Tablets
Wacom, Inc.
West 115 Century Road
Paramus, NJ 07652
201-265-4226

Utilities, Desk Accessories and INITs

Adobe Type Manager
Adobe Systems, Inc.
PO Box 7900
Mountain View, CA 94039-7900
800-344-8335

After Dark screen saver
Berkeley Systems, Inc.
1700 Shattuck Avenue
Berkeley, CA 94709
415-540-5535

DiskTools Plus
Electronic Arts
1820 Gateway Drive
San Mateo, CA 94404
800-245-4525

Exposure
Preferred Publishers, Inc.
5100 Poplar Avenue, Suite 706
Memphis, TN 38137
901-683-3383

Flowfazer
Utopia Grokware
300 Valley Street, Suite 204
Sausalito, CA 94965
415-331-0714

Font/DA Juggler Plus
Alsoft, Inc.
PO Box 927
Spring, TX 77383-0929
713-353-4090

Kodak Colorsqueeze
Kodak
343 State Street
Rochester, NY 14650
800-233-1650

New Fountain
David Blatner, Parallax Productions
5001 Ravenna Avenue N.E., Suite 13
Seattle, WA 98105

On Cue
Icom Simulations, Inc.
648 S. Wheeling Road
Wheeling, IL 60090
708-520-4440

Overwood 2.0, shareware
Jim Donnelly, College of Education
University of Maryland
College Park, MD 20742

QuicKeys
CE Software
PO Box 65580
W. Des Moines, IA 50265
515-224-1995

Screen-to-PICT, public domain
Educorp
531 Stevens Avenue, Suite B
Solana Beach, CA 92075
800-843-9497

SmartScrap
Solutions International
30 Commerce Street
Williston, VT 05495
802-658-5506

Suitcase II
Fifth Generation Systems
10049 N. Reiger Road
Baton Rouge, LA 70809
800-873-4384

Scanners and Digitizers

Abaton Scan 300/FB and 300/S
Abaton Technology Corporation
48431 Milmont Drive
Fremont, CA 94538
415-683-2226

Apple Scanner
Apple Computer, Inc.
20525 Mariani Avenue
Cupertino, CA 95014
408-996-1010

Dest PC Scan 1000 and 2000 series
Dest Corporation
1201 Cadillac Court
Milpitas, CA 95035
408-946-7100

DigiView
NewTek
115 W. Crane Street
Topeka, KS 66603
800-843-8934

Howtek ScanMaster II
Howtek
21 Park Avenue
Hudson, NH 03051
603-882-5200

HP ScanJet Plus
Hewlett-Packard Company
700 71st Avenue
Greeley, CO 80634
303-845-4045

JX-300 and JX-450 Color Scanners
Sharp Electronics
Sharp Plaza, Box C Systems
Mahwah, NJ 07430
201-529-8200

MacVision 2.0
Koala Technologies
70 N. Second Street
San Jose, CA 95113
408-438-0946

Microtek Scanners
Microtek Labs, Inc.
16901 S. Western Avenue
Gardena, CA 90247
213-321-2121

Silverscanner
La Cie
19552 S.W. 90th Court
Tualatin, OR 97062
800-999-0143

ThunderScan
Thunderware, Inc.
21 Orinda Way
Orinda, CA 94563
415-254-6581

Monitors

Amdek Corporation
3471 N. First Street
San Jose, CA 95134
800-722-6335

Apple Computer, Inc.
20525 Mariani Avenue
Cupertino, CA 95014
408-996-1010

E-Machines, Inc.
9305 S.W. Gemini Drive
Beaverton, OR 97005
503-646-6699

MegaGraphics, Inc.
439 Calle San Pablo
Camarillo, CA 93010
805-484-3799

Mitsubishi Electronics
991 Knox Street
Torrance, CA 90502
213-217-5732

Moniterm Corporation
5740 Green Circle Drive
Minnetonka, MN 55343
612-935-4151

Nutmeg Systems, Inc.
25 South Avenue
New Canaan, CT 06840
800-777-8439

Radius, Inc.
1710 Fortune Drive
San Jose, CA 95131
408-434-1010

RasterOps Corporation
2500 Walsh Avenue
Santa Clara, CA 95051
408-562-4200

SuperMac Technology
485 Portrero Avenue
Sunnyvale, CA 94086
408-245-0022

Color Calibration

The Calibrator
Barco, Inc.
1500 Wilson Way, Suite 250
Smyrna, GA 30082
404-432-2346

PrecisionColor Calibrator
Radius, Inc.
1710 Fortune Drive
San Jose, CA 95131
408-434-1010

TekColor
Visual Systems Group
5770 Ruffin Road
San Diego, CA 92123
619-292-7330

Prepress Systems

Aldus PrePrint
Aldus Corporation
411 First Avenue S.
Seattle, WA 98104
206-622-5500

Crosfield
Crosfield Systems, Marketing Division
65 Harristown Road
Glen Rock, NJ 07452
201-447-5800, ext. 5310

Freedom of Press
Custom Applications, Inc.
900 Technology Park Drive, Bldg 8
Billerica, MA 01821
508-667-8585

Lightspeed Color Layout System
Lightspeed
47 Farnsworth Street
Boston, MA 02210
617-338-2173

Printware 720 IQ Laser Imager
Printware, Inc.
1385 Mendota Heights Road
Saint Paul, MN 55120
612-456-1400

SpectreSeps PM
Pre-Press Technologies, Inc.
2441 Impala Drive
Carlsbad, CA 92008
619-931-2695

APPENDIX

Visionary
Scitex America Corporation
8 Oak Park Drive
Bedford, MA 01730
617-275-5150

Storage Systems

Jasmine Technology, Inc.
1740 Army Street
San Francisco, CA 94124
415-282-1111

Mass Micro Systems
550 Del Ray Avenue
Sunnyvale, CA 94086
800-522-7979

SuperMac Technology
485 Portrero Avenue
Sunnyvale, CA 94086
408-245-2202

Printers and Imagesetters

BirmySetter 300 & 400 Imagesetters
Birmy Graphics Corporation
PO Box 42-0591
Miami, FL 33142
305-633-3321

CG 9600/9700-PS Imagesetters
Agfa Compugraphic Corporation
90 Industrial Way
Wilmington, MA 01887
800-622-8973

Chelgraph A3 Imageprinter
Electra Products, Inc.
1 Survey Circle
N. Billerica, MA 01862
508-663-4366

Chelgraph IBX Imagesetter
Electra Products, Inc.
1 Survey Circle
N. Billerica, MA 01862
508-663-4366

ColorQuick
Tektronix, Inc.
Graphics Printing & Imaging Division
PO Box 500, M/S 50-662
Beaverton, OR 97077
503-627-1497

Colorsetter 2000
Optronics, An Intergraph Division
7 Stuart Road
Chelmsford, MA 01824
508-256-4511

Compugraphic Imagesetters
Agfa Compugraphic Corporation
200 Ballardvale Street
Wilmington, MA 01887
508-658-5600

4CAST
Du Pont Electronic Imaging Systems
300 Bellevue Parkway, Suite 390
Wilmington, DE 19809
800-654-4567

HP LaserJet Series II
Hewlett-Packard Company
PO Box 60008
Sunnyvale, CA 94088-60008
800-538-8787

HP PaintJet
Hewlett-Packard Company
PO Box 60008
Sunnyvale, CA 94088-60008
800-538-8787

ImageWriter II
Apple Computer, Inc.
20525 Mariani Avenue
Cupertino, CA 95014
408-996-1010

JLaser CR1
Tall Tree Systems
2585 Bayshore Road
Palo Alto, CA 94303
415-493-1980

Lasersmith PS-415 Laser Printers
Lasersmith, Inc.
430 Martin Avenue
Santa Clara, CA 95050
408-727-7700

LaserWriter II family of printers
Apple Computer, Inc.
20525 Mariani Avenue
Cupertino, CA 95014
408-996-1010

Linotronic imagesetters
Linotype Company
425 Oser Avenue
Hauppauge, NY 11788
516-434-2000

LZR Series Laser Printers
Dataproducts
6200 Canoga Avenue
Woodland Hills, CA 91365
818-887-8000

Mitsubishi G330-70
color thermal printer
Mitsubishi Electronics America
Computer Peripherals Products
991 Knox Street
Torrance, CA 90502
213-515-3993

Omnilaser Series 2000
Texas Instruments Inc.
12501 Research
Austin, TX 78769
512-250-7111

Pacific Page
(PostScript emulation cartridge)
Golden Eagle Micro, Inc.
8515 Zionsville Road
Indianapolis, IN 46268
317-879-9696

Phaser Color Image Printer
Tektronix, Inc.,
Graphics Printing & Imaging Division
PO Box 500, M/S 50-662
Beaverton, OR 97077
503-627-1497

QMS ColorScript printers
QMS, Inc.
1 Magnum Pass
Mobile, AL 36618
800-631-2693

QMS-PS Series Laser Printers
QMS, Inc.
1 Magnum Pass
Mobile, AL 36618
800-631-2693

Series 1000 Imagesetters
Linotype Company
4215 Oser Avenue
Hauppauge, NY 11788
516-434-2014

Turbo PS Series Laser Printer
NewGen Systems Corporation
17580 Newhope Street
Fountain Valley, CA 92708
714-641-2800

UltreSetter
Ultre Corporation
145 Pinelawn Road
Melville, NY 11747
516-753-4800

Varityper printers
Varityper, A Tegra Company
11 Mt. Pleasant Avenue
East Hanover, NJ 07936
201-884-6277

Large-Format Output Services

Computer Image Systems
20030 Normandie Avenue
Torrance, CA 90502
800-736-5105

Gamma One
12 Corporate Drive
North Haven, CT 06473
203-234-0440

Jetgraphix
1531 Pontus Avenue, Suite 300
Los Angeles, CA 90025
213-479-4994

Film Recorders

Agfa-Matrix Film Recorder
Agfa
1 Ramland Road
Orangeburg, NY 10962
914-365-0190

FilmPrinterPlus
Mirus
4301 Great America Parkway
Santa Clara, CA 95054
408-980-9770

Periodicals

Aldus magazine
Aldus Corporation
411 First Avenue S.
Seattle, WA 98104
206-622-5500

Colophon
Adobe Systems, Inc.
PO Box 7900
Mountain View, CA 94039-7900
800-344-8335

Font & Function
Adobe Systems, Inc.
PO Box 7900
Mountain View, CA 94039-7900
800-833-6687

MacUser
Ziff-Davis Publishing Company
1 Park Avenue
New York, NY 10016
800-627-2247

Macworld
IDG Communications, Inc.
501 Second Street
San Francisco, CA 94107
800-234-1038

PC magazine
Ziff-Davis Publishing
1 Park Avenue
New York, NY 10016
800-289-0429

Personal Publishing
Hitchcock Publishing Company
191 S. Gary Avenue
Carol Stream, IL 60188
800-727-6937

Publish
PCW Communications, Inc.
501 Second Street
San Francisco, CA 94107
800-222-2990

Step-by-Step Electronic Design
Dynamic Graphics, Inc.
6000 N. Forest Park Drive
Peoria, IL 61614-3592
800-255-8800

U&lc
International Typeface Corporation
2 Hammarskjold Place
New York, NY 10017
212-371-0699

Verbum magazine
Verbum, Inc.
PO Box 15439
San Diego, CA 92115
619-233-9977

Books

The Gray Book
Ventana Press
PO Box 2468
Chapel Hill, NC 27515
919-942-0220

Making Art on the Macintosh II
Scott, Foresman and Company
1900 E. Lake Avenue
Glenview, IL 60025
312-729-3000

PostScript Type Sampler
MacTography
326D N. Stonestreet Avenue
Rockville, MD 20850
301-424-1357

Bulletin Board Services

CompuServe Information Services, Inc.
5000 Arlington Center Boulevard
Columbus, OH 43260
800-848-8199

Connect Professional Information Network
Connect, Inc.
10161 Bubb Road
Cupertino, CA 95014
408-973-0110

Desktop Express
Dow Jones & Company
Princeton, NJ 08543
609-520-4000

Genie
GE Information Services
401 N. Washington Street
Rockville, MD 20850
800-638-9636

MCI Mail
MCI Mail
1150 17th Street N.W., Suite 800
Washington, DC 20036
800-444-6245

Communication Software

Microphone II
Software Ventures
2907 Claremont Avenue, Suite 220
Berkeley, CA 94705
800-336-6477

Red Ryder
Free Soft
150 Hickory Drive
Beaver Falls, PA 15010
412-846-2700

This book was designed and produced primarily on Macintoshes, although several other kinds of computer systems were used. Text was input primarily in Microsoft Word on a Macintosh IIci and a Mac Plus. Other computers used in design and production of the book included a Mac II, a second Macintosh IIci, a IIcx, an SE and a Plus.

Text files supplied by artists were converted, if necessary, to Microsoft Word format on the Mac. Files were checked with Word's Spelling function; the Change (search-and-replace) function was used to find and eliminate extra spaces and to insert *fi* and *fl* ligatures.

Pages were laid out and styled using PageMaker 4.0. Body text was set in Adobe's Galliard (10/14.5), and captions in Franklin Gothic (8/11). A Zapf Dingbats "z" was used for the "hint" symbol.

Illustrations for the project chapters and gallery were created as described in the text and in most cases were supplied by the artist as application files. Most artwork for the book and cover was saved in TIFF or PICT format and placed in the PageMaker files. Screen shots to show software interfaces were made on a Mac II using FKeys such as Command-Shift-6 (color screen clip), Command-Shift-7 (screen-to-PICT) or the Camera desk accessory on a Mac Plus. Color PICT files were imported into Adobe Photoshop for conversion to color TIFF files before being placed. The "Verbum Book of" logo was created in FreeHand and placed as an EPS in the PageMaker file for the cover.

During final layout and production, files were stored on 45 MB removable hard disk drives. An Apple IINTX laser printer and a Tektronix Phaser color PostScript printer were used for proofing pages. Pages were output by Central Graphics of San Diego on a Linotronic L-300 imagesetter with a RIP 30. Pages with type and line art only were output as negatives at 1270 dpi; pages with screen tints or grayscale images were output as negatives at 2540 dpi. Pages with embedded four-color graphics were separated using Aldus PrePrint and output as negatives at 2540 dpi.

In some cases artwork was provided to Applied Graphics Technologies of Foster City, California as 35mm transparencies or as final printed pieces, which were shot as halftones or color separated and stripped into the page negatives. Artwork from computer systems other than Macintosh were handled this way, for example. Because the SuperPaint 2.0 artwork in Chapter 3 would not print consistently through PageMaker 4.0, some of it was output as LaserWriter prints, photographically reduced and stripped.

INDEX

INDEX

SUBSCRIBE!

KEEP YOUR EDGE!

"If I were stranded on a desert island, this is the magazine I'd want with me" – Bob Roberts, *MIPS Journal*

PUSH THE ENVELOPE!

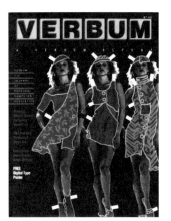

CHANGE THE WORLD!

"Artists are grabbing the cursor and spawning a distinct design sense, which this classy journal explores." – *Whole Earth Review*

MULTI YOUR MEDIA!

"The emergence of good taste... these guys are very serious about doing things right." – John Dvorak, PC Industry Analyst

GET RICH!

"I love your inspiring use of media...what should we call this? 'Magazine' hardly seems appropriate." – Chuck Pratt, subscriber, University of Texas

THE JOURNAL OF PERSONAL COMPUTER AESTHETICS

Join the inner circle of electronic art, design and multimedia professionals who've counted on *Verbum* since 1986 to deliver the cutting edge: the Verbum Gallery, regular columns, feature stories, new products, ideas, insights — *synergy. Verbum* is both substance *and* style — each issue uses the latest tools and programs to push the limits of desktop publishing.

Verbum Stack 2.0
1990 version of the famous Verbum Stack with usable start-up screens and icons, as well as tons of great bitmap art, sounds, animations and surprises. Shipped on two 800k floppies.

Verbum **Digital Type Poster** Designed by Jack Davis and Susan Merritt, this deluxe 5-color, 17 x 22-inch poster showcases the variety of digital type effects possible on the Macintosh. Produced on a Mac II with PageMaker 3.0, output on a Linotronic L-300 and printed on a 100 lb. coated sheet. Text explains the history of initial caps in publishing, and how each sample letter was created. A framable "illuminated manuscript" for every electronic design studio! Limited edition of 2000. Shipped in capped tube.

Keep abreast of technology and creativity...

Subscribe to VERBUM, order back issues and products by filling in this user-friendly form and we'll keep you up-to-date on the latest in pc art and news!

Name _____ Organization _____

Address _____ Phone _____

City _____ State _____ ZIP _____ Country _____

☐ **ONE YEAR/4-ISSUE SUBSCRIPTION** – $24; Canada & Mexico – $36 US funds; all other countries – $45 US funds

☐ **TWO YEAR/8-ISSUE SUBSCRIPTION** – $46; Canada & Mexico – $72 US funds; all other countries – $90 US funds

☐ **BACK ISSUES** – $7 each: (circle issue/s) 1.1 1.2 1.3 2.1 2.3 3.1 3.2 3.3 3.4 4.1 4.2 4.3

☐ **VERBUM STACK 2.0** – $12 (includes lifetime registration for add-on releases)

☐ **VERBUM DIGITAL TYPE POSTER** – $10 (including tube and shipping)

TOTAL AMOUNT (plus $2.50 shipping for products and back issues) **$** _____
California residents please add 7¼% sales tax for products and back issues.

☐ **Check enclosed**

☐ **VISA/MC #** _____ exp _____

Send to: VERBUM, PO Box 15439, San Diego, CA 92115 or call 619/233-9977 with credit card number. Allow six weeks for delivery.

DP Book